THE POLAROID BOOK

SELECTION FROM THE POLAROID COLLECTIONS OF PHOTOGRAPHY

THE POLAROID BOOK

SELECTION FROM THE POLAROID COLLECTIONS OF PHOTOGRAPHY

Edited by Steve Crist
Essay by Barbara Hitchcock

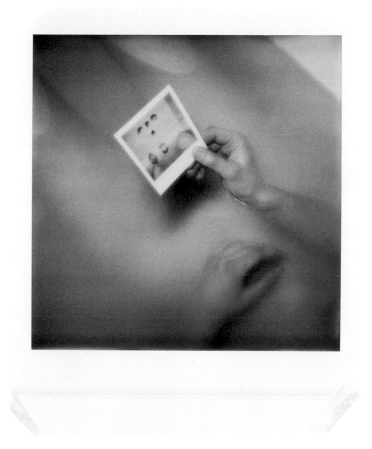

TASCHEN

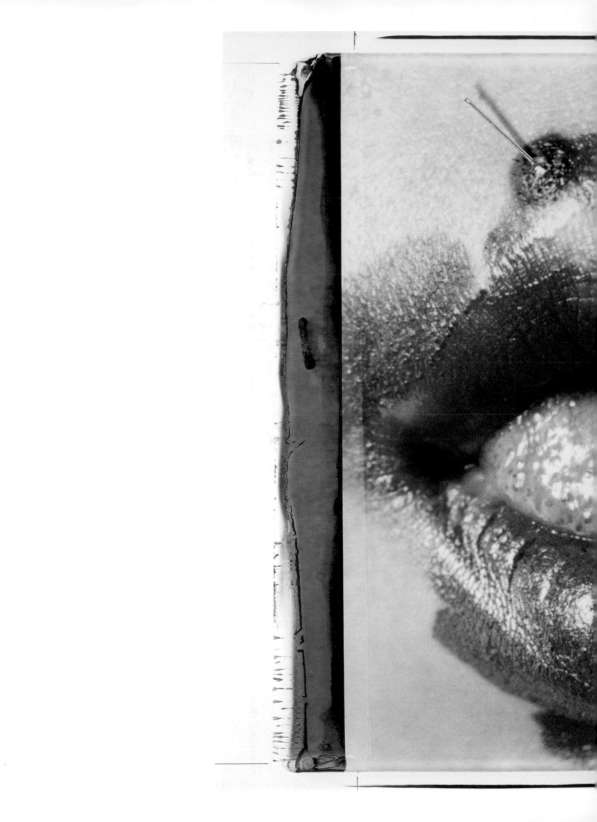

MASAHISA FUKASE

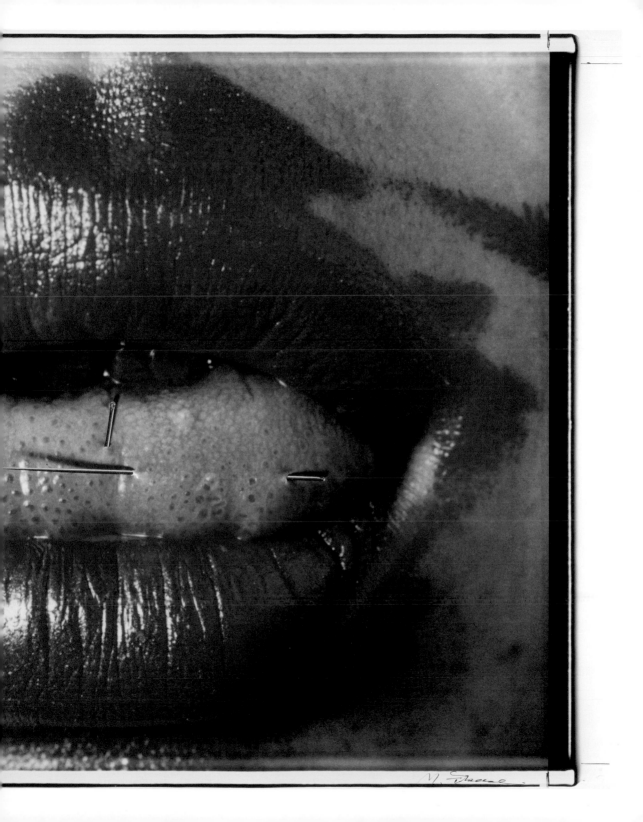

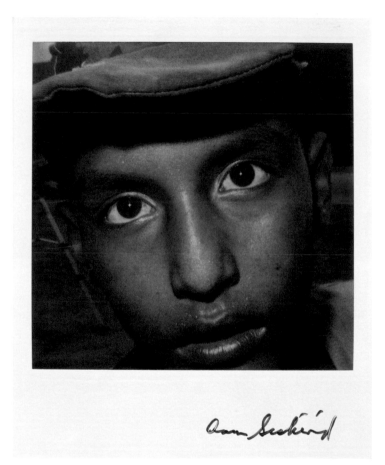

CONTENTS

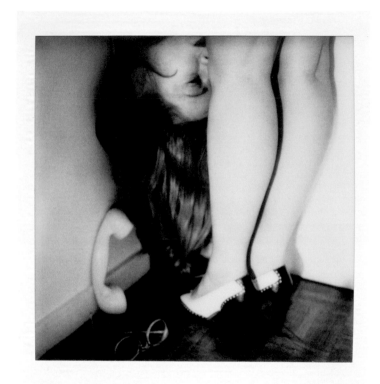

INTRODUCTION

The photography reflected within the pages of this book represents some really amazing examples of what can be accomplished with Polaroid film.

When I first visited the Polaroid Collections in the Fall of 2003, I was impressed with the variety and quality of the images. The collections are vast, and making selections for this book was definitely not an easy task. Barbara Hitchcock watches over this precious treasure trove and graciously granted the access to the archive.

Much of everything, and especially photography, is "instant" today. Digital cameras have changed our lives forever, but it is interesting to note that Edwin Land and his company first made the "instant photography" experience possible for the average person. The sense of seeing your pictures develop in your hand, and the ability to make creative and technical adjustments while shooting photographs was really an amazing new experience!

While conventional photography has changed dramatically in the past few years, Polaroid continues to be a vital, sensitive, and expressive material that has a unique look and feel of its own. While the digital world has seemed to take over, Polaroid has remained a true love to many devout users and finds new followers all the time.

After spending time with this book, my hope is that you, the reader, will be as inspired as I am to pick up a camera and create some wondrous Polaroids of your own.

STEVE CRIST
Los Angeles, September 2004

EINLEITUNG

Die im vorliegenden Buch versammelten Fotografien vermitteln einen wirklich erstaunlichen Eindruck davon, was man mit einem Polaroid-film alles machen kann.

Als ich die Polaroid Collections im Herbst 2003 zum ersten Mal auf-suchte, war ich von der Vielfalt und Qualität der Bilder beeindruckt. Die Sammlung ist sehr umfangreich und es war keine leichte Auf-gabe, eine Auswahl zu treffen. Barbara Hitchcock ist die Hüterin dieses kostbaren Schatzes und gewährte großzügig den Zugang zum Archiv.

Fast alles hat heute „sofort" zu passieren, besonders in der Foto-grafie. Digitalkameras haben unser Leben für immer verändert, aber man darf nicht vergessen, dass es Edwin Land und sein Unternehmen waren, die den normalen Verbrauchern die Erfahrung der Sofortbildfotografie als Erste ermöglichten. Mit eigenen Augen zu sehen, wie sich die Fotos entwickeln, und künstlerisch wie auch technisch Einfluss auf das Ergebnis nehmen zu können, war eine völlig neue Erfahrung!

Während die herkömmliche Fotografie in den vergangenen Jahren dramatische Veränderungen durchlaufen hat, sind Polaroids weiterhin ein lebendiges, sensibles und ausdrucksstarkes Medium mit einer unverwechselbaren Anmutung und einem ganz eigenen Appeal. Wenn es auch oft so scheinen mag, als hätte die digitale Welt alles andere verdrängt, so ist die Polaroidfotografie für viele treue Fans doch nach wie vor eine große Liebe und gewinnt ständig neue Anhänger hinzu.

Meine Hoffnung ist es, dass Sie, die Leser, von diesem Buch dazu inspiriert werden, genau wie ich gleich eine Sofortbildkamera zur Hand zu nehmen und selbst ein paar wunderbare Polaroids zu schaffen.

STEVE CRIST
Los Angeles, September 2004

INTRODUCTION

Les photographies rassemblées dans ce livre sont autant d'exemples étonnants de ce qu'il est possible d'accomplir avec une pellicule Polaroïd.

Lors de ma première visite des collections Polaroïd en automne 2003, je fus frappé par la diversité et la qualité des images exposées. Les collections sont tellement vastes que j'eus bien du mal à sélectionner les clichés destinés à figurer dans ce livre. Barbara Hitchcock, qui veille sur ce véritable trésor, mit gracieuse-ment les archives à ma disposition.

Beaucoup de choses sont instantanées de nos jours, à commencer par la photographie. Les appareils numériques ont changé notre vie à jamais, mais c'est à Edwin Land et à sa compagnie que l'on doit d'avoir mis la photographie instantanée à la portée de tout un chacun. Quelle sensation merveilleuse que de voir se développer la photo qu'on tient à la main, et de pouvoir réaliser divers effets techniques et esthétiques au moment même où on la prend !

La photographie traditionnelle a énormément évolué au cours des quelques dernières années, mais le Polaroïd reste un outil essentiel et plein de sensibilité, à l'aspect et à la personnalité propres. À l'heure des technologies numériques, de nombreux photographes lui restent fidèles et il fait sans cesse de nouveaux adeptes.

J'espère que ce livre incitera de nombreux lecteurs à se munir, comme moi, d'un appareil Polaroïd afin de créer leurs propres chefs-d'œuvre.

STEVE CRIST
Los Angeles, Septembre 2004

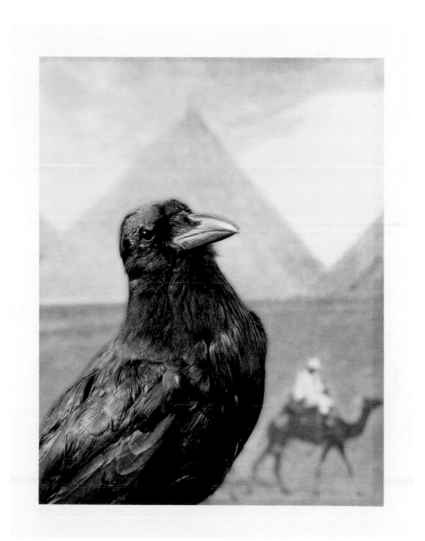

WHEN LAND MET ADAMS
BY BARBARA HITCHCOCK

At age 26, I walked into a Polaroid laboratory where I met the legendary figure for whom the camera was named, Edwin H. Land, the company's founder. My knowledge of instant photography was limited then, so I was amazed at the new world that opened before me.

Little did I know that my new job would also place me in a group that worked with another famous figure, Ansel Adams, a warm, affable gentleman who is regarded as the preeminent landscape photographer of our time. What brought Land and Adams together was what attracted me to Polaroid: photography.

Perhaps it was destiny that Land and Adams should meet. Both were brilliant and intellectually curious. Developments in science and technology fascinated them, yet they were both artists at heart. They had delicious senses of humor. Land was rather reserved. Adams was an extrovert. Most of all, they were men of vision.

Edwin H. Land, scientist, inventor and founder of the Polaroid Corporation, met Ansel Adams in 1948. The art historian Clarence Kennedy, a business colleague of Land's who photographed classical sculpture, introduced the two. Kennedy had approached Land in the 1930s to explore the idea of using stereo photography as a classroom aid. This business relationship grew into a warm friendship and set the stage for what became a model, the long-term collaboration between artist and industry.

When Land announced the invention of instant photography to the Optical Society of America in 1947, he'd taken a detour from his company's original path, the making of polarizers, that led him to a new business adventure—one-step photography. Click! You snap a picture. Seconds later, you peel away the negative to reveal a sepia print. It was magical! Seeing this demonstration, Clarence Kennedy knew that Land had to meet Ansel Adams.

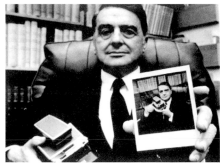

Invited to Cambridge, Massachusetts to see instant photography for himself, Adams was immediately enthusiastic. He envisioned the enormous possibilities of instant photography as Land demonstrated his invention. That night over dinner, the conversation continued. The seeds for another long and fruitful friendship were planted that evening.

Edwin Land with SX70 self-portrait, Boston, 1972, © Getty Images.

Shortly after this meeting, Land purchased Adams' *Portfolio I*. In a letter to Adams, he wrote: "My own admiration for your combination of aesthetic and technical competence is complete. As a small indication of this I should like to send you a camera and associated equipment and film as a personal gift."[1] Receiving the gift, Adams replied: "I look forward to trying the camera out. … I am tremendously excited about the actual use in the field and studio. I think it promises to be one of the greatest steps in the development of photography."[2]

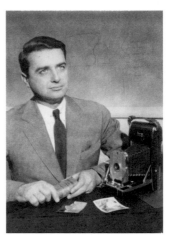

Co-workers at Polaroid have said that it took Edwin Land about one hour to figure out the basic concept of how one-step instant photography could work. Turning the idea into practical steps, however, took five years of hard work in the lab. But the science of instant photography wasn't everything. Land believed in the innate, creative potential of instant photography and that there were many people with an artistic bent who would love to use it. Recognized as a scientist, inventor, educator and leader, Land viewed himself, he once said, as an artist. To him, artistic inquiry was a critical element in the exploration of Polaroid products. The work of creating a fine, successful photograph could push the limits of a film in a way that was unlike the theoretical blueprint of the company's technical staff. This notion pitted making pictures in the field against a film's mathematical paradigm—the empirical performance plan—designed by scientists and engineers.

Consequently, Ansel Adams had by 1948 become the first of several artist consultants hired by Land. The assignment was to test cameras, films and related photographic paraphernalia, using them in the field and in the studio. How did a camera function? What could be done to make it better? Would a film capture high-key highlights or would it burn out, leaving no details to be seen? What improvements were needed for the next film generation? These questions and thousands more formed the basis for a dialogue between Adams and Land—and later select colleagues—that continued for more than 30 years.

Adams was meticulous and thorough. In Yosemite National Park, he'd photograph and re-photograph El Capitan, rock formations, waterfalls and friends, making exhaustive exposure records, analysing film and camera performance and committing his discoveries to paper. His friend, the modernist painter and photographer Charles Sheeler, sat before his camera in dappled light. Could the film handle the extremes of light burning into the dark trousers and weathered boards of the cabin behind him? Letters to Land detailed this experience. Adams enthused over points of excellence and explored

Edwin Land and model 95v2, courtesy of Polaroid.

ideas for improvements where he saw a need. Ultimately, he wrote more than 5,000 pages of letters, memoranda, postcards and notes to report his findings and to explore the technical and aesthetic essence of photography.

Land found in Adams a proponent of the acceptance of photography as a fine art form. Adams felt it important that Polaroid photographs should be exhibited with museum-quality photos made by renowned photographers. This goal was not to legitimize the Polaroid photograph, but to illustrate its superb quality when displayed side-by-side with conventional prints.

In early 1956, Land requested Adams' help in selecting and collecting photographs by American masters as well as his friends and acquaintances whose work he admired and respected. This collection would be a model of excellence. "I have always felt that Polaroid could interest itself in photography-in-general," Adams wrote in a letter to Land, "thereby associating itself with the art in its entirety and avoiding 'compartmentization.' The association of fine Polaroid-Land pictures with the best photographs in other media will only enhance the value and importance of the Polaroid process," Adams concluded.[3]

With a budget in hand, Adams decided first to acquire works by Edward Weston and Paul Strand. By year's end, he had purchased works, ranging in price from $5.00 to $100.00 each, by Eliot Porter, Dorothea Lange, Laura Gilpin, Minor White, Eugene Smith, Margaret Bourke-White and Brett Weston. "I have approached Paul Strand," he wrote, "but he has a too-high minimum ($125.00 for a 5 x 7!!). Enough is enough!"[4] His own *Portfolio Two: The National Parks and Monuments*, containing fifteen 8 x 10-inch pristine prints, Adams sold to Land for $100.

Known as the Library Collection, Ansel Adams' selection of prints forms the model of distinction and achievement with which Polaroid photographs would be compared. Any photographs made with each newly invented instant film would need to match the technical and aesthetic brilliance of works in the Library Collection. It was quite a standard to set, but also an expensive one, judged by 1957 dollars. How could this small, young company afford to continue to purchase original art by the best artists?

One solution was to commission additional artists and young photographers as consultants, charging them with the task of experimenting with the cameras and films they were given. They would then share their resulting images with Polaroid. The best pictures would be set aside for the company's collection. Among the accomplished artists who accepted this arrangement in the 1950s and 1960s

Portrait of Ansel Adams, courtesy of Polaroid.

were Paul Caponigro, Marie Cosindas, Philippe Halsman, Bert Stern, Arnold Newman and Yousuf Karsh. Nick Dean, then a fledgling Boston-based photographer who was also hired, described in a letter to Polaroid years later the atmosphere of working as a consultant to the company:

"For five or six years in the late 1950s and early 1960s, early weekend mornings often saw a car loaded with Boston area photographers and their view cameras headed out to Gloucester or Essex or perhaps to Bald Head Cliff, just over the Maine border. It was not a formal or planned group excursion, but somehow the same people used to head fairly regularly to a number of favorite spots. After a while we could predict what the light would be like at a given place and time of day or tide. There was a shared perception that they were involved in doing something very unique."[5]

One of Land's trusted associates, Meroe Marston Morse, had another idea: give Polaroid equipment and films to young, unknown, but aspiring photographers in exchange for a selection of their best photographs made with the films. If a concept like this could be sustained, a collection of photographs could simultaneously document the technical growth of instant photography and aspects of American culture. Polaroid's technical staff would still obtain important insights into the equipment and films from these photographers, so everyone benefited. The grant idea evolved into a formalized arrangement, the Artist Support Program, which continues to assist photographers and artists today.

Initially, there was no curatorial professional to review submissions and make grants. Individuals throughout the company—from research to advertising, from film manufacturing to marketing—were engaged in shipping film to photographers. One Polaroid pundit described this condition as "controlled anarchy." With the establishment of the Clarence Kennedy Gallery in 1972, however, a structure was designed to facilitate—and channel—the grant making. Fifteen Polaroid employees volunteered to meet bi-annually to review portfolios and authorize grants. In the 1980s, a steering committee of six employees who worked regularly in the arts and the Kennedy Gallery's director took over the decision-

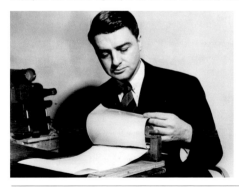

making process. The committee faded away as experienced curators took over the reins. I was lucky enough to have participated in each of these curatorial strategies.

The Library Collection and the prolific work by Ansel Adams formed the foundation of the Polaroid Collections. The Artist Support Program opened a new, rapidly growing avenue of acquisition that often deviated from the black-and

Edwin Land working with photo paper, 1947, © Corbis.

white-landscape genre influenced by Adams. The 1970s heralded an age of photographic experimentation in both the technical and aesthetic arenas. Polaroid curators selected artists' imagery that "pushed the envelope," reflecting the company's self-perception of innovation, creativity and invention. We did not neglect the perfect print or a beautiful, evocative image, but we were open to hand-worked prints, antique processes, and the artist's imaginative visualization of ideas and experiences.

Fewer and fewer portfolios that were submitted for review contained "straight" or documentary photography. Instead, we reveled in the adventures into the imagination that were placed before us.

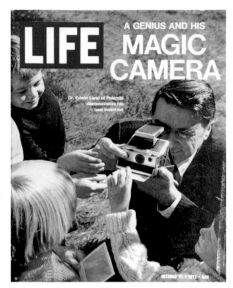

For many artists, the Polaroid print is an unfinished canvas, begging for a personal touch. Lucas Samaras embellished his self-portraits with designs in ink and paint in the 1960s. When Polaroid introduced the revolutionary SX-70 camera system in 1972, Samaras pushed the emerging dyes with a stylus to create malformed versions of himself. Robert Rauschenberg painted his black-and-white 20 x 24-inch photograph with a swath of printcoater and allowed the remainder of the print to go un-coated for days. The un-coated surface began to oxidize, transforming that section of the print into a rich sepia color. Other artists applied ink, acrylic paints, dyes, pastels and even blood. Some pierced the prints with needles, scratched on the negative or positive and printed with liquid light, platinum, palladium or other antique processes.

Stories abound about how Image Transfer, a uniquely Polaroid instant film process, was discovered and by whom, but one with great credence is that students at the School of the Museum of Fine Arts in Boston stumbled upon it. Another rumor suggests that Rosamond Purcell, a Boston photographer who loved experimenting with Polaroid pack films, accidentally created the first transfer. Regardless of its provenance, image transfer was initially a well-guarded secret. Those who made these rather pastel, watercolor-like prints remained silent about how they created them.

Edwin Land, cover of Life Magazine, October 27, 1972.

John Reuter, Polaroid's director of its 20 x 24 Studio, pioneered the art of the image transfer and began teaching its technique in response to the clamor of professionals and amateur photographers alike. Within a couple of years, transferring the dyes in a Polaroid photograph to unorthodox receiving "sheets" like bees wax, glass, silk or watercolor paper proliferated. Today, the desire to make "straight" transfers or to embellish them with paint is as strong as ever, evidenced by its use in personal artwork as well as photographers' commercial assignments.

Two Italian artists, Antonio Strati and Sergio Tornaghi, made the first Polaroid Emulsion Lifts that I had ever seen. It was 1990. They presented portfolios that held 8 x 10-inch prints characterized by a dimensionality I had never before witnessed. They explained how they'd heated water in pots, then submerged their developed Polacolor prints in them for about 5 minutes. Then they gently loosened the emulsion off the plastic base and slid it on to a piece of watercolor paper, pushing and pulling the edges into place. Tornaghi's print of goldfish swimming in deep blue waters was transformed. The image, captured in the ragged-edged gel, appeared to float on the surface of the paper, simulating the presence of water. With a delicate touch, you could feel the bas-relief of the emulsion beneath your fingers.

I have long been fascinated by the artist's imagination and technical exploration of Polaroid instant films used in the pursuit of visualizing ideas. In harboring this preoccupation, I point my finger at Edwin Land and Ansel Adams, whose words and deeds influenced my thinking about and love for photography. Both were primarily concerned about the art of photography—the aesthetics— but they knew it was essential to investigate the techniques and create the technology to make the aesthetic possible.

Thanks to the vision of Land and Adams, we are now able to enjoy, share and learn from the approximately 23,000 photographs—created by almost 2,000 photographers—that are held in the Polaroid Collections. Their friendship and mutual concerns led to an exceptional relationship between an artist and, ultimately, a corporation. There were many outcomes, but the Polaroid Collections in my view stands as a shining example of the quality and diversity of images created in art—and industry— throughout the world.

BARBARA HITCHCOCK
Director, The Polaroid Collections
Waltham, Massachusetts, September 2004

1 "Ansel Adams: An Autobiography", Ansel Adams and Mary Street Alinder, New York Graphic Society, 1985

2 Letter from Ansel Adams to Edwin H. Land (1948). Reprinted in "Ansel Adams' Polaroid Connection, Part 1", Mary Street Alinder, The Polaroid Newsletter for Photographic Education, Spring 1987 Volume IV, No. 2

3 Letter from Ansel Adams to Edwin H. Land (March 2, 1956), Polaroid Corporation Archive

4 Memorandum from Ansel Adams to Edwin H. Land, Meroe Marston Morse and Mrs. Sykes (January 23, 1957), Polaroid Corporate Archive

5 Letter from Nick Dean to Polaroid Corporation (n.d.), Polaroid Corporation Archive. Reprinted in "Polaroid and the Arts," Reference Volume Seven, prepared and compiled by Cheryl Collins, 1984

ALS LAND AUF ADAMS TRAF
VON BARBARA HITCHCOCK

Als ich 26 war, betrat ich zum ersten Mal ein Polaroid-Fotolabor und traf dort den legendären Erfinder der Kamera, Edwin H. Land, den Polaroid-Firmengründer. Meine Kenntnisse der Sofortbildfotografie waren damals noch begrenzt, weswegen ich über die neue Welt, die sich da vor mir auftat, nur staunen konnte.

Ich ahnte nicht, dass ich in meinem neuen Job zu einer Gruppe stoßen würde, die mit einem anderen berühmten Mann zusammenarbeitete, mit Ansel Adams, einem warmherzigen, umgänglichen Gentleman, der allgemein als der herausragendste Landschaftsfotograf unserer Zeit gilt. Land und Adams hatten aus dem gleichen Grund zusammengefunden, der auch mich zu Polaroid geführt hatte: die Fotografie.

Vielleicht war es vom Schicksal vorherbestimmt, dass Land und Adams sich treffen sollten. Beide waren hochbegabt und intellektuell aufgeschlossen. Beide waren von den Entwicklungen in Wissenschaft und Technik fasziniert, doch im Grunde ihres Herzens waren sie Künstler. Sie hatten einen wundervollen Sinn für Humor. Land war ein eher reservierter Mensch, Adams war extrovertiert. Vor allem jedoch waren sie Männer mit einer Vision.

Edwin H. Land lernte Ansel Adams 1948 kennen. Der Kunsthistoriker Clarence Kennedy, ein Geschäftskollege von Land, der klassische Skulpturen fotografierte, stellte die beiden einander vor. Kennedy hatte Land in den dreißiger Jahren vorgeschlagen, die Stereofotografie für den Einsatz im Unterricht zu erforschen. Aus dieser Geschäftsverbindung erwuchs eine enge Freundschaft und eine modellhafte, langfristige Zusammenarbeit zwischen Künstlern und Industrie.

Als Land 1947 vor der Optical Society of America die Erfindung der Sofortbildfotografie bekannt gab, stellte das eine Abweichung vom ursprünglichen Konzept seines Unternehmens dar, der Herstellung von Polarisationsfiltern. Sie führte ihn in ein ganz neues geschäftliches Abenteuer – die Einstufenfotografie. Klick! Man schießt ein Foto. Sekunden später konnte man das Negativ abziehen und hatte den fertigen Sepiaprint für sich. Es war das reinste Zauberkunststück! Als er diese Demonstration sah, wusste Clarence Kennedy, dass Land und Ansel Adams sich kennen lernen mussten.

Als Adams nach Cambridge, Massachusetts, eingeladen wurde, um sich die Sofortbildfotografie selbst anzusehen, war er begeistert. Er sah die enormen Möglichkeiten der Polaroidfotografie sofort vor Augen, als Land seine Erfindung vorführte. Beim Abendessen ging ihr Gespräch weiter. Der Grundstein für eine lange und fruchtbare Freundschaft wurde an jenem Abend gelegt.

Kurz nach dieser Begegnung kaufte Land Adams' *Portfolio I*. In einem Brief an Adams schrieb er: „Meine Bewunderung für Ihre Kombination von ästhetischem und technischem Können ist total. Als kleinen Ausdruck meiner Verbundenheit möchte ich Ihnen

eine Kamera mit zugehöriger Ausrüstung und Filmmaterial als persönliches Geschenk überreichen."[1] Adams antwortete ihm: „Ich freue mich darauf, Ihre Kamera auszuprobieren … Ich bin sehr angetan von den praktischen Anwendungsmöglichkeiten unterwegs und im Studio. Ich glaube, dass sie sich als einer der wesentlichsten Schritte in der Entwicklung der Fotografie erweisen wird."[2]

Polaroid-Mitarbeiter haben mir erzählt, dass Edwin Land nur ungefähr eine Stunde brauchte, um das grundlegende Konzept zu entwickeln, wie die einstufige Sofortbildfotografie funktionieren könnte. Die Idee dann jedoch praktisch umzusetzen, erforderte fünf Jahre harter Arbeit im Labor. Aber die Wissenschaft der Polaroidfotografie war nicht alles. Land glaubte an das kreative Potenzial der Sofortbildfotografie; er war überzeugt, dass viele künstlerisch begabte Menschen liebend gern damit arbeiten würden. Land, der als Wissenschaftler, Erfinder, Lehrer und Führungspersönlichkeit Ansehen genoss, betrachtete sich selbst als Künstler. Für ihn waren künstlerische Fragestellungen ein entscheidender Aspekt bei der Weiterentwicklung der Polaroid-Produkte. Der kreative Prozess zur Schaffung eines schönen, wirkungsvollen Fotos war in ganz anderer Weise geeignet, die Weiterentwicklung von Filmen voranzutreiben, als die theoretischen Überlegungen von Technikern dies vermochten. Aufgrund dieser Erkenntnis wurden die tatsächlichen Erfahrungen der Fotografen vor Ort mit den von Wissenschaftlern und Ingenieuren entwickelten mathematischen Paradigmen abgeglichen.

In der Folge wurde Ansel Adams 1948 der Erste einer ganzen Reihe von Künstlern, die von Land als Berater angestellt wurden. Seine Aufgabe war es, Kameras, Filme und Fotozubehör vor Ort und im Studio zu testen. Wie funktionierte die Kamera? Wie konnte man sie besser machen? War ein Film in der Lage, die Glanzlichter zu verzeichnen oder würden keine Details mehr zu erkennen sein? Diese und tausend andere Fragen bildeten die Grundlage für den Dialog zwischen Adams und Land – zu dem später ausgewählte Kollegen hinzugezogen wurden –, der über dreißig Jahre lang weitergeführt wurde.

Adams ging bei seiner Arbeit sehr methodisch vor. Im Yosemite National Park fotografierte er den Berg El Capitan, Steinformationen, Wasserfälle und Freunde immer und immer wieder, wobei er umfassende Notizen zu den Belichtungsverhältnissen machte, die Leistungen von Film und Kamera analysierte und sämtliche Beobachtungen auf Papier festhielt. Sein Freund, der moderne Maler und Fotograf Charles Sheeler, saß im Streulicht vor der Polaroid-Kamera Modell. Würde der Film in der Lage sein, die extremen Kontraste des Lichts, das grell auf seine dunklen Hosen und die verwitterten Holzplanken der Hütte hinter ihm schien, zu bewältigen? In Briefen an Land beschrieb Adams seine Erfahrungen genau. Adams schwärmte von den hervorragenden Eigenschaften der Polaroidkamera und schlug, wo notwendig, Ideen zur Verbesserung vor. Insgesamt verfasste er mehr als

5 000 Seiten Briefe, Memos, Postkarten und Notizen, in denen er seine Beobachtungen festhielt und die technische und ästhetische Essenz der Fotografie zu erfassen versuchte.

Land fand in Adams einen großen Fürsprecher für die Anerkennung der Fotografie als Kunstform. Adams hielt es für wichtig, dass Polaroidaufnahmen bekannter Fotografen zusammen mit Abzügen in Museumsqualität ausgestellt wurden. Sein Ziel war dabei nicht die Legitimierung des Sofortbildes, sondern die Darstellung seiner hervorragenden Qualität.

Anfang 1956 bat Land Adams um seine Beratung bei der Auswahl und Sammlung von Fotografien amerikanischer Meister sowie seiner Freunde und Bekannten, deren Werk er bewunderte und respektierte. Diese Sammlung sollte exzellente Fotografie modellhaft vorführen. „Ich habe immer den Eindruck gehabt, dass Polaroid ein Interesse an der Fotografie im Allgemeinen entwickeln könnte", schrieb Adams in einem Brief an Land, „und so einen Kontakt zu dieser Kunstrichtung als Ganzem schaffen und die Beschränkung auf eine bestimmte Nische vermeiden könnte. Die Verbindung hervorragender Polaroid-Land-Bilder mit den besten Fotografien auf anderen Medien wird den Wert und die Bedeutung des Polaroid-Prozesses nur noch steigern", argumentierte Adams.[3]

Als er dann mit einem Budget ausgestattet war, beschloss Adams, als Erstes Werke von Edward Weston und Paul Strand anzukaufen. Am Ende des Jahres hatte er Fotografien zum Preis von 5 bis 100 Dollar pro Stück von Eliot Porter, Dorothea Lange, Laura Gilpin, Minor White, Eugene Smith, Margaret Bourke-White und Brett Weston erworben. „Ich habe Paul Strand angesprochen", schrieb er, „aber sein Mindestpreis ist zu hoch (125 $ für ein 13 x 18!!). Was zu viel ist, ist zu viel!"[4] Sein eigenes Portfolio Two: The National Parks and Monuments, das fünfzehn makellose 20 x 25 cm-Abzüge enthielt, verkaufte Adams für 100 $ an Land.

Ansel Adams' Sammlung von Fotografien, Library Collection genannt, war das Vorbild in Rang und Leistung, an dem sich die Polaroidbilder zu messen hatten. Die Aufnahmen, die mit jedem neu entwickelten Sofortbildfilm gemacht wurden, mussten der technischen und ästhetischen Brillanz der Werke in der Library Collection entsprechen. Das war ein sehr hoher Anspruch, aber auch, gemessen am Wert des Dollars im Jahr 1957, ein sehr teures Unterfangen für ein kleines, junges Unternehmen. Wie konnte es sich finanzieren?

Ein Lösungsansatz war, andere Künstler und Jungfotografen als Berater zu verpflichten. Ihre Aufgabe würde es sein, mit den zur Verfügung gestellten Kameras und Filmmaterialien zu experimentieren und die dabei entstehenden Bilder Polaroid zu überlassen. Die besten Bilder würden in die Sammlung aufgenommen werden. Zu den bekannten Künstlern, die in den

Fünfzigern und Sechzigern auf diese Bedingungen eingingen, waren Paul Caponigro, Marie Cosindas, Philippe Halsman, Bert Stern, Arnold Newman und Yousuf Karsh. Nick Dean, damals ein noch ganz unerfahrener Fotograf aus Boston, der ebenfalls angeheuert worden war, beschrieb viele Jahre später in einem Brief an Polaroid, wie es war, als Berater für das Unternehmen zu arbeiten:

„Ende der fünfziger, Anfang der sechziger Jahre konnte man am Wochenende oft frühmorgens ein Auto beobachten, das vollgeladen mit Fotografen und ihren Großbildkameras aus der Bostoner Gegend hinaus nach Gloucester oder Essex oder vielleicht zum Bald Head Cliff direkt hinter der Grenze von Maine fuhr. Es war keine förmliche Gruppenexkursion; aus irgendeinem Grund fuhren dieselben Leute ziemlich regelmäßig zu mehreren Lieblingsstellen. Nach einer Weile konnten wir vorhersagen, wie das Licht an einem bestimmten Ort zu der und der Tageszeit oder dem Gezeitenstand sein würde. Alle Beteiligten hatten das Gefühl, mit etwas ganz Einmaligem beschäftigt zu sein."[5]

Einer von Lands Vertrauten, Meroe Marston Morse, hatte noch eine andere Idee: Man gibt jungen, unbekannten, ehrgeizigen Fotografen eine Polaroid-Ausrüstung und -Filme im Austausch gegen eine Auswahl ihrer besten Bilder, die sie damit gemacht haben. Wenn dieses Konzept dauerhaft durchführbar wäre, könnte die entstehende Sammlung von Fotografien die technische Weiterentwicklung der Sofortbildfotografie und gleichzeitig wichtige Aspekte der amerikanischen Kultur dokumentieren. Die technischen Mitarbeiter von Polaroid würden nach wie vor wichtige Erkenntnisse von diesen Fotografen erhalten, so dass allen damit gedient wäre. Diese Idee eines Förderprogramms entwickelte sich zu einem offiziellen Stipendienprogramm, dem Artist Support Program, das auch heute noch Fotografen und Künstler unterstützt.

Anfangs gab es keine professionellen Kuratoren, die Bewerbungsunterlagen bewertet oder Fördermittel vergeben hätten. Überall in der Firma gab es Einzelpersonen – in Forschung und Werbung, in Filmherstellung und Marketing –, die Filmmaterial an Fotografen verschickten. Ein Polaroid-Kenner beschrieb diese Situation einmal als „kontrollierte Anarchie". Mit der Einrichtung der Clarence Kennedy Gallery im Jahr 1972 wurde jedoch eine Struktur geschaffen, mit der die Stipendienvergabe durchgeführt und kanalisiert werden konnte. 15 Polaroid-Mitarbeiter erklärten sich bereit, zweimal im Jahr zusammenzukommen, Künstlermappen zu bewerten und Stipendien zu vergeben. Ab den achtziger Jahren unterstanden diese Entscheidungen einem Lenkungsausschuss, der aus sechs Mitarbeitern, die regelmäßig mit künstlerischer Arbeit zu tun hatten, und dem Direktor der Kennedy Gallery bestand. Dieser Ausschuss löste sich auf, als professionelle Kuratoren die Leitung übernahmen. Ich hatte das große Glück, in jeder dieser Phasen mitwirken zu können.

Die Library Collection und die in großer Zahl vorhandenen Arbeiten Ansel Adams' bildeten die Grundlage der Polaroid Collections. Das Künstlerförderungsprogramm eröffnete einen schnell anwachsenden Bereich der Neuerwerbungen, der oft nichts mehr mit dem von Adams beeinflussten Genre der schwarzweißen Landschaftsfotografie zu tun hatte. Die siebziger Jahre läuteten eine Ära technischer und ästhetischer Experimentierfreudigkeit ein. Polaroid-Kuratoren wählten Bilder von Künstlern aus, die die Herausforderung suchten und das Selbstbild des Unternehmens als innovativ, kreativ und erfindungsreich reflektierten. Wir vernachlässigten das gelungene Bild oder das schöne, ansprechende Foto nicht, waren aber ebenso offen für von Hand nachbearbeitete Abzüge, historische Druckverfahren und alle Arten einer phantasievollen Visualisierung der Ideen und Erfahrungen von Künstlern.

Immer weniger Mappen, die zur Beurteilung eingereicht wurden, enthielten „normale" oder dokumentarische Fotografien. Wir hatten unsere wahre Freude an den Höhenflügen der Phantasie, die da auf unseren Schreibtischen landeten.

Für viele Künstler ist der Polaroid-Abzug eine Art unfertige Leinwand, die geradezu danach schreit, dass man sich ihrer mit einem persönlichen Duktus annimmt. In den Sechzigern verzierte Lucas Samaras seine Selbstporträts mit Tinte und Farbe. Als Polaroid 1972 das revolutionäre SX-70-Kamerasystem einführte, drückte Samaras mit einem Griffel auf die sich entwickelnden Farbschichten, um verzerrte Abbilder von sich selbst zu schaffen. Robert Rauschenberg bemalte ein schwarzweißes 50 x 60 cm-Foto mit einem Streifen Schutzlack, während die restliche Fläche tagelang ungeschützt blieb. Die unbehandelte Oberfläche begann in einem kräftigen Sepiaton zu oxidieren. Andere Künstler trugen Tinte, Acrylfarben, Farbstoffe und sogar Blut auf. Manche durchbohrten die Abzüge mit Nadeln, zerkratzten Negativ und Positiv und stellten Abzüge mit lichtempfindlicher Emulsion, in Platin- und Palladiumdruck oder anderen historischen Verfahren her.

Es gibt eine Vielzahl von Legenden über die Endeckung des Image Transfers, eines Prozesses, der nur mit Polaroid-Sofortbildfilm durchgeführt werden kann. Höchstwahrscheinlich waren es Studenten an der School of the Museum of Fine Arts in Boston, die zufällig darauf stießen. Ein anderes Gerücht besagt, dass Rosamond Purcell, eine Bostoner Fotografin, die gern mit Polaroid-Packfilmen experimentierte, aus Versehen den ersten Transfer durchführte. Jedenfalls war der Image-Transfer-Prozess anfangs ein wohlgehütetes Geheimnis. Die Hersteller der typisch pastellfarbenen, aquarellartigen Prints bewahrten strenges Stillschweigen darüber, wie sie diese machten.

John Reuter, Leiter des Polaroid 20 x 24 Studio, war einer der Pioniere in der Kunst des Image Transfers und begann, diese Technik gegen den lautstarken Protest von Profi- und Amateurfotografen zu unterrichten. Innerhalb der nächsten Jahre wurde die Übertragung der Farbschichten im Negativ des Polaroidfotos auf so unkonventionelle Bildträger wie Bienenwachs, Glas, Seide oder Aquarellpapier sehr populär. Heute herrscht nach wie vor ein großes Interesse an der Herstellung „unveränderter" Transfers oder an deren Weitergestaltung durch Übermalung.

Zwei italienische Fotokünstler, Antonio Strati und Sergio Tornaghi, machten die ersten Bilder mit Polaroid Emulsion Lift, die ich gesehen habe. Das war im Jahr 1990. Sie hatten Mappen mit 20 x 25 cm-Abzügen eingereicht, die eine Plastizität aufwiesen, wie ich sie noch nie zuvor gesehen hatte. Sie erklärten, dass sie Wasser in Kochtöpfen erhitzt und ihre ausentwickelten Polacolor-Bilder ungefähr fünf Minuten hineingelegt hätten. Dann lösten sie die Bildschicht behutsam vom Trägermaterial und übertrugen sie auf ein Stück Aquarellpapier, wobei sie die Ränder vorsichtig zurechtzogen. Tornaghis Bild von Goldfischen, die in dunkelblauem Wasser schwimmen, war verwandelt. Das Bild in der Emulsion mit den ausgefransten Kanten schien auf der Papieroberfläche zu schweben und versinnbildlichte das Motiv des Wassers. Wenn man es vorsichtig berührte, konnte man sogar das Relief der Emulsion mit den Fingerspitzen spüren.

Es hat mich immer fasziniert, mit wie viel Phantasie und Lust am Betreten technischen Neulands Künstler die Polaroid-Sofortbildfilme zur Visualisierung ihrer Ideen benutzt haben. Meine große Begeisterung für diese Bilder verdanke ich Edwin H. Land und Ansel Adams, deren Worte und Taten meine Haltung und Liebe zur Fotografie maßgeblich beeinflusst haben. Beiden ging es im Wesentlichen um Fotografie als Kunst, um Ästhetik, aber beide wussten auch, wie wichtig es war, sich mit der Technik zu beschäftigen und die Technologie zur Verfügung zu stellen, um das Ästhetische möglich zu machen.

Der Vision von Land und Adams ist es zu verdanken, dass wir heute in den Polaroid Collections ca. 23 000 Fotografien besitzen – aufgenommen von fast 2 000 Fotografen –, an denen wir uns erfreuen, die wir zeigen, ausstellen und studieren können. Die Freundschaft und die gemeinsamen Interessen dieser beiden Männer führten zu einer außergewöhnlichen Beziehung zwischen einem Künstler und einem Unternehmen. Sie hat viele Früchte getragen, aber in meinen Augen bilden die Polaroid Collections den Höhepunkt. Sie sind ein leuchtendes Beispiel für die Qualität und Vielfalt der in der Kunst – und Industrie – geschaffenen Bilder in aller Welt.

BARBARA HITCHCOCK
Director, The Polaroid Collections
Waltham, Massachusetts, September 2004

Fußnoten siehe Seite 17

QUAND LAND RENCONTRA ADAMS
PAR BARBARA HITCHCOCK

J'avais 26 ans lorsque, entrant dans un laboratoire de la firme Polaroïd, je fis la connaissance de son fondateur : Edwin H. Land, célèbre inventeur de l'appareil photographique instantané. À l'époque, je ne connaissais pas grand-chose à ce domaine. Je découvris donc avec émerveillement tout un nouveau monde.

J'étais loin de me douter que mon nouvel emploi allait aussi m'amener à côtoyer un autre personnage légendaire : Ansel Adams, homme chaleureux et affable, que beaucoup considèrent comme le meilleur photographe paysagiste de notre époque. Land et Adams avaient gravité l'un vers l'autre pour la même raison qui m'avait fait atterrir chez Polaroïd : l'amour de la photographie.

Land et Adams semblaient voués à se rencontrer : ils étaient tous les deux très doués et d'une grande curiosité intellectuelle. Ils s'intéressaient l'un comme l'autre au progrès scientifique et technique, mais restaient au fond d'eux-mêmes des artistes. Leur sens de l'humour était savoureux. Land était plutôt réservé, Adams extraverti. Mais ils étaient avant tout, l'un comme l'autre, visionnaires.

Edwin H. Land, scientifique, inventeur, et fondateur de la Corporation Polaroid, fit la connaissance d'Ansel Adams en 1948, par l'intermédiaire de l'historien de l'art Clarence Kennedy. Celui-ci avait contacté Land au cours des années 1930 parce qu'il s'intéressait à la photographie stéréo et à ses applications possibles dans le domaine de l'enseignement. D'associés, Land et Kennedy devinrent bientôt des amis proches, jetant les bases de ce qui allait devenir un exemple parfait de collaboration harmonieuse entre artiste et industriel.

Lorsque'en 1947, Land présenta son invention – la photographie instantanée – à la Optical Society of America, il s'était écarté de l'objectif initial de sa compagnie, à savoir la fabrication de polariseurs, et s'apprêtait à s'embarquer dans une nouvelle aventure – la photographie instantanée. On appuyait sur un bouton et quelques secondes plus tard, ôtant le négatif d'un geste, on découvrait comme par magie une photo sépia. Clarence Kennedy assista à cette démonstration et décida d'emblée de présenter Land à Ansel Adams.

Invité à Cambridge, dans Massachusetts, Adams eut droit lui aussi à une démonstration et fut immédiatement conquis, pressentant les lumineuses possibilités de cette nouvelle technique. Le soir au dîner, les deux personnages poursuivirent leur conversation. Ce fut le point de départ d'une longue et fructueuse amitié.

Peu de temps après cette rencontre, Land acheta le *Portfolio I* d'Adams. « J'ai pour vos compétences esthétiques aussi bien que techniques la plus grande admiration », lui écrivit-il. « En gage de celle-ci, j'aimerais vous faire cadeau d'un appareil photo et de quelques pellicules et accessoires. »[1] Ayant reçu le cadeau,

Adams répondit : « J'ai hâte d'essayer l'appareil… Je suis véritablement enthousiasmé à l'idée de m'en servir en studio et sur le terrain. Il s'agit là, à mon avis, d'une des plus grandes avancées en matière de photographie. »[2]

Les collègues de Land affirment qu'il ne lui fallut qu'une heure pour établir dans les grandes lignes le fonctionnement de l'appareil photographique instantané. Sa mise en pratique, en revanche, ne prit pas moins de cinq ans de recherches assidues en laboratoire. Mais l'aspect scientifique n'était pas tout. Land était convaincu de l'immense potentiel artistique de la photographie instantanée, et que nombreux étaient ceux qui voudraient s'en servir à des fins créatives. Land, qui jouissait d'une grande reconnaissance en tant que scientifique, inventeur, éducateur et chef d'entreprise, se voyait, disait-il, comme un artiste. Il estimait que la recherche artistique avait un rôle essentiel à jouer dans le développement des produits Polaroid. C'était en s'efforçant de créer une image aussi belle que possible qu'on pourrait repousser les limites de la pellicule – pas en multipliant les études théoriques en laboratoires. De la même manière, le paradigme mathématique d'une pellicule et les études empiriques élaborés par les chercheurs et ingénieurs ne pouvaient se substituer au travail sur le terrain.

C'est ainsi qu'en 1948, Ansel Adams fut le premier de plusieurs conseillers artistiques à être engagé par Land. Son rôle était de tester des appareils, de la pellicule et du matériel photographique, en studio comme sur le terrain. Comment fontionnait tel appareil ? Que pouvait-on faire pour l'améliorer ? Telle pellicule allait-elle mettre en valeur les points les plus lumineux, ou au contraire être surexposée et noyer tous les détails ? Ces questions et bien d'autres constituent l'essentiel des conversations qui eurent lieu entre entre Adams et Land – et, plus tard, quelques autres collègues triés sur le volet – pendant plus de 30 ans.

Adams travaillait de manière méticuleuse et consciencieuse. Au parc national de Yosemite, il avait pris de multiples photos de ses compagnons ainsi que de formations rocheuses, de cascades et du mont El Capitan, notant scrupuleusement les temps d'exposition et analysant les performances des appareils et de la pellicule. Son ami Charles Sheeler, lui-même peintre et photographe moderniste, posa pour lui au milieu de taches de lumière. La pellicule serait-elle capable de rendre la manière dont celle-ci éclairait son pantalon sombre et les planches usées de la cabane qui se trouvait derrière lui ? Dans ses lettres à Land, il relatait en détail ses expériences. Adams s'enthousiasmait pour les qualités du matériel et suggérait des améliorations lorsqu'il les jugeait nécessaires. Il écrivit, en tout et pour tout, 5 000 pages sous forme de lettres, cartes postales et notes diverses, détaillant ses découvertes et réfléchissant en profondeur sur la photographie dans ses aspects techniques et esthétiques.

Land trouva en Adams un défenseur de la photographie en tant qu'art à part entière. Celui-ci pensait que les clichés Polaroïd gagneraient à être exposés aux côtés d'œuvres de maîtres. Leur but n'était pas tant de légitimer la photographie Polaroïd que de mettre en évidence ses qualités intrinsèques en la confrontant avec des tirages plus conventionnels.

Au début de l'année 1956, Land demande à Adams de l'aider à choisir des œuvres de photographes américains célèbres en vue de constituer une collection. Il souhaitait aussi inclure des images prises par des amis et connaissances qu'il tenait en estime. Cette collection se voulait un modèle d'excellence. « J'ai toujours pensé que le Polaroïd devrait garder un lien avec la photographie au sens large », écrivit Adams à Land, « ceci afin qu'il en fasse pleinement partie, et pour éviter tout compartimentage. C'est en associant les clichés Polaroïd-Land avec les meilleurs exemples du genre que la technique Polaroïd pourra être jugée à sa juste valeur. »[3]

Adams obtint un budget pour acheter des œuvres d'Edward Weston et de Paul Strand. Avant que l'année se fût écoulée, il avait fait l'acquisition de plusieurs œuvres d'Eliot Porter, de Dorothea Lange, de Laura Gilpin, de Minor White, d'Eugene Smith, de Margaret Bourke-White et de Brett Weston, coûtant entre $5,00 et $100,00 chacune. « J'ai pris contact avec Paul Strand », écrivit-il, « mais son prix minimal est trop élevé ($125,00 pour un 13 x 18 !!). Trop, c'est trop ! »[4] De son côté, il vendit à Land pour $100 son propre *Portfolio Two: The National Parks and Monuments*, qui contenait quinze tirages impeccables en 8 x 10.

Baptisée la Library Collection, la sélection constituée par Ansel Adams se voulait un modèle de qualité et de réussite auquel les instantanés Polaroïd allaient pouvoir se mesurer. Toute œuvre réalisée grâce à cette nouvelle technique devrait égaler l'excellence technique et esthétique des œuvres de la Library Collection. La barre était haut placée, et le prix à payer l'était également – n'oublions pas qu'on était en 1957. Comment une petite compagnie nouvellement fondée allait-elle pouvoir continuer à s'offrir les originaux de grands artistes?

Une solution était d'engager d'autres jeunes artistes et photographes comme consultants afin qu'ils testent les appareils et la pellicule. Les clichés ainsi obtenus seraient ensuite partagés avec Polaroïd, qui garderait les plus réussis pour sa collection. Au cours des années 50 et 60, plusieurs artistes accomplis, dont Paul Caponigro, Marie Cosindas, Philippe Halsman, Bert Stern, Arnold Newman et Yousuf Karsh, acceptèrent de participer. L'un d'entre eux était Nick Dean, jeune photographe débutant habitant Boston. Plusieurs années plus tard, il décrivit en ces termes son travail et l'atmosphère qui régnait dans l'entreprise:

« Pendant cinq ou six ans vers la fin des années 50 et au début des années 60, on voyait, le samedi et le dimanche matin, partir

une voiture pleine de photographes de la région de Boston armés de leurs appareils. Ils se dirigeaient vers Gloucester ou Essex, parfois vers Bald Head Cliff, au sud de l'État du Maine. L'excursion n'avait rien d'officiel ou de préparé, mais les mêmes finissaient souvent par retourner aux mêmes endroits. Au bout d'un certain temps, on pouvait prévoir quelle serait la lumière à tel endroit et à telle heure, en fonction des marées. Tous avaient le sentiment qu'ils étaient en train de participer à quelque chose d'unique. »[5]

Meroe Marston Morse, l'un des associés les plus proches de Land, eut une autre idée: pourquoi ne pas confier du matériel Polaroïd à de jeunes photographes encore inconnus mais prometteurs, en échange de quelques-unes des photos les plus réussies qu'ils réaliseraient avec celui-ci? La collection ainsi constituée permettrait de souligner l'évolution technique de la photographie instantanée, tout en servant de témoignage sur certains aspects de la culture américaine. Tout le monde aurait à y gagner, y compris les techniciens de la firme Polaroïd, qui pourraient en tirer des enseignements précieux sur le matériel et la pellicule. L'idée se concrétisa en un système de bourse, l'Artist Support Program, qui, encore aujourd'hui, apporte son soutien à un certain nombre d'artistes et de photographes.

Au départ, il n'y avait pas de conservateur professionnel pour réceptionner les propositions et distribuer les bourses. Des employés de divers départements – de la recherche à la publicité, en passant par le marketing et les ateliers de fabrication de pellicule – étaient chargés d'acheminer la pellicule jusqu'aux photographes. Un observateur qualifia cette situation d'« anarchie contrôlée ». Il fallut attendre 1972, date de la fondation de la Clarence Kennedy Gallery, pour qu'une structure fût mise en place pour faciliter – et canaliser – l'octroi des bourses. Quinze employés de chez Polaroïd étaient volontaires pour se réunir deux fois par ans afin de passer en revue les portfolios et décerner les bourses. Pendant les années 80, cette tâche fut assurée par un comité de direction composé de six employés habitués à travailler dans le domaine artistique, et du directeur de la Kennedy Gallery. Ce comité disparut ensuite progressivement et fut remplacé par des conservateurs professionnels. À chaque stade, j'eus la grande chance de prendre part aux décisions.

Les œuvres de la Library Collection et celles, très nombreuses, d'Ansel Adams constituaient au départ l'essentiel de la collection Polaroïd. Avec l'Artist Support Program, de nouvelles acquisitions commencèrent à affluer, dont beaucoup s'affranchissaient de l'influence d'Adams et de ses paysages en noir et blanc. C'était les années 70, début d'une phase d'expérimentation en termes techniques et esthétiques. Conformément à l'image de marque de l'entreprise, qui se voulait innovante, créative et inventive, les conservateurs de Polaroïd privilégiaient les œuvres les plus avant-gardistes. Certes, nous n'avions rien contre les tirages bien léchés ou les belles images évocatrices, mais nous accueillions

aussi à bras ouvert les tirages retouchés à la main, ceux qui avaient été réalisé d'anciens procédés de fabrications à partir, bref, toute image dans laquelle l'artiste faisait preuve d'imagination pour exprimer ses idées et ses expériences.

Nous recevions de moins en moins de photographies conventionnelles ou documentaires. Au contraire, nous découvrions avec joie de véritables chefs-d'œuvre pleins d'imagination.

Pour beaucoup d'artistes, un tirage Polaroïd est comme une toile inachevée qui n'attend que leur touche personnelle. Au cours des années 60, Lucas Samaras retouchait ses autoportraits de dessins à l'encre et à la peinture. En 1972, lorsque Polaroïd lança son nouvel appareil révolutionnaire, le SX-70, Samaras manipulait les pigments avec une aiguille de manière à créer des effigies déformées de lui-même. Quant à Rauschenberg, il badigeonnait grossièrement ses photos 50 x 60 cm pouce en noir et blanc de fixateur. Les parties non traitées s'oxydaient au bout de quelques jours et viraient au sépia. D'autres appliquaient sur leurs œuvres de l'encre, de la peinture acrylique, des teintures diverses, voire même du sang. Certains perçaient les tirages avec des aiguilles, grattaient les négatifs ou les positifs, et faisaient leurs tirages au platine, au palladium et autres formules anciennes.

Il existe une foule d'anecdotes sur l'origine du transfert d'image, procédé unique à la photographie instantanée de Polaroid. La plus crédible raconte qu'il fut découvert par hasard par des étudiants de l'École du Musée des Beaux-Arts de Boston. D'autres prétendent que c'est Rosamond Purcell, photographe de Boston qui adorait expérimenter avec les pellicules Polaroïd, qui réalisa malgré elle le premier transfert. Quelle que soit son origine, le transfert d'image fut au départ un secret bien gardé. Ceux qui réalisaient ces tirages aux couleurs pastel et aux allures d'aquarelles ne révélèrent rien de leur technique.

C'est John Reuter, le directeur du studio 20 x 24 de Polaroïd, qui fut le premier à mettre au point la technique du transfert d'image et à l'enseigner à la demande pressante de photographes amateurs et professionnels. En quelques années, la technique, qui consistait à transférer les pigments d'une photographie Polaroïd sur un support inhabituel (cire d'abeille, verre, soie ou papier aquarelle) rencontra un énorme succès. Sa popularité continue d'ailleurs aujourd'hui, comme en attestent le grand nombre de transferts réalisés par les particuliers comme par les professionnels.

Les premiers transferts d'émulsion Polaroïd que j'aie vus étaient les œuvres de deux photographes italiens, Antonio Strati et Sergio Tornaghi. C'était en 1990. Leurs portfolios contenaient des tirages en 20 x 25 cm qui ne ressemblaient à rien de ce que j'avais vu auparavant. Ils expliquèrent qu'ils avaient fait chauffer de l'eau dans des casseroles, dans lesquelles ils avaient ensuite plongé leurs tirages en Polacolor pendant environ 5 minutes. Ils

avaient ensuite délicatement décollé l'émulsion du support en plastique et l'avait fait glisser sur du papier aquarelle en ajustant les bords. Une photo de Tornaghi, représentant des poissons rouges en train de nager dans une eau d'un bleu profond, en était transformée. L'image était comme emprisonnée dans la gélatine au rebord déchiquetés, qui imitait l'apparence de l'eau, et semblait flotter à la surface du papier. En touchant délicatement l'œuvre du doigt, on sentait le relief de l'émulsion.

J'ai toujours été fascinée par l'imagination des artistes, et par la manière dont ils parviennent à mettre à profit la technique du Polaroïd pour donner formes et couleurs à leurs idées. Je rends donc hommage à Edwin H. Land et Ansel Adams, qui ont tous les deux, par leurs paroles et leurs actes, profondément influencé ma vision et mon amour de la photographie. Chacun s'intéressait avant tout à la photographie en tant qu'art, mais ils savaient aussi que cette dimension esthétique devait d'abord passer par une exploration des aspects techniques.

Grâce à Adams et Land, nous disposons aujourd'hui d'environ 23 000 clichés, réalisés par près de 2 000 photographes, qui sont conservés dans les Collections Polaroïd et dont nous pouvons tirer plaisir et instruction. Leurs affinités d'esprit et leur grande amitié sont à la base du rapport exceptionnel qui exista entre l'artiste et, finalement, la compagnie. Quelles que soient les autres issues de cette collaboration, les Collections Polaroïd offrent, à mon sens, au monde entier un exemple admirable de la qualité et de la diversité auxquelles l'art – et l'industrie – peuvent aspirer.

BARBARA HITCHCOCK
Director, The Polaroid Collections
Waltham, Massachusetts, Septembre 2004

Notes voir page 17

FROM THE POLAROID COLLECTIONS

DIE POLAROID-SAMMLUNGEN

PHOTOS DES COLLECTIONS POLAROÏD

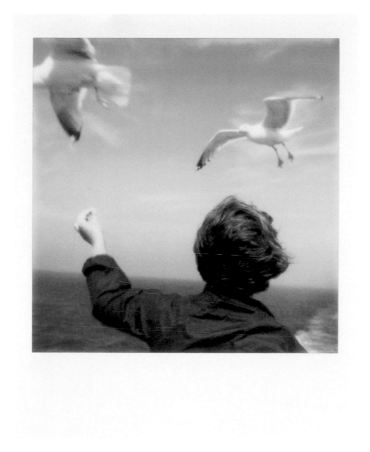

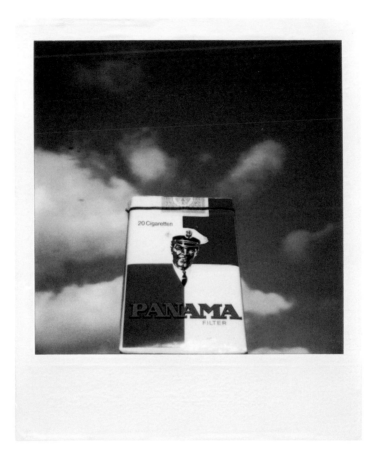

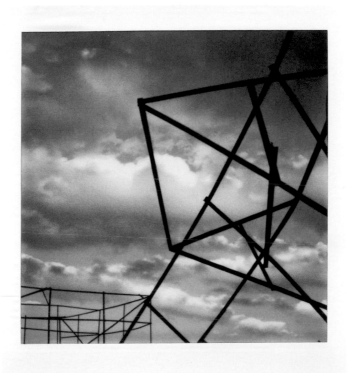

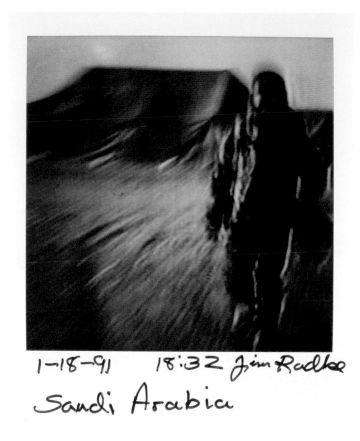

1-18-91 18:32 Jim Radke
Sandi Arabia

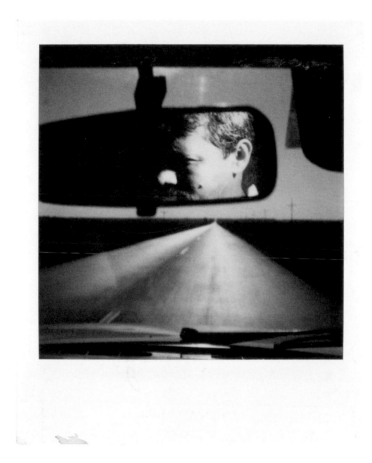

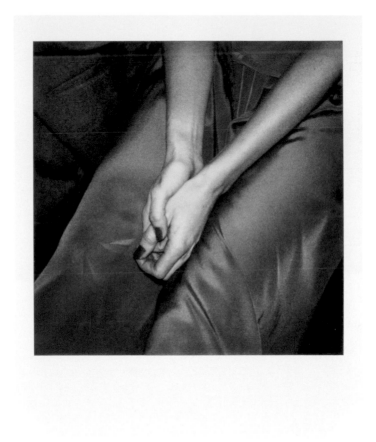

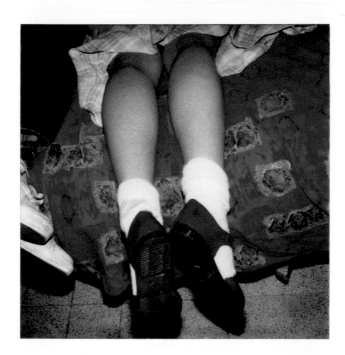

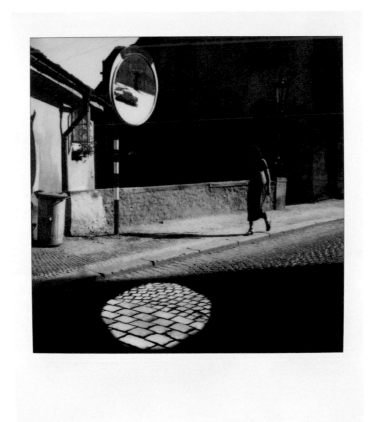

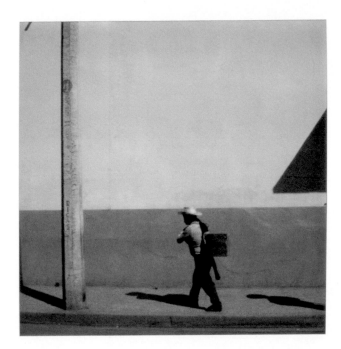

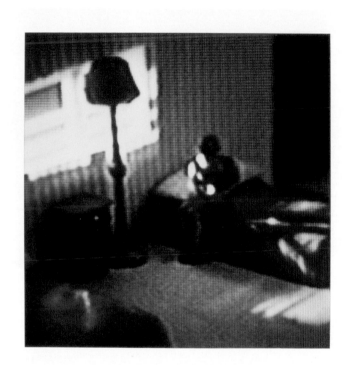

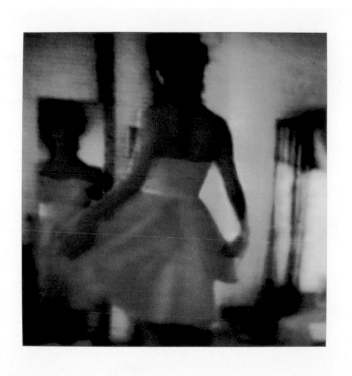

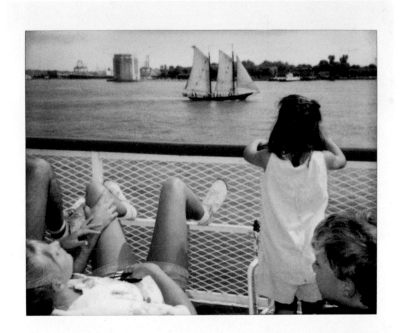

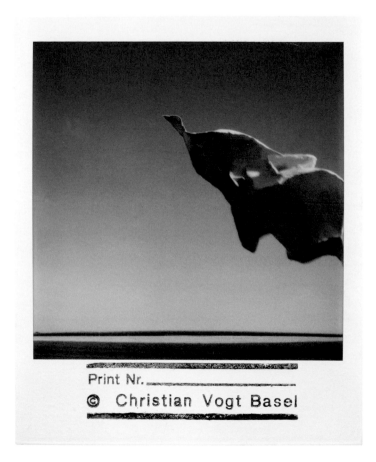

Print Nr.
© Christian Vogt Basel

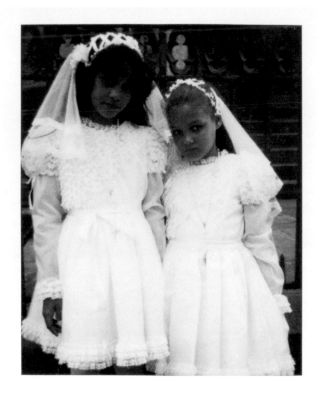

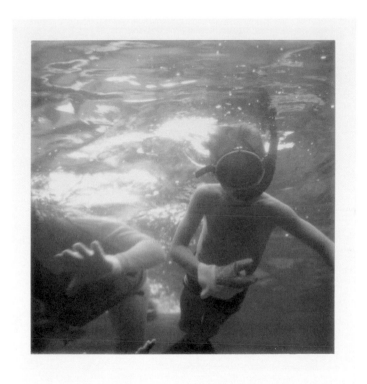

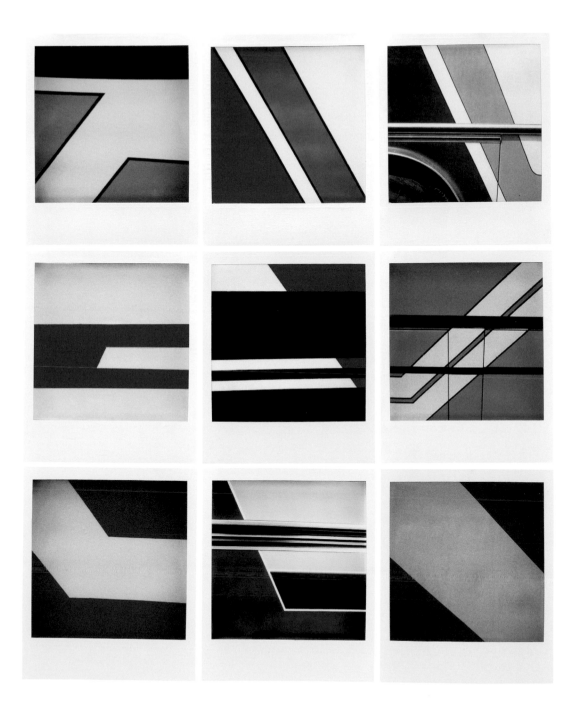

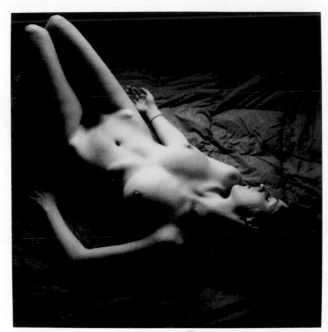

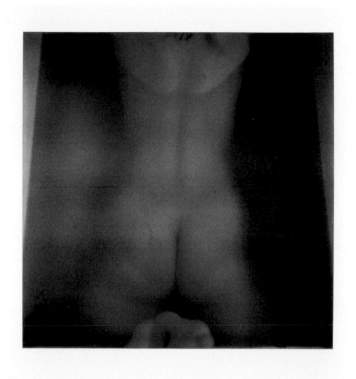

David Aschkenas 1980

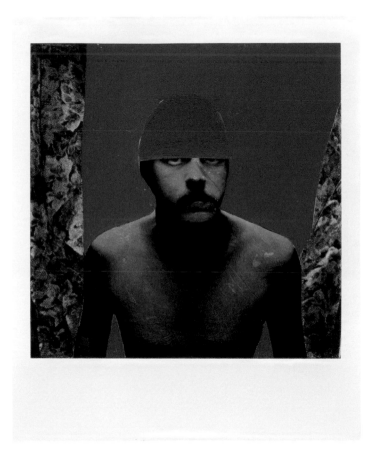

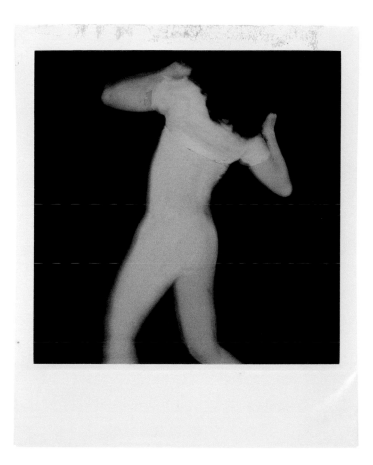

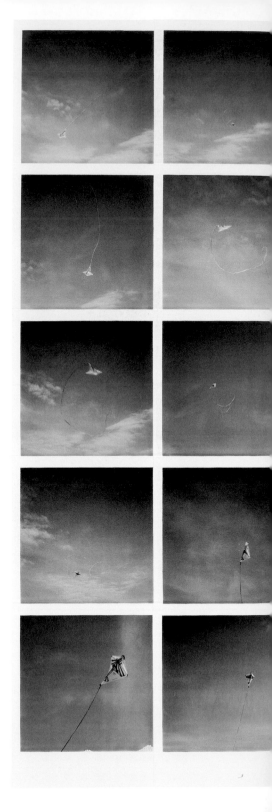

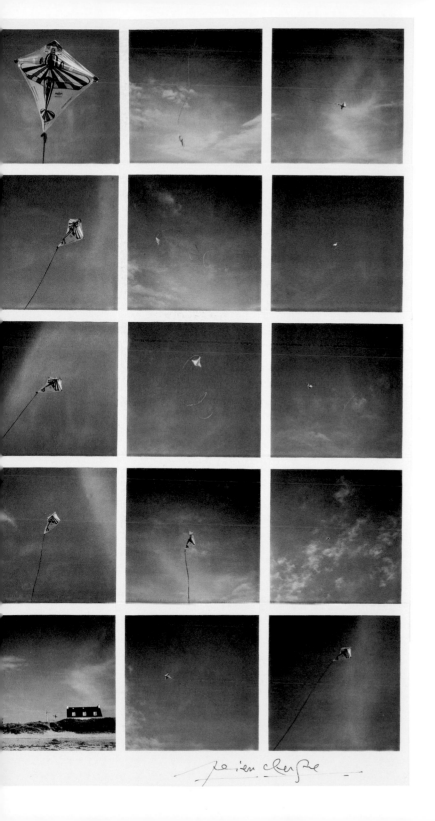

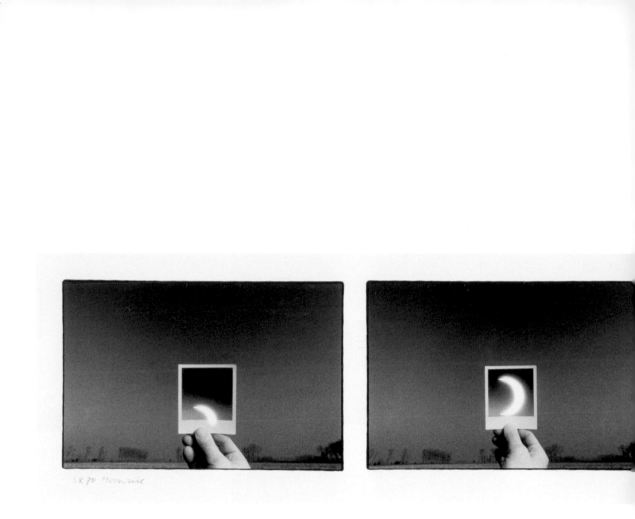

SX 70 Moonrise

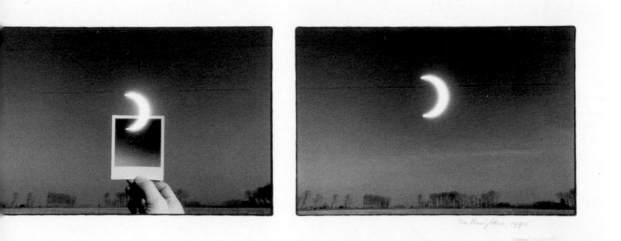

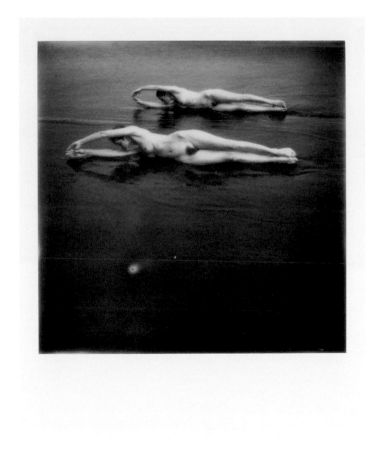

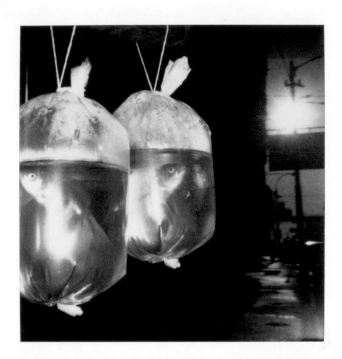

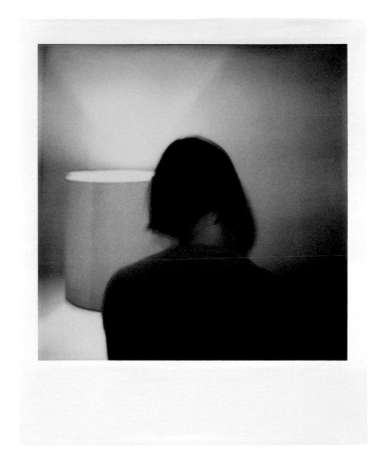

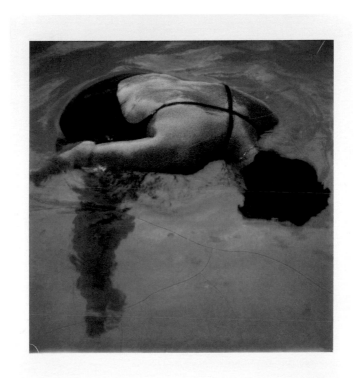

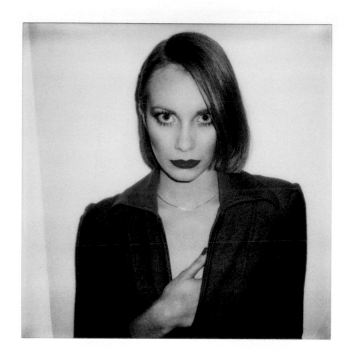

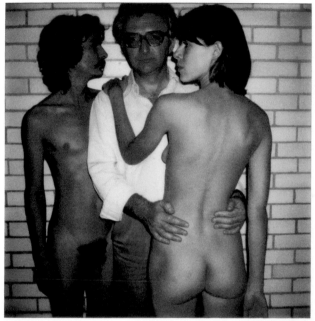

May 19, 1978
Mexico

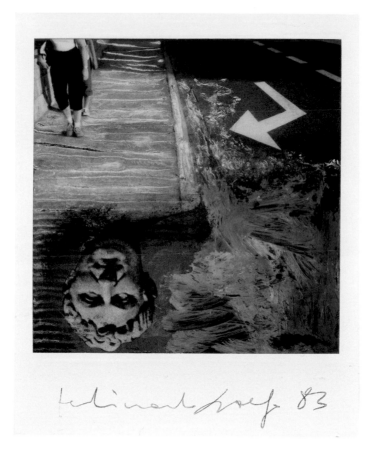

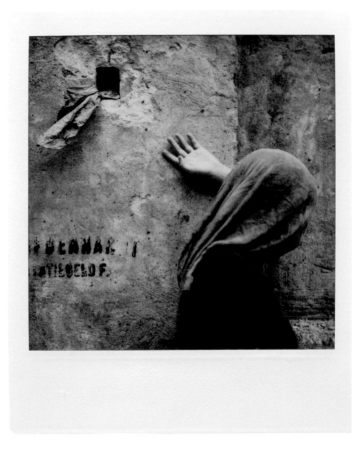



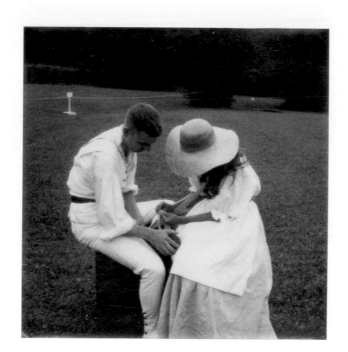

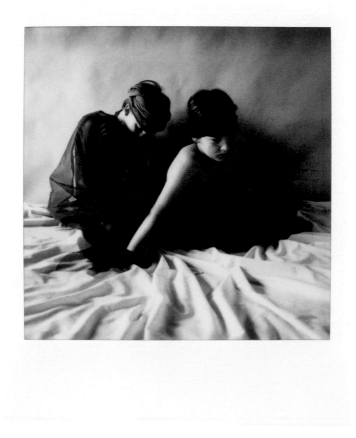

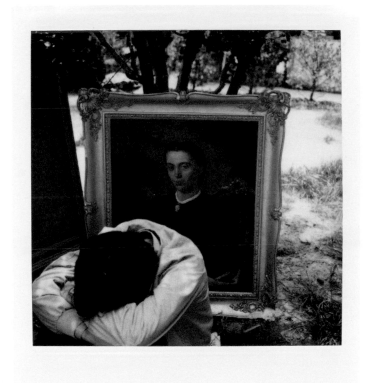

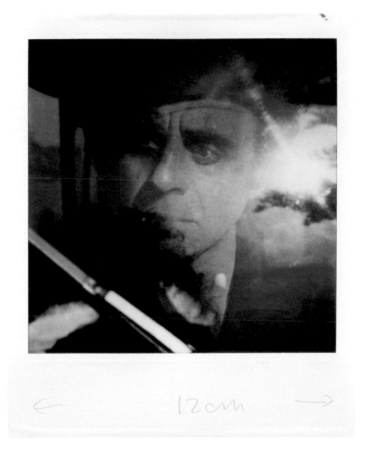

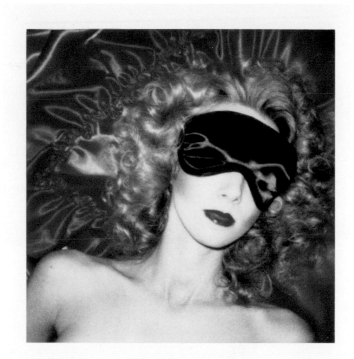

HYPNOS

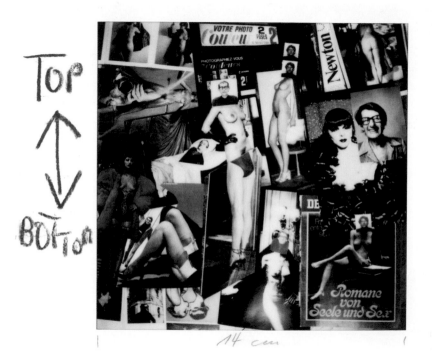

TOP
↕
BOTTOM

14 cm

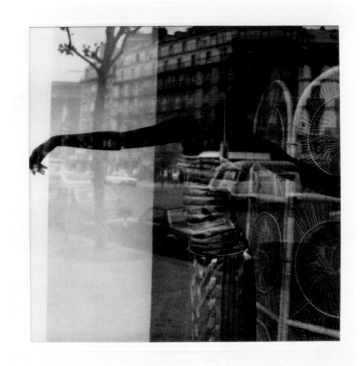

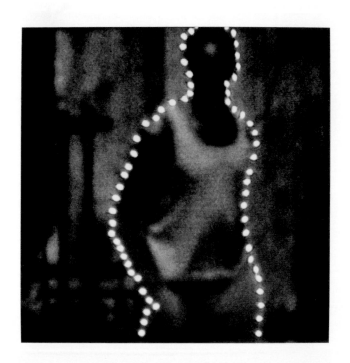

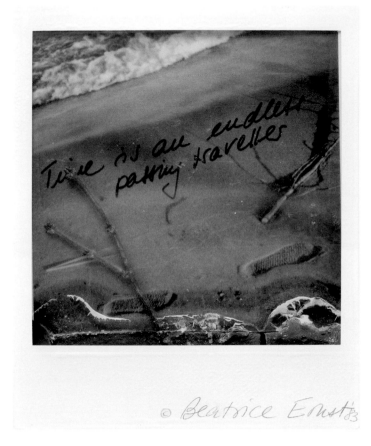

© Beatrice Ernst 83

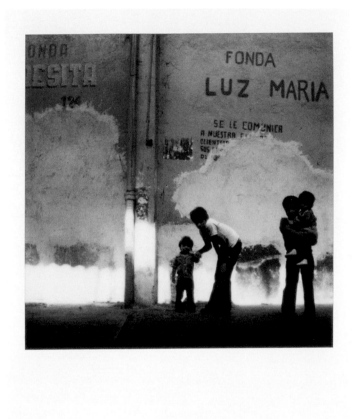

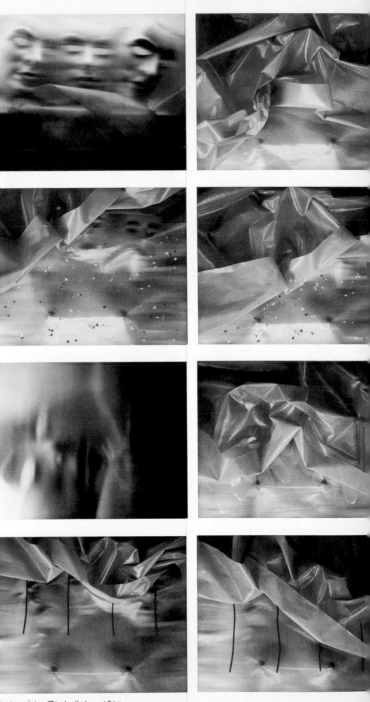

MASCULIN - FEMININ 1987

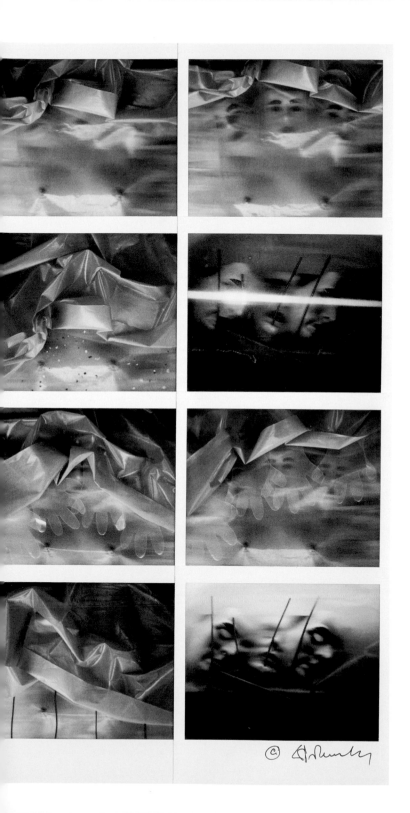

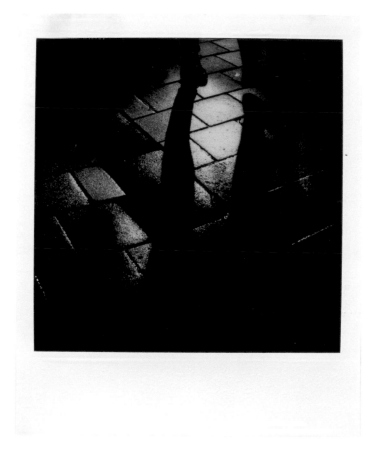

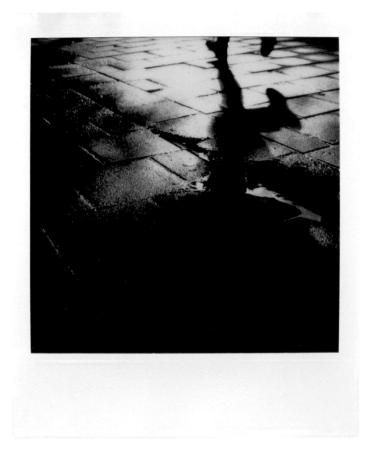

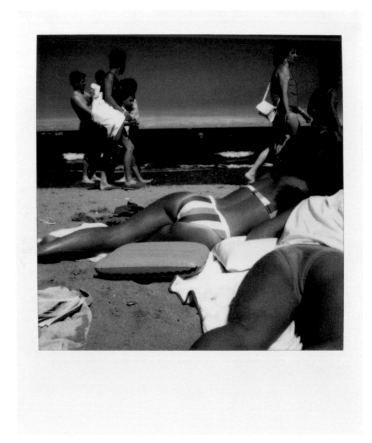

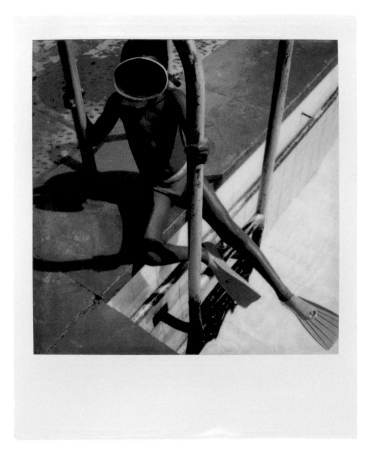

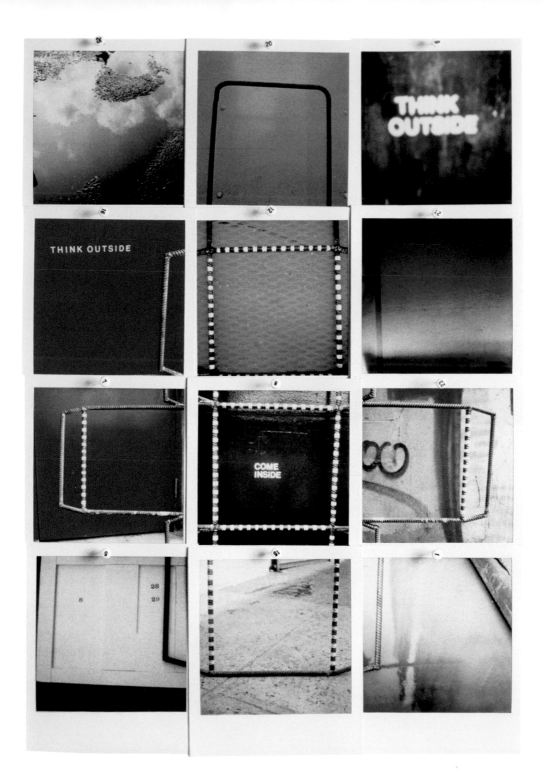

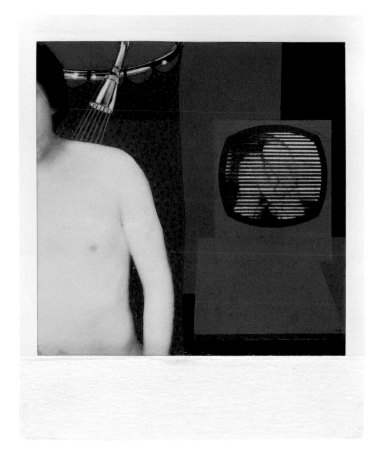

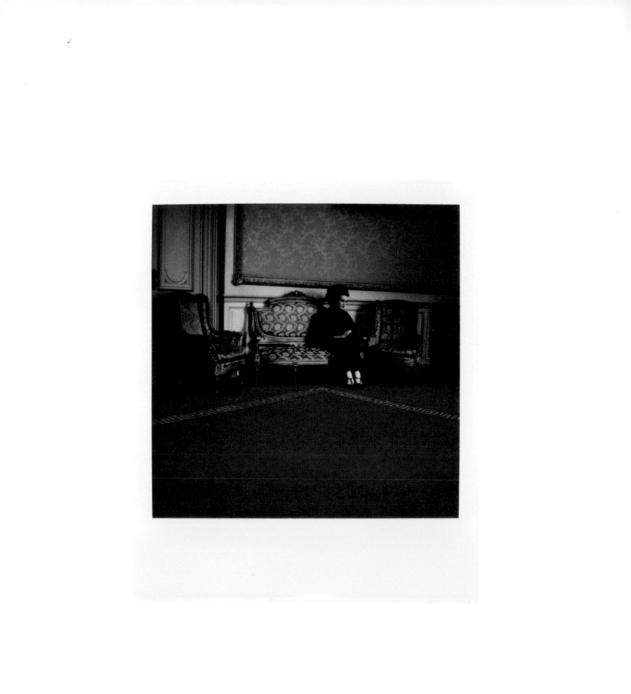

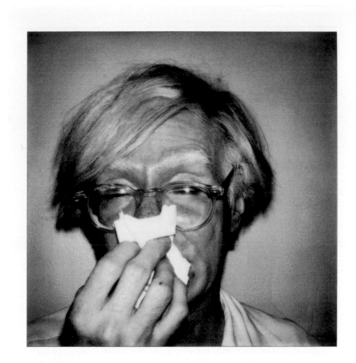

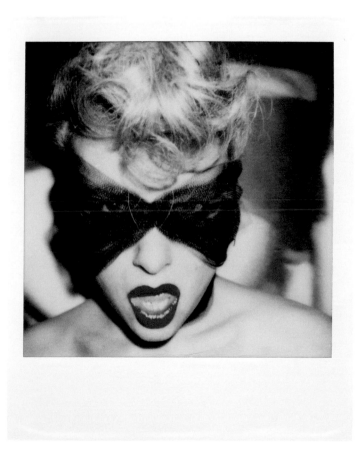

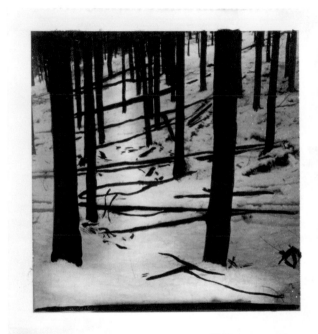

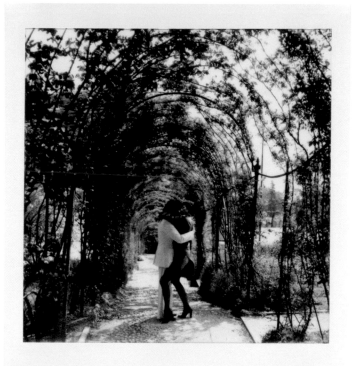

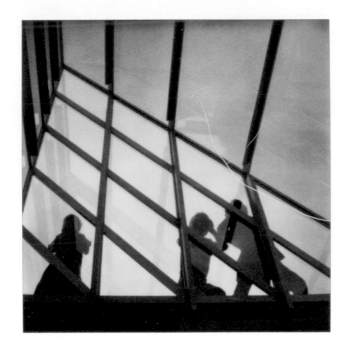

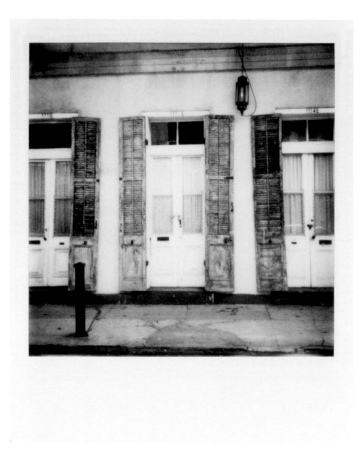

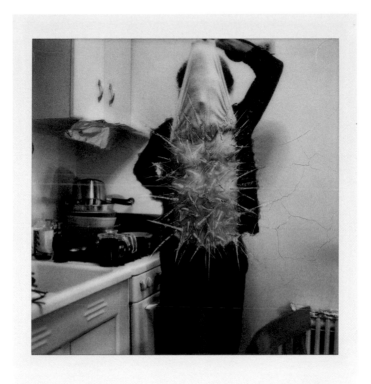

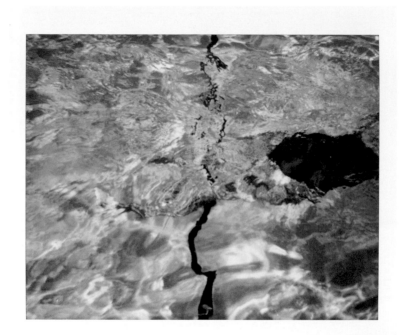

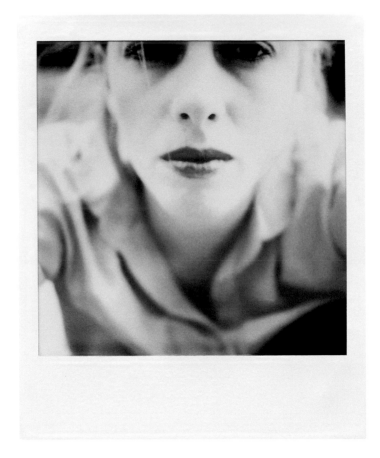

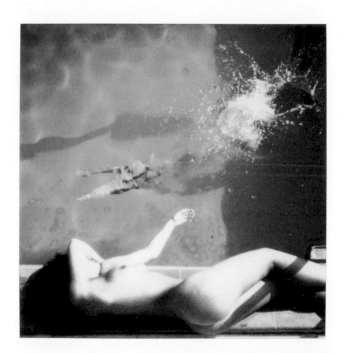

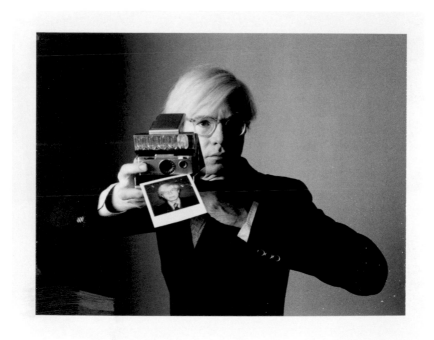

94

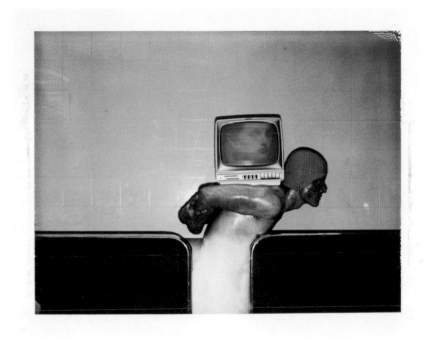

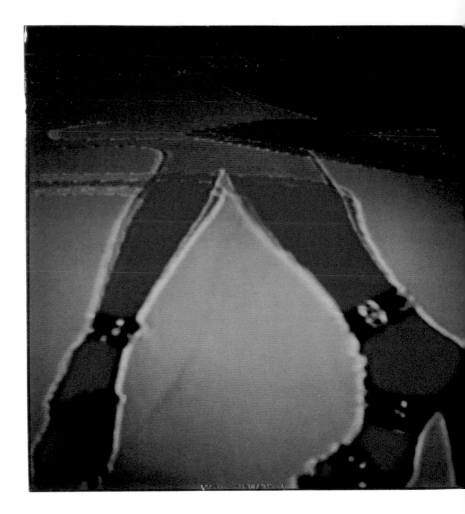

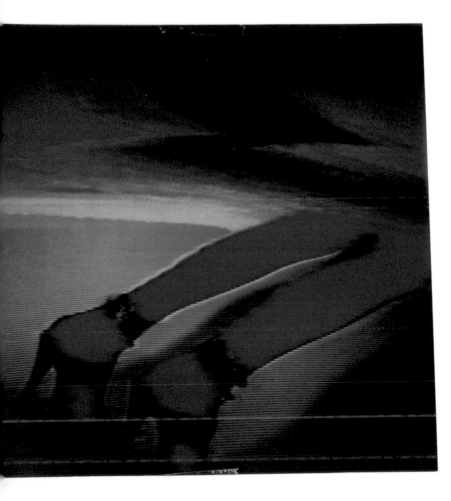

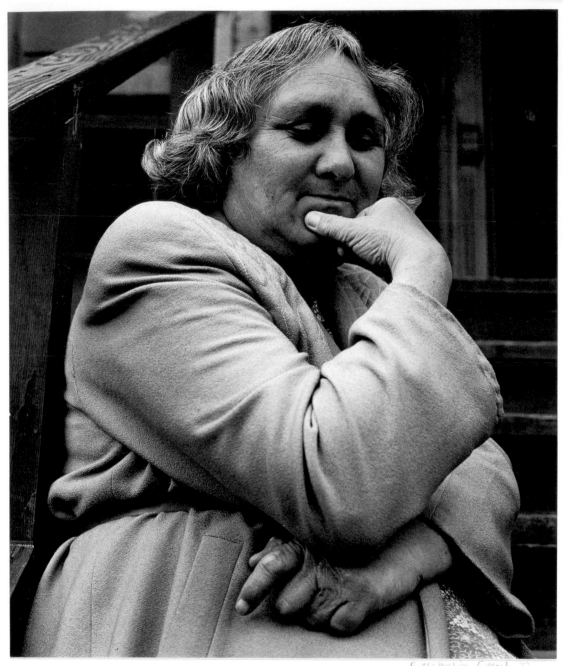

98

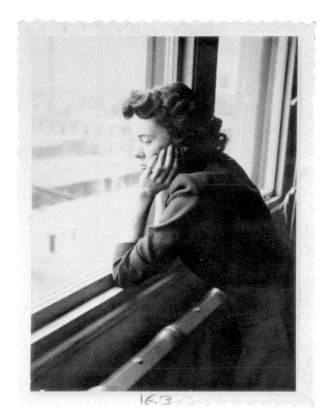

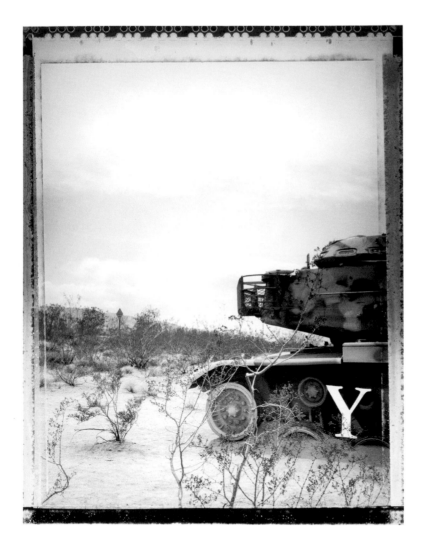

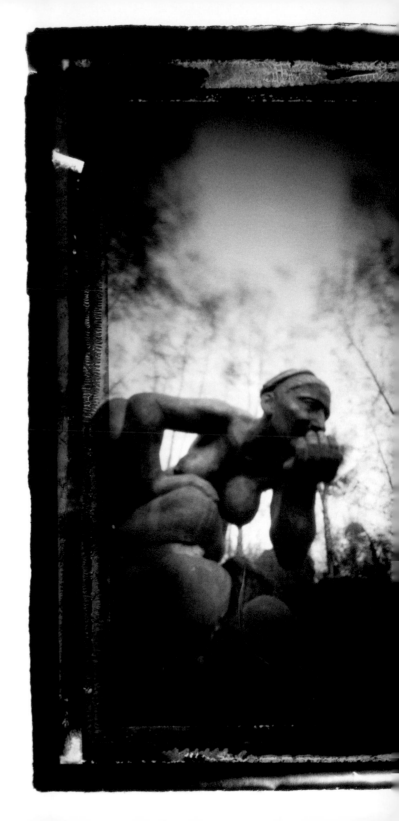

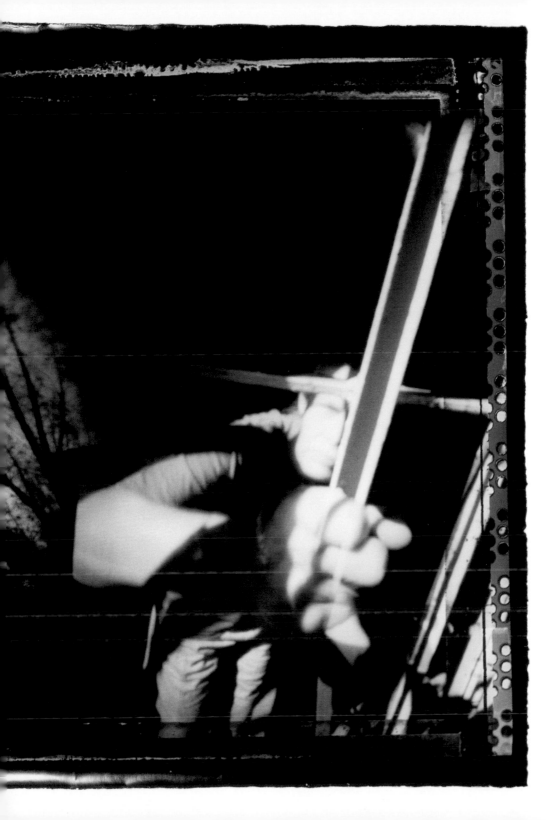

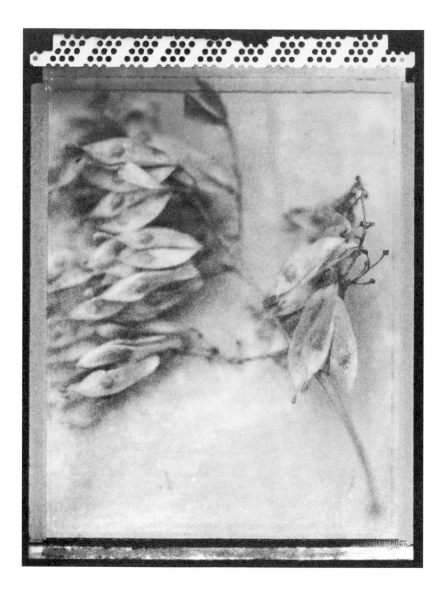

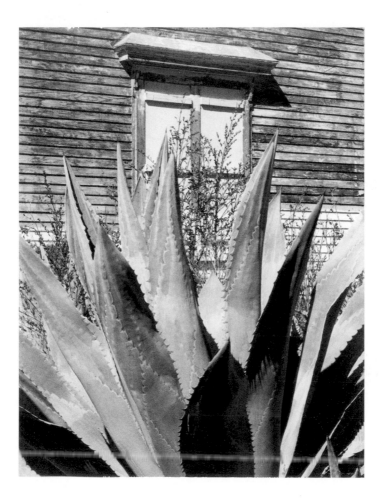

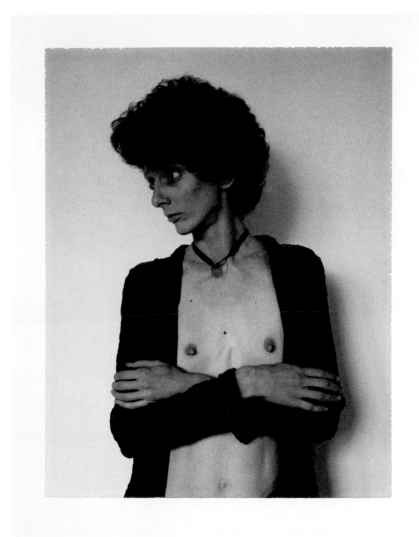

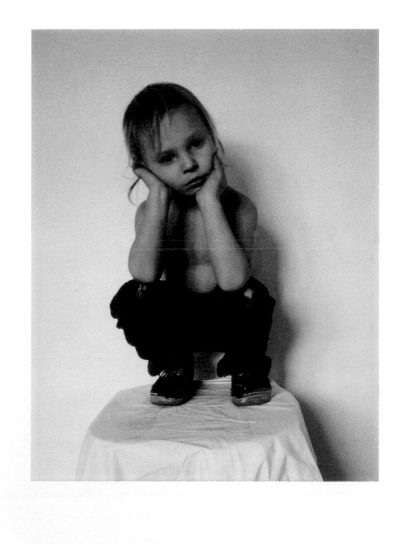

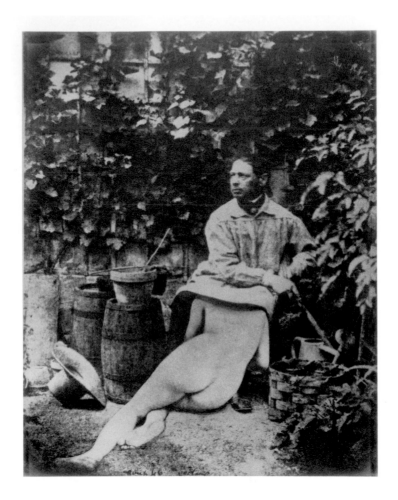

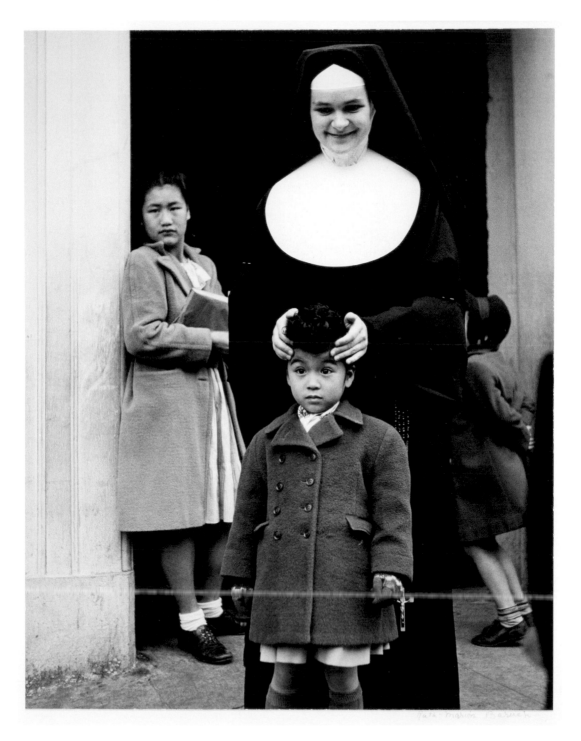

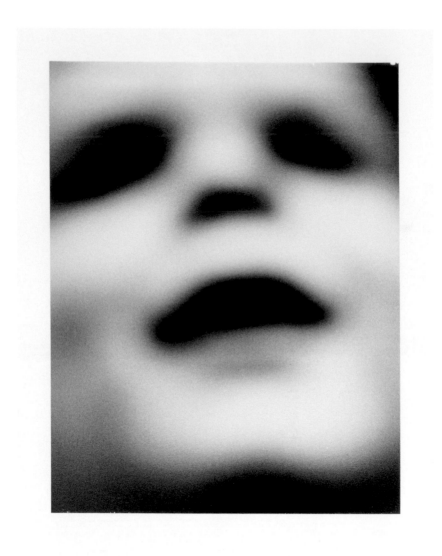

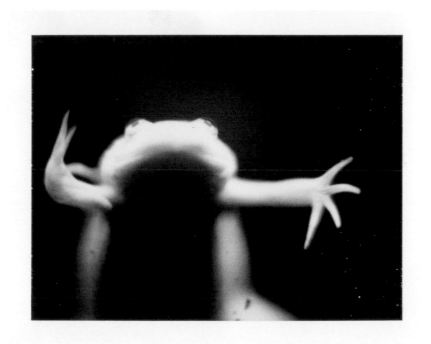

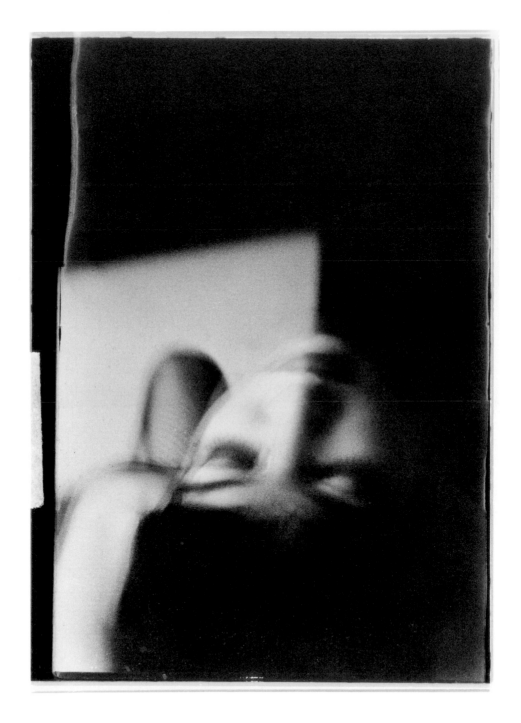

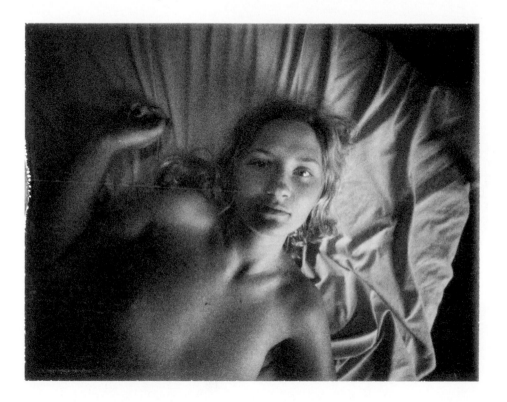

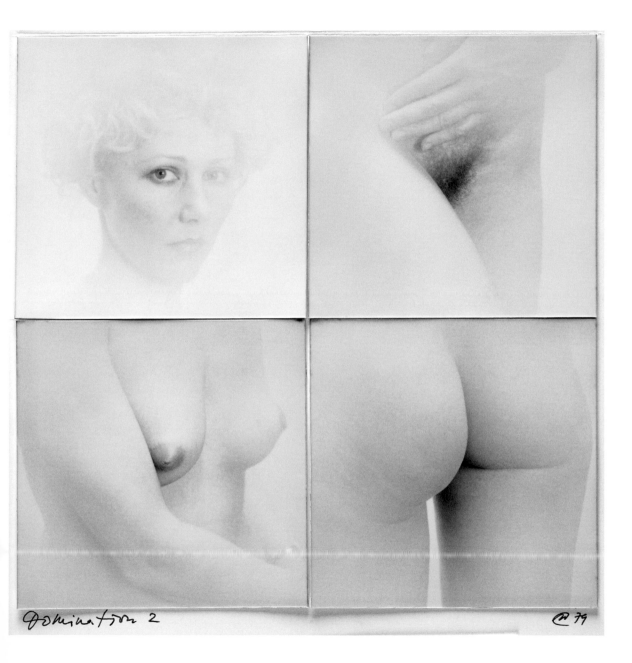

Domination 2 ℗ 79

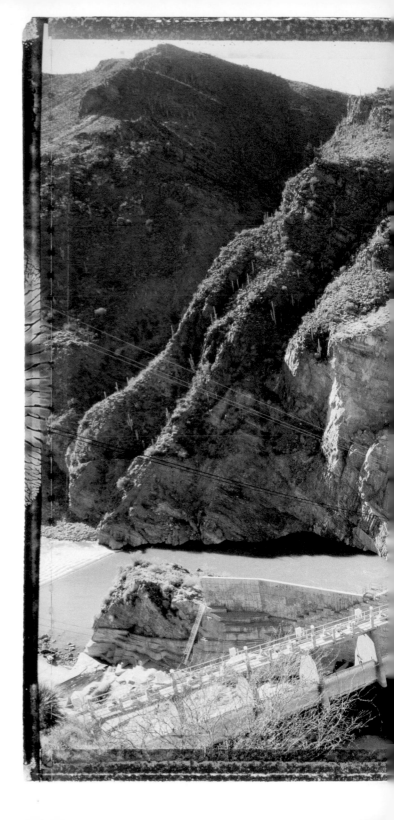

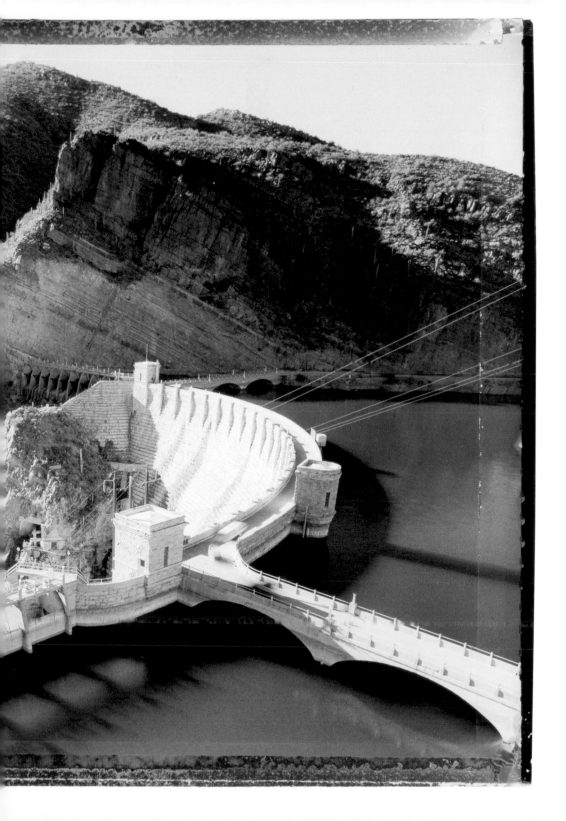

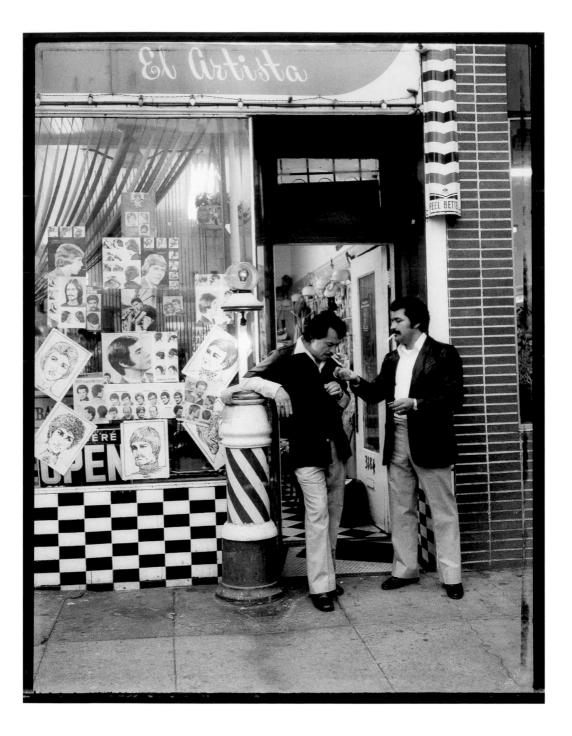

118

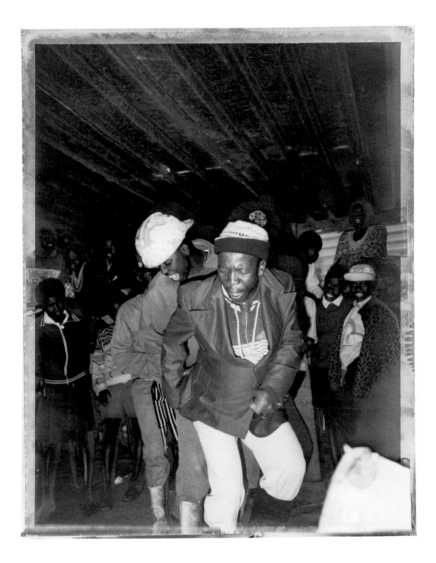

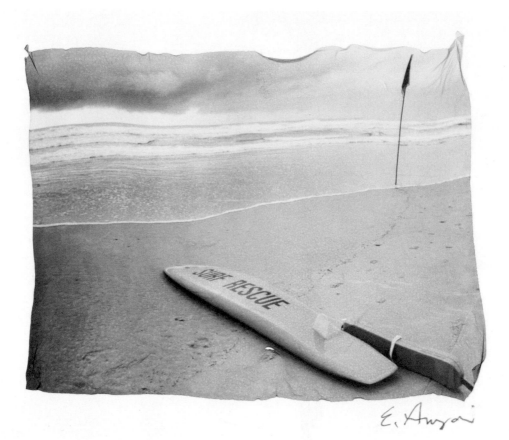

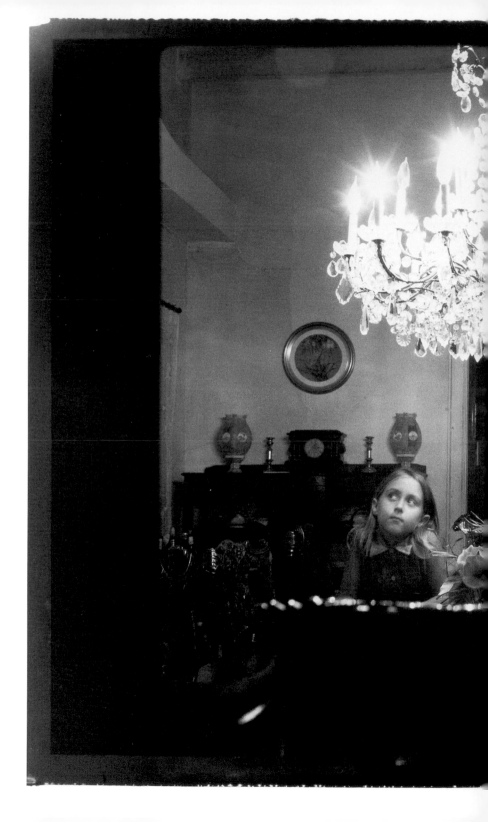

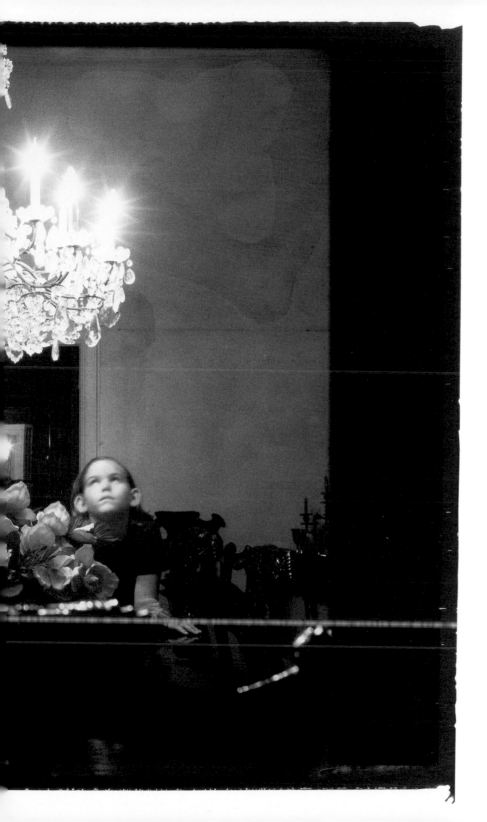

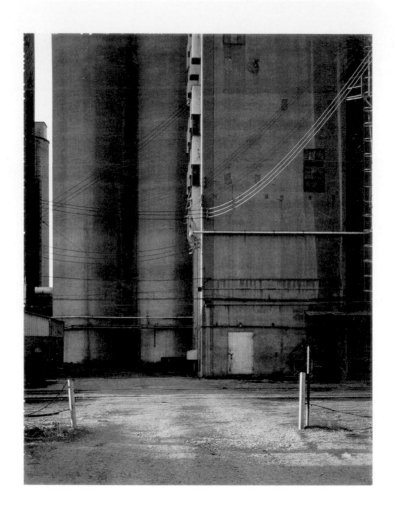

FRANK GOHLKE

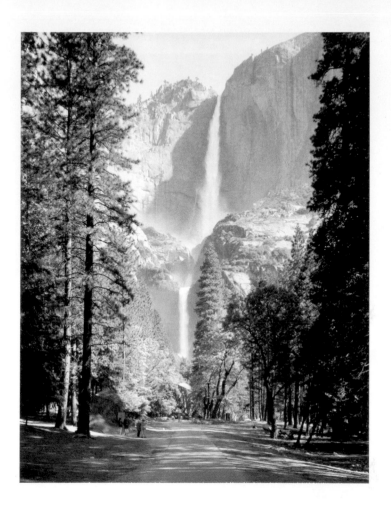

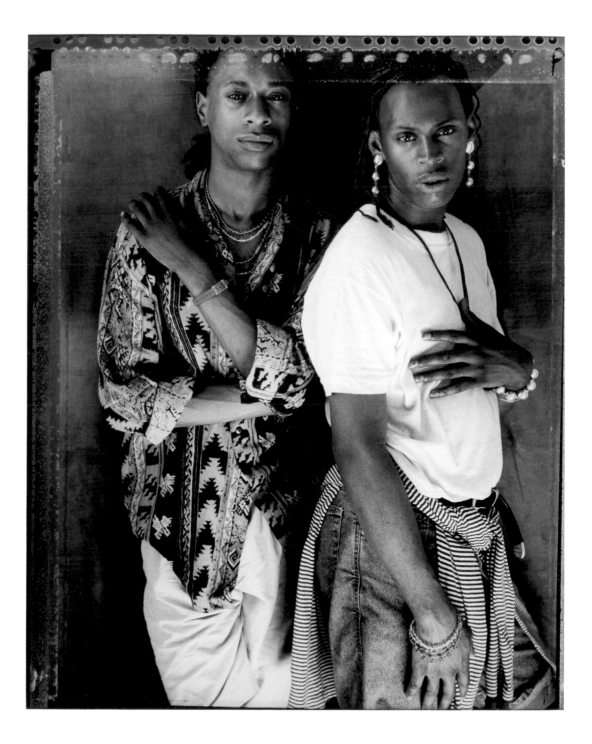

126

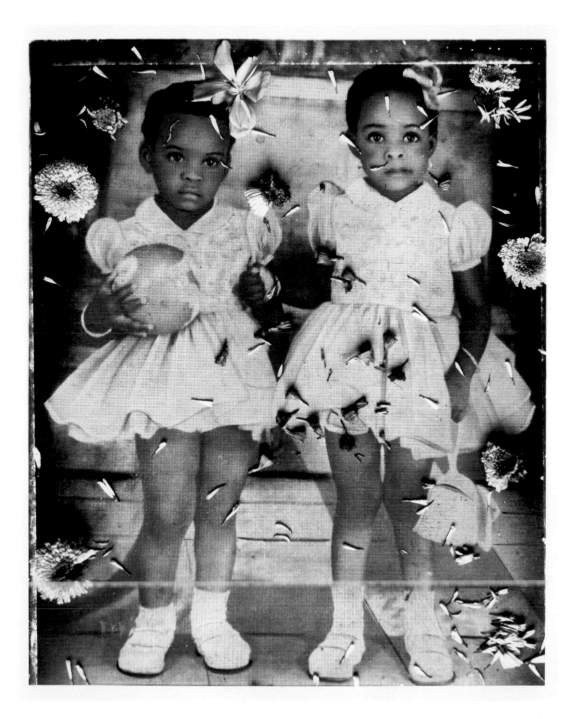

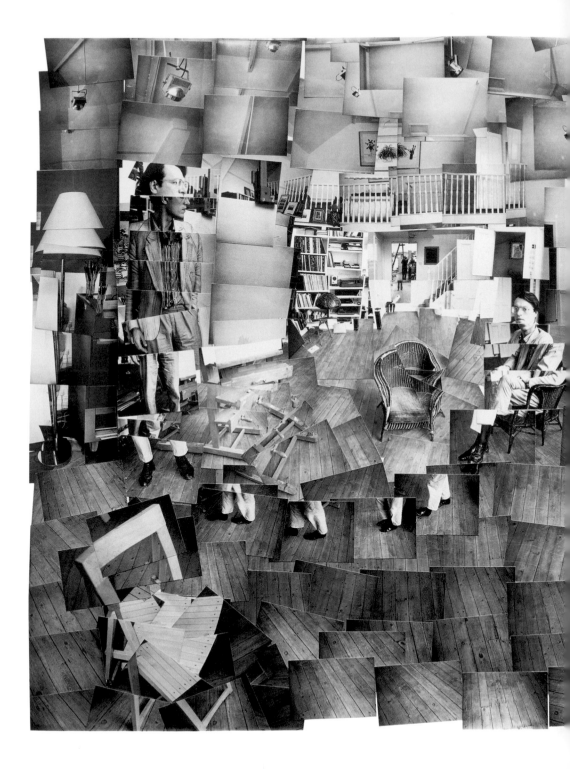

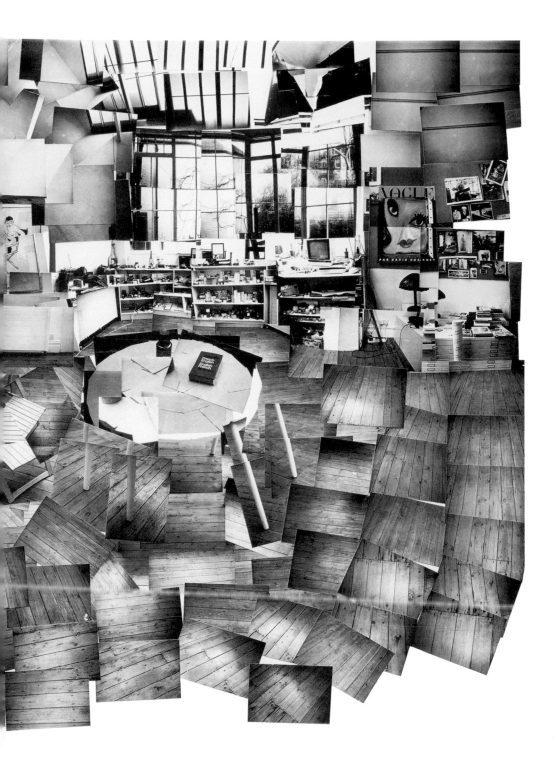

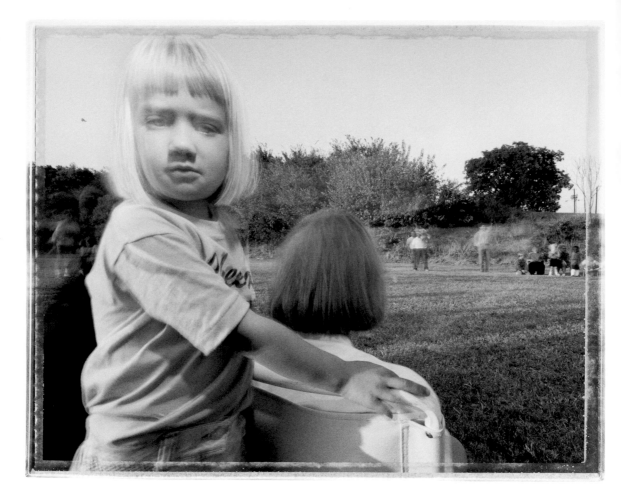

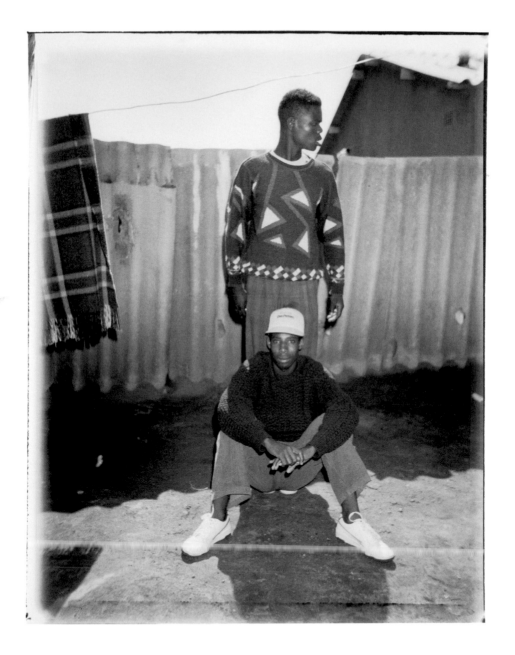

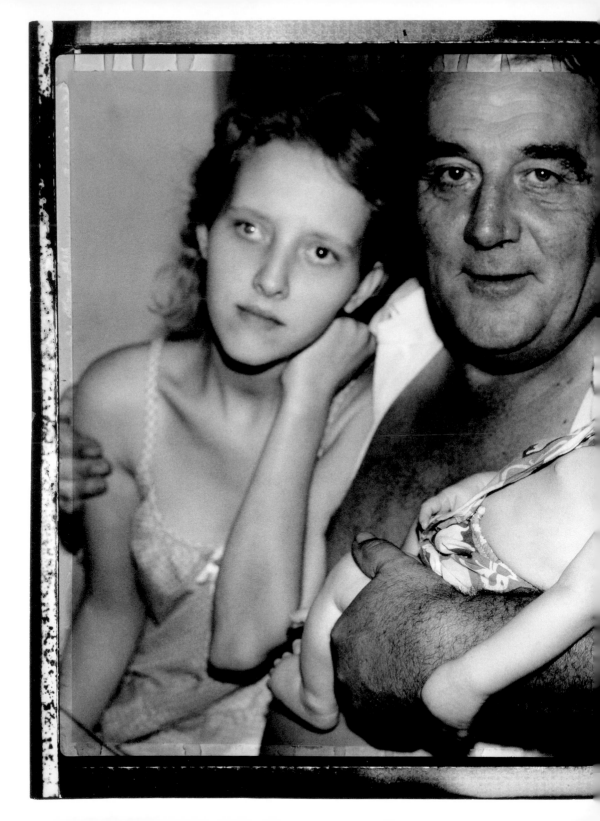

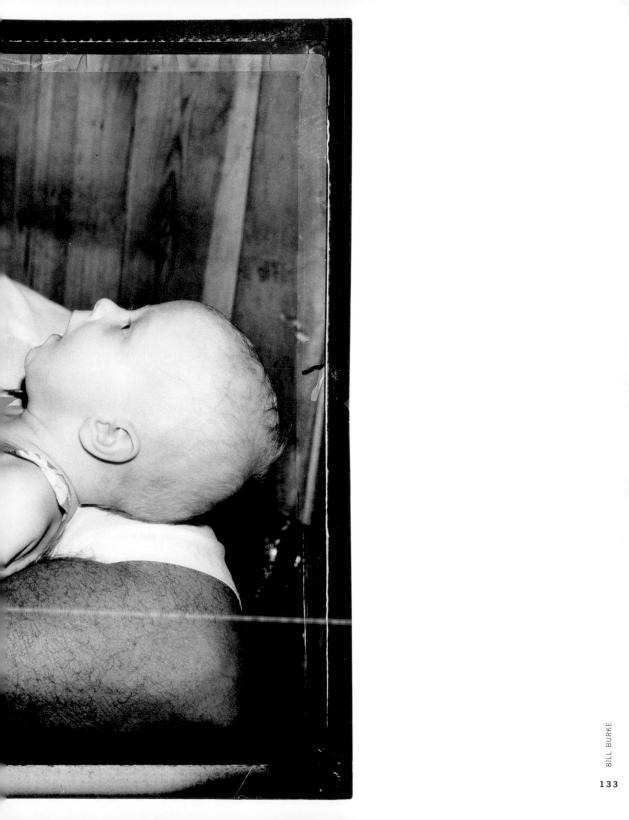

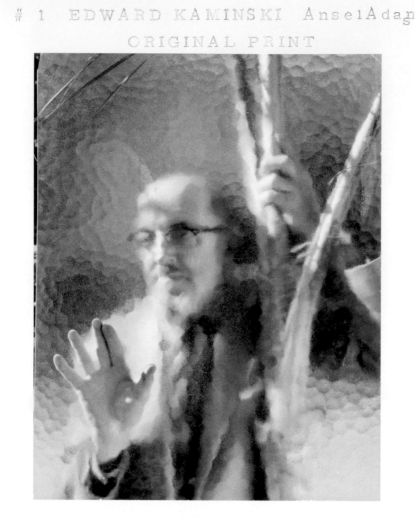

Kaminski
X

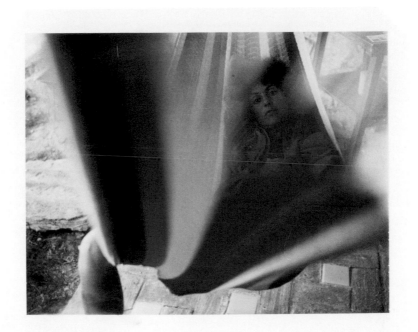

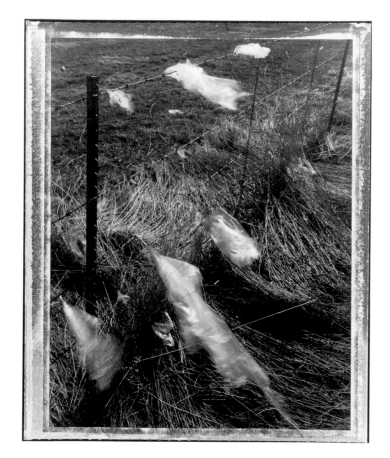

136

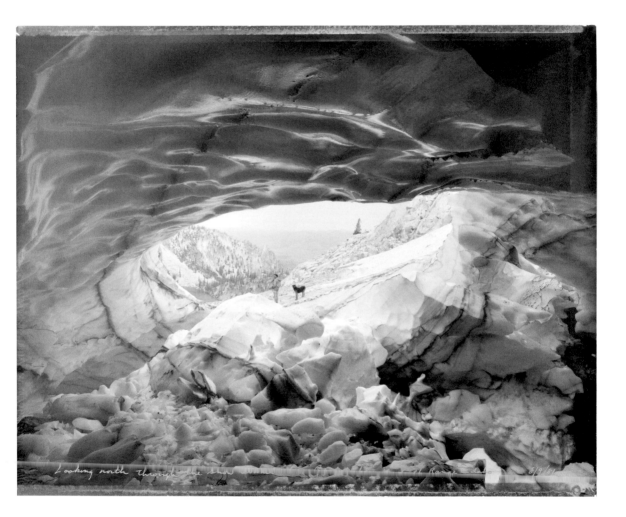

Looking north through the edge ... Range ... 8/9/81

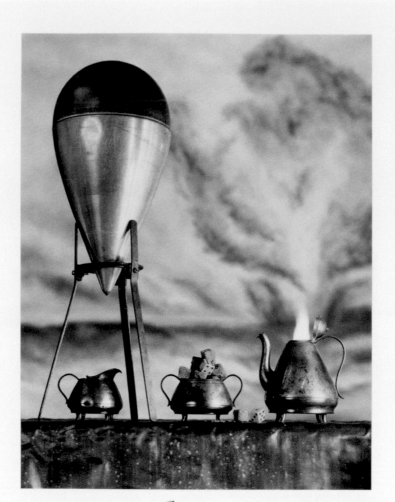

" ATOMIC TEA PARTY" © JO WHALEY 1993

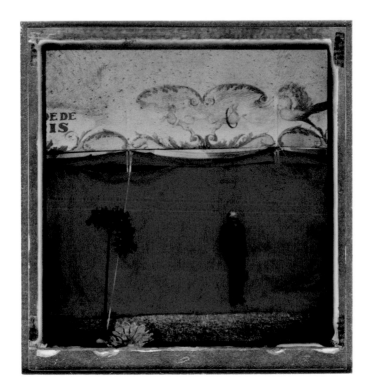

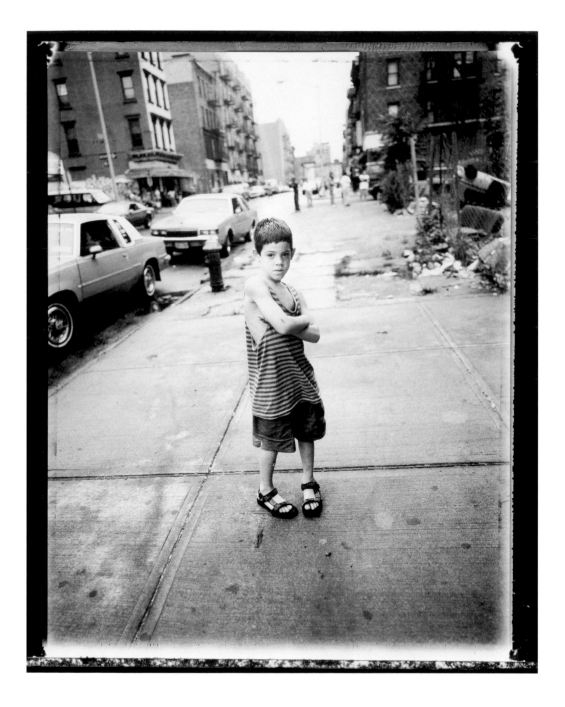

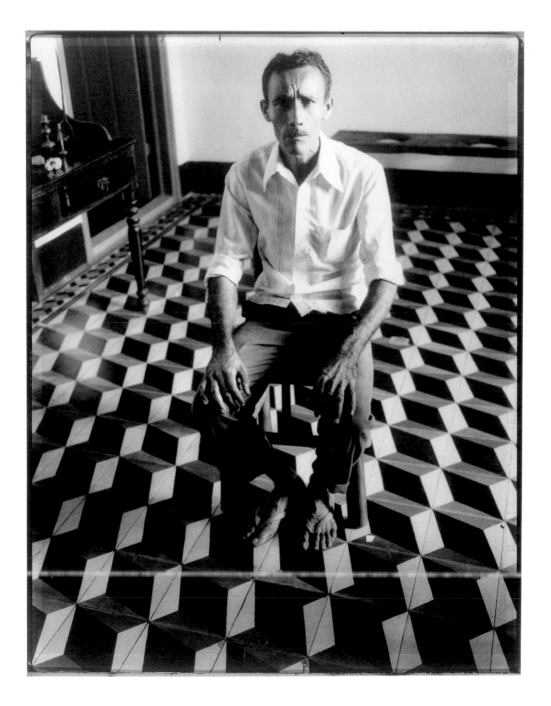

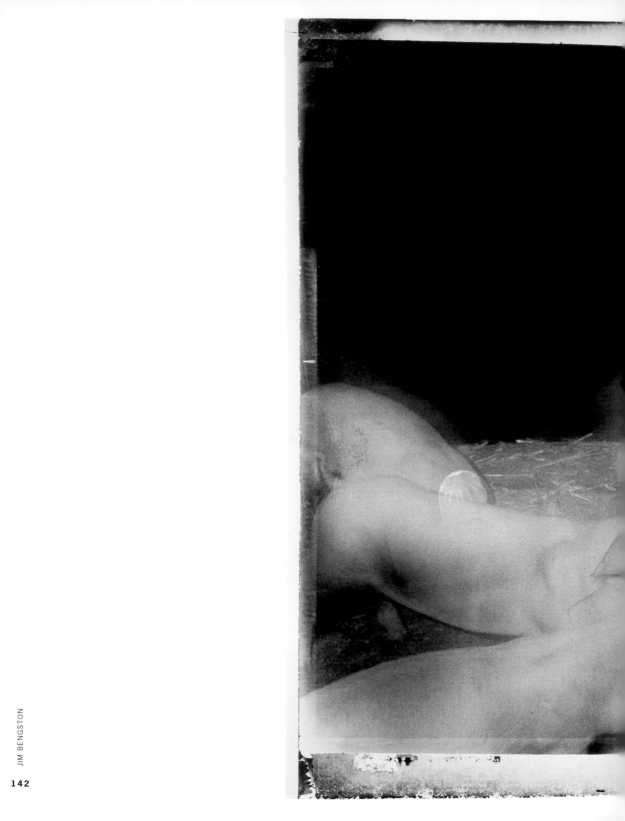

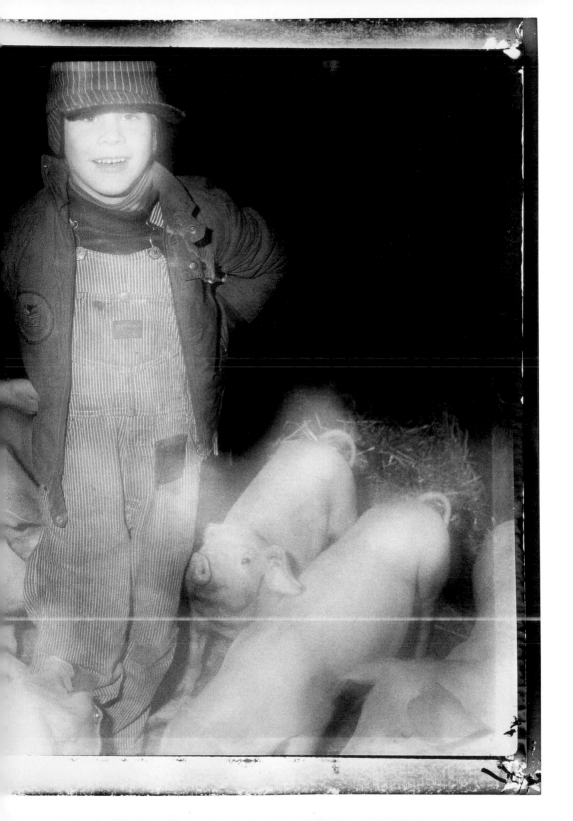

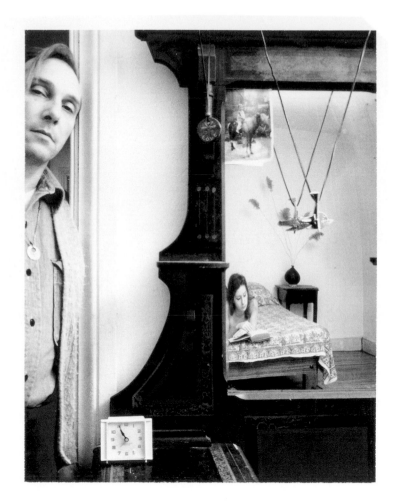

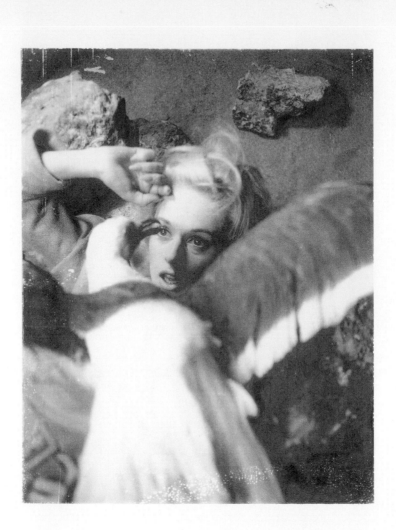

Tippi being attacked by the birds in
"THE BIRDS" movie directed by Hitchcock
Story in LOOK MAGAZINE page 58 Dec.4,1962
issue

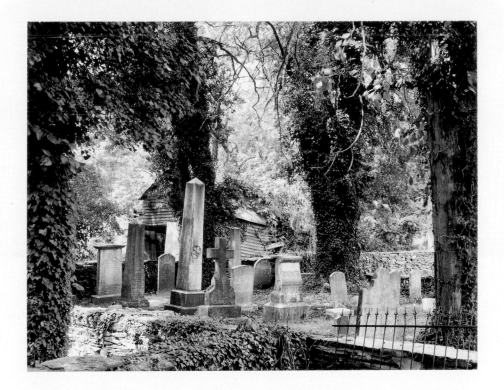

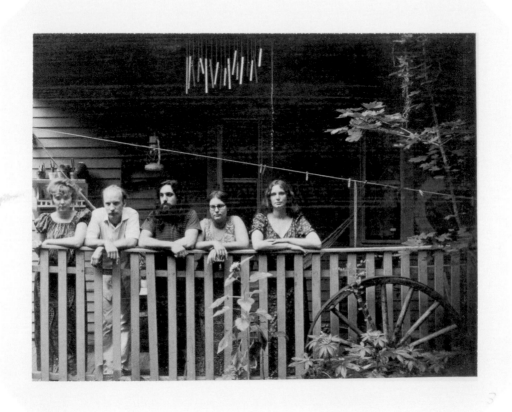

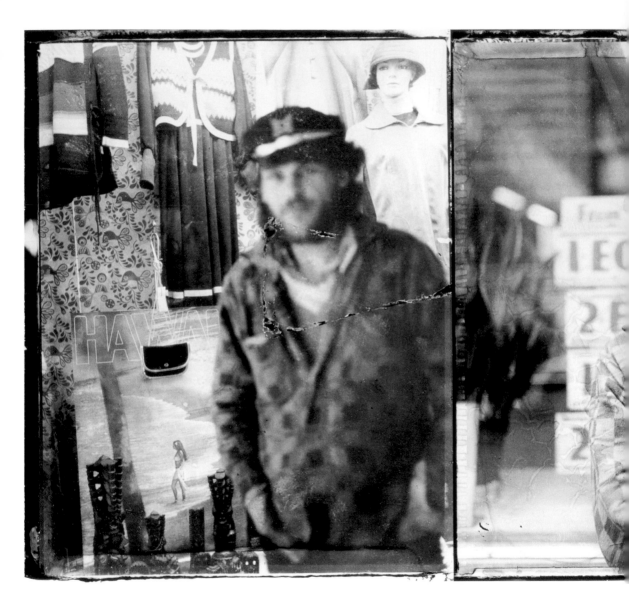

148

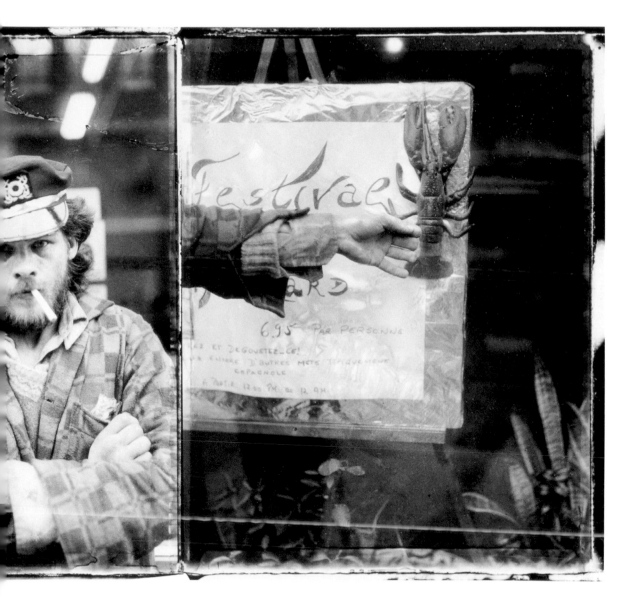

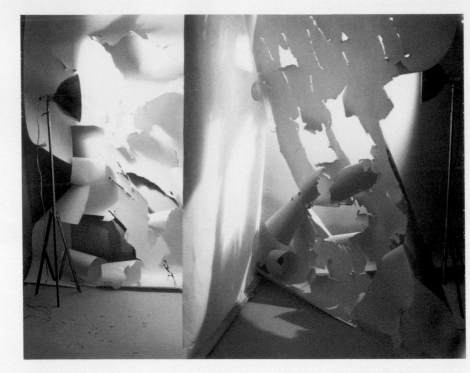

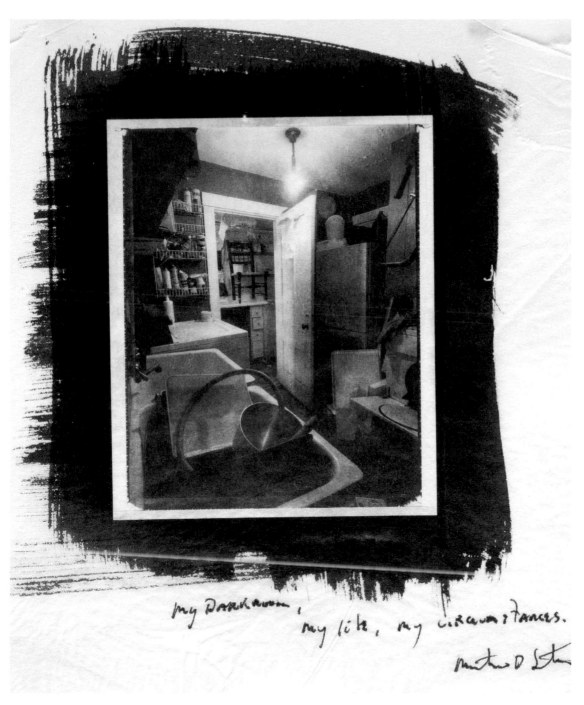

my Darkroom,
my life, my circumstances.

Michael D. Silver

151

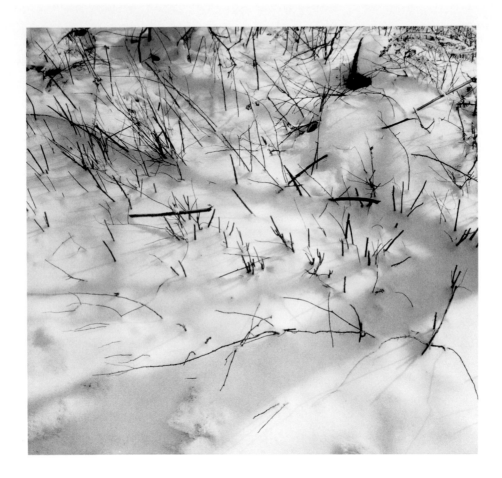

ROBERT HAIKO

152

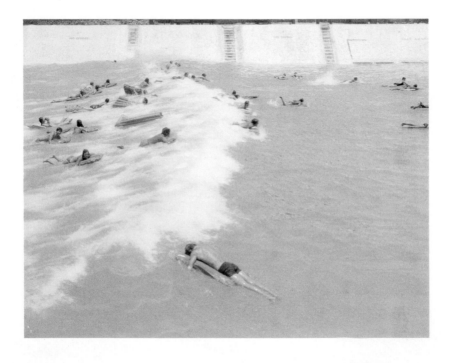

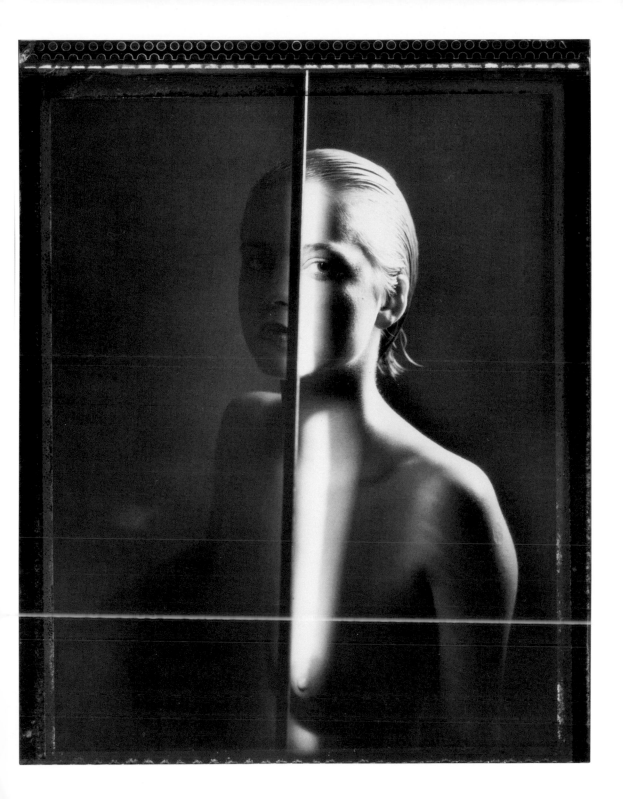

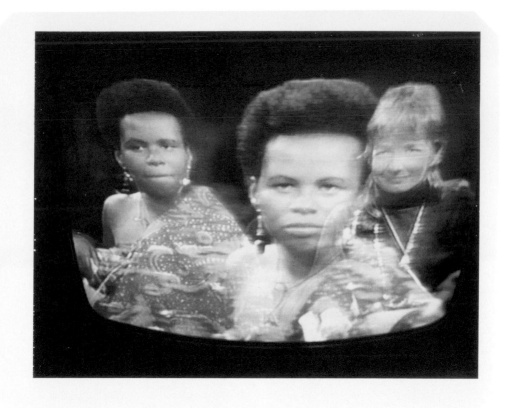

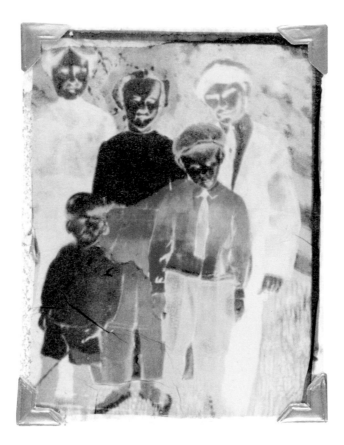

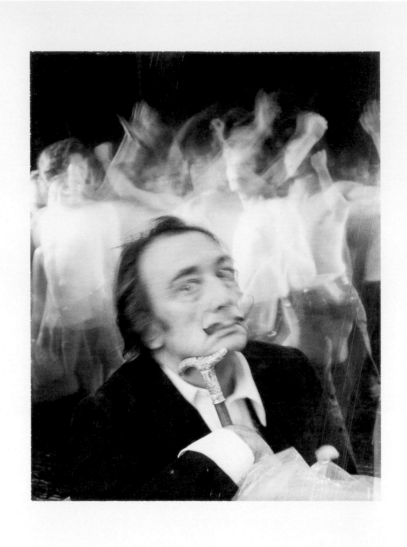

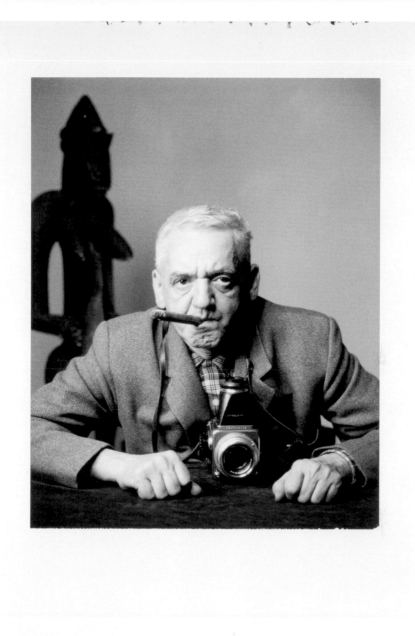

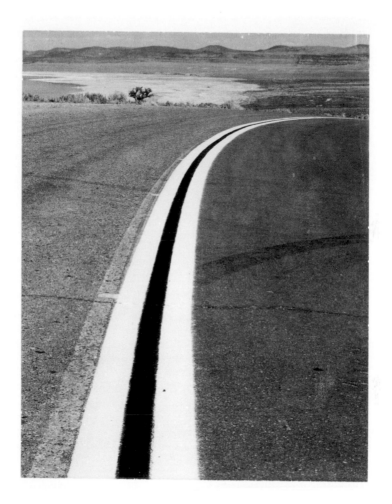

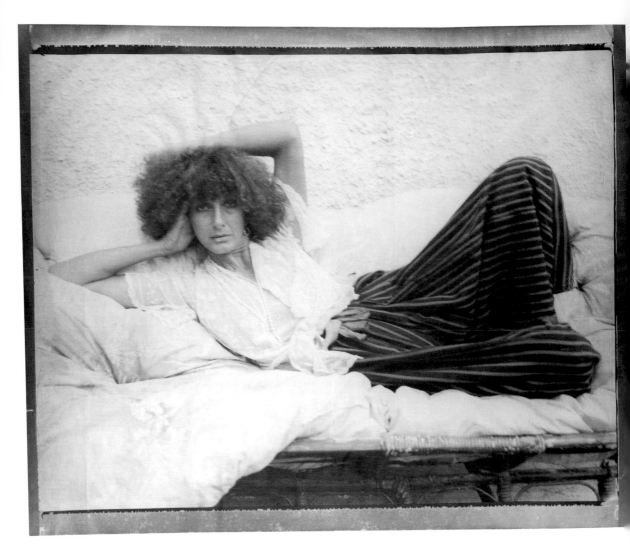

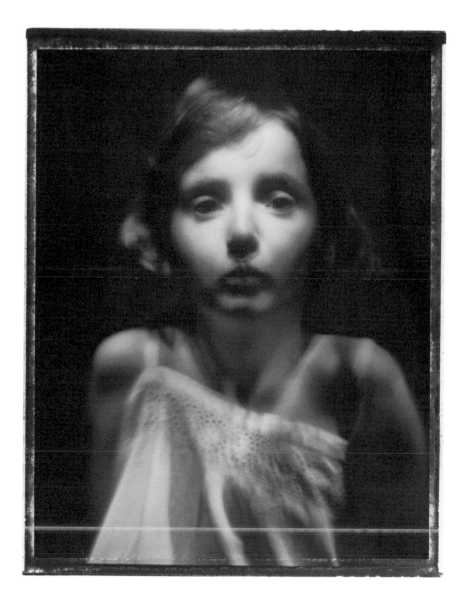

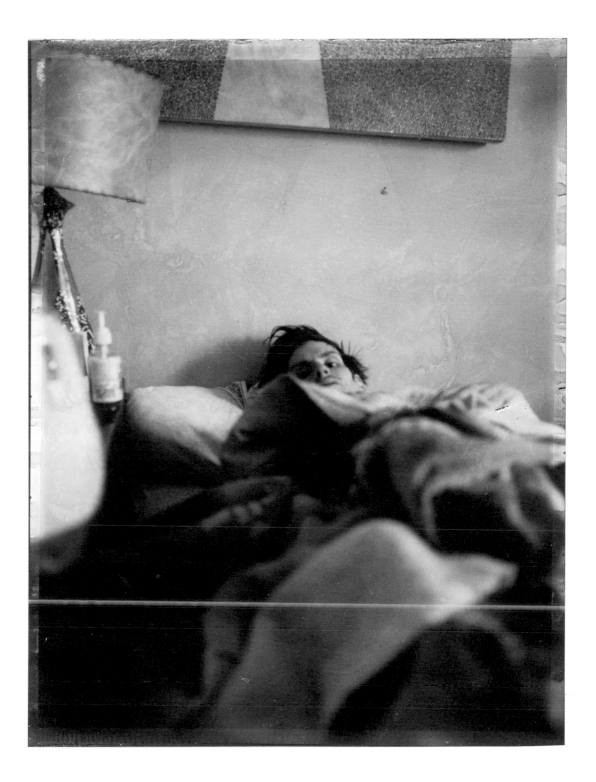

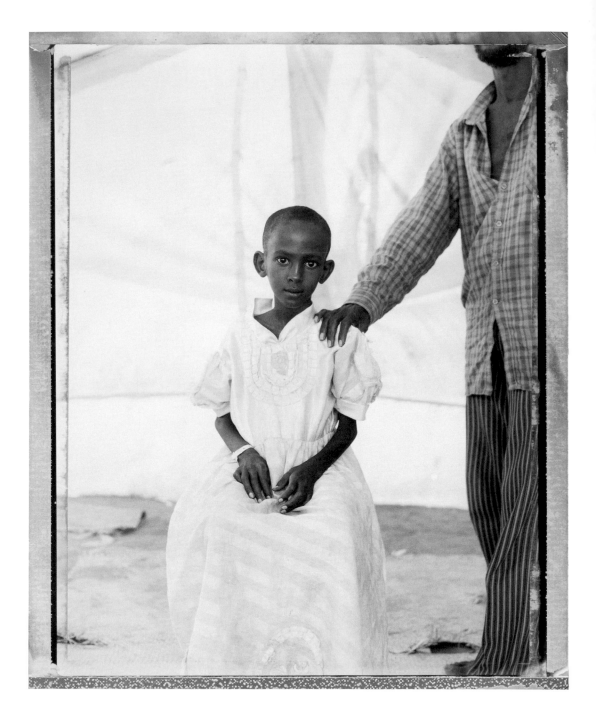

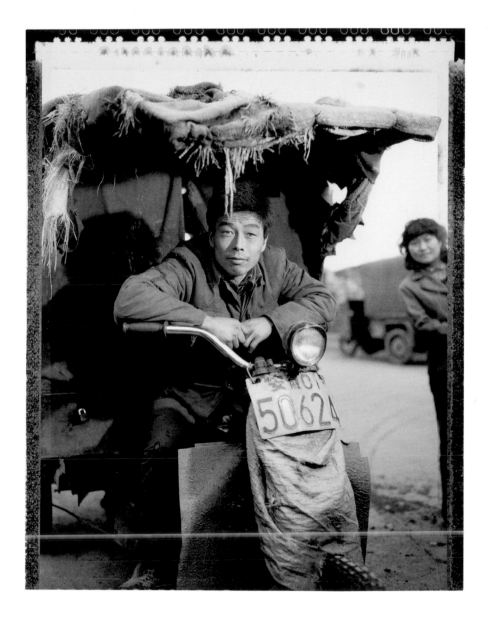

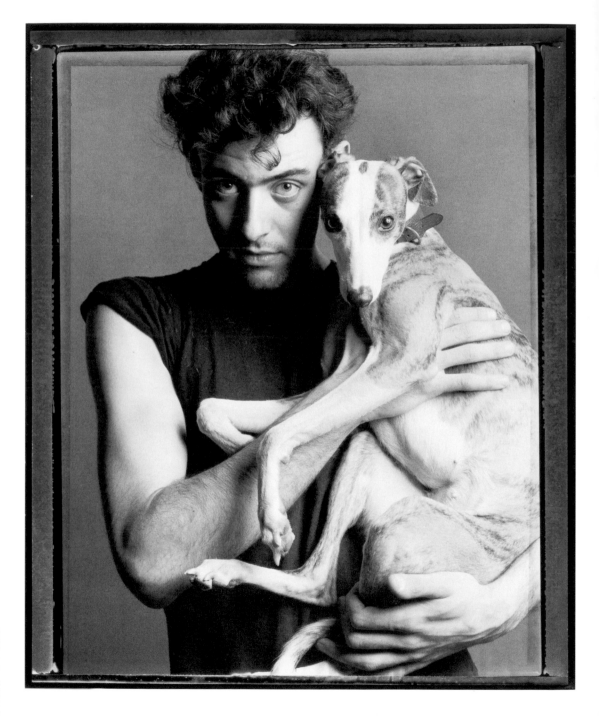

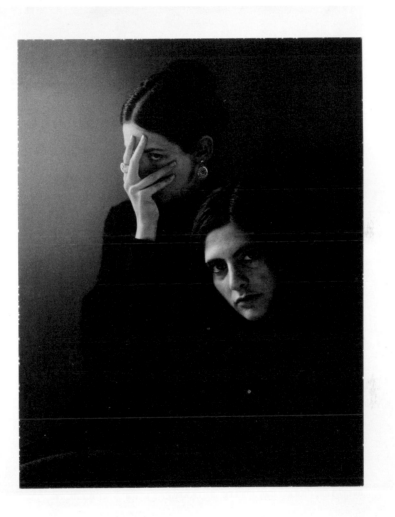

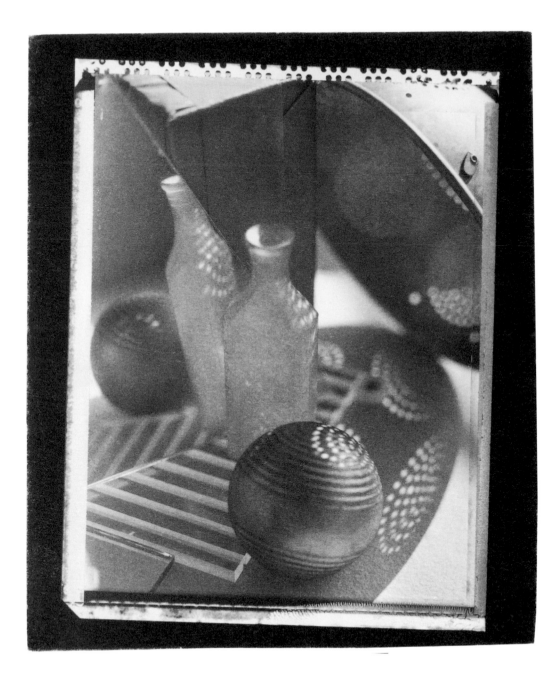

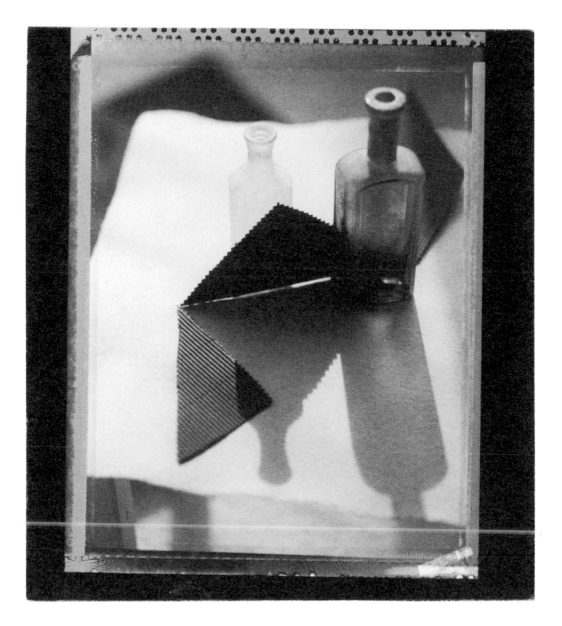

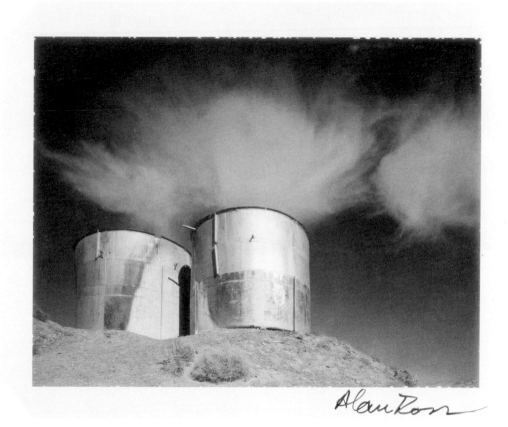

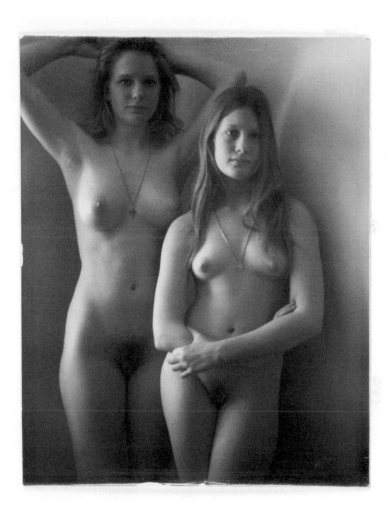

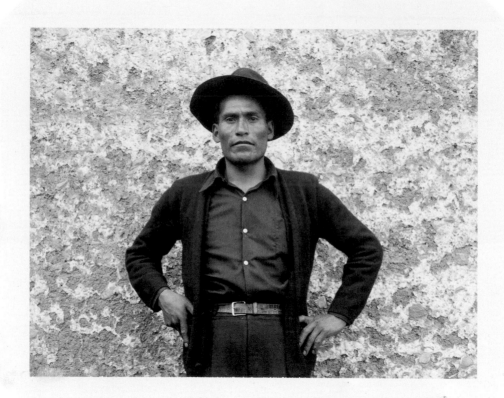

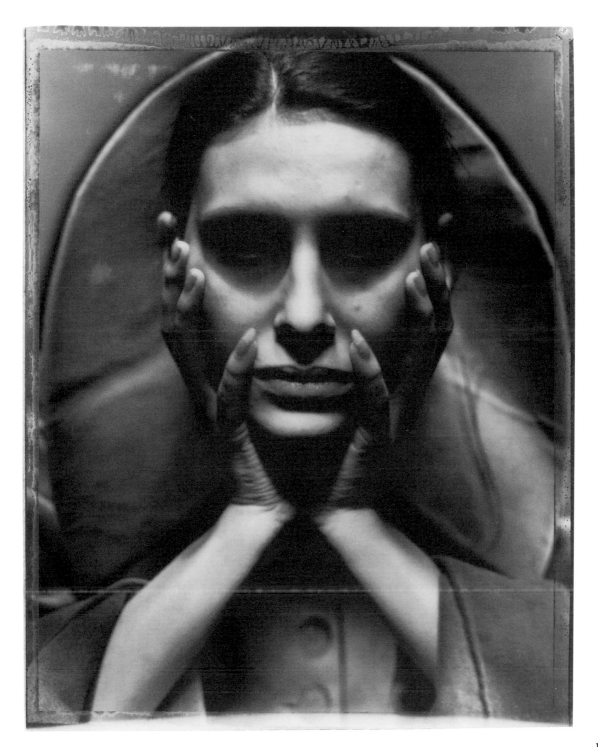

175

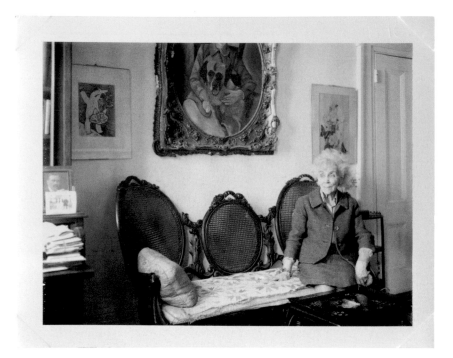

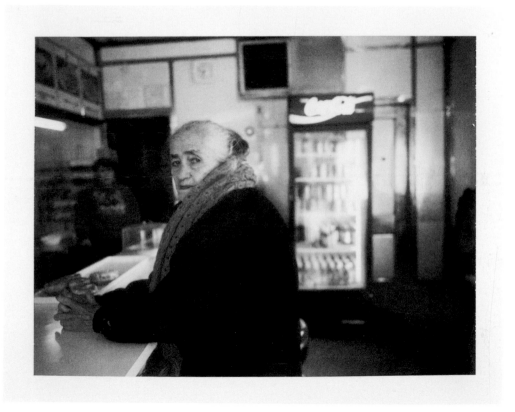

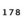

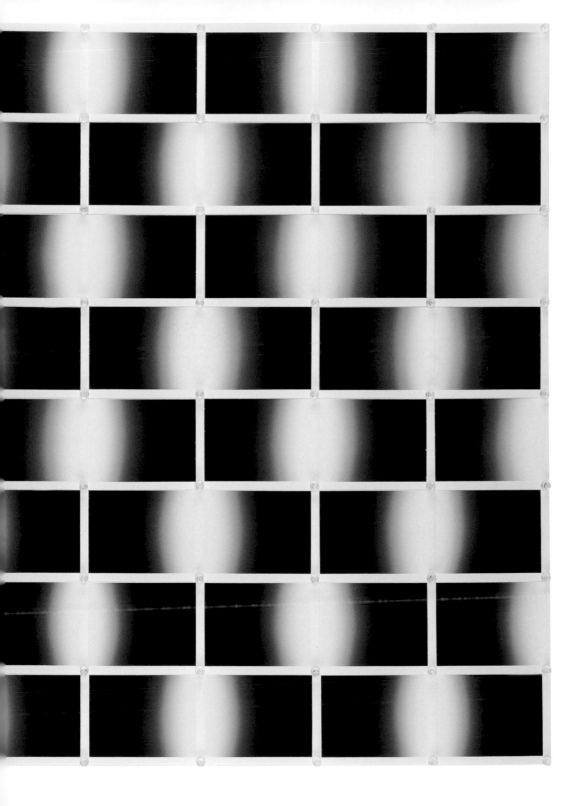

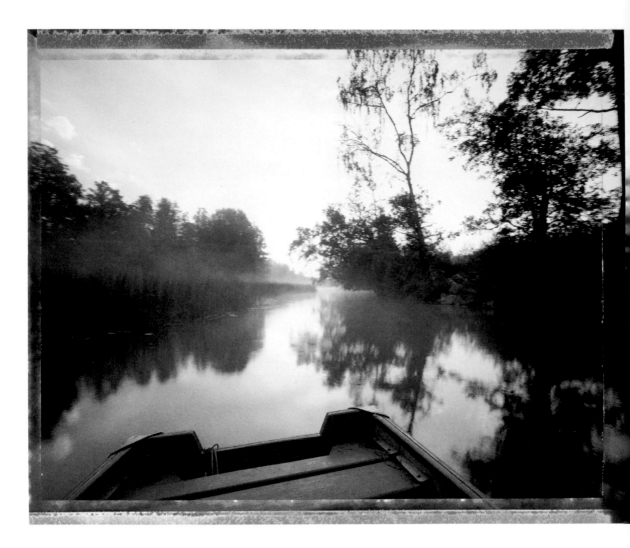

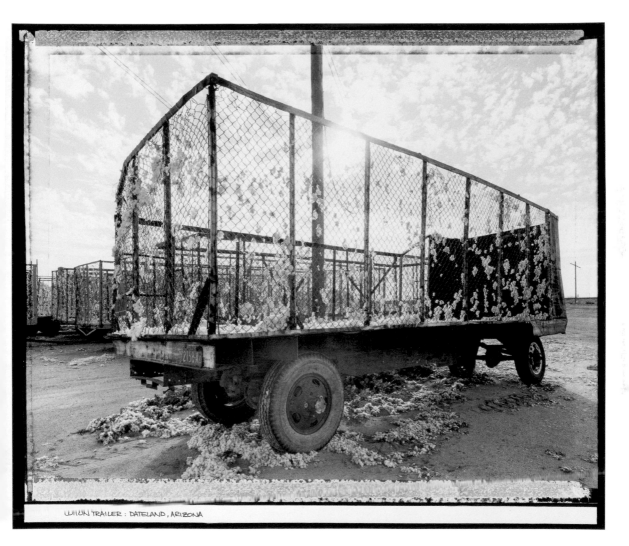

COTTON TRAILER: DATELAND, ARIZONA

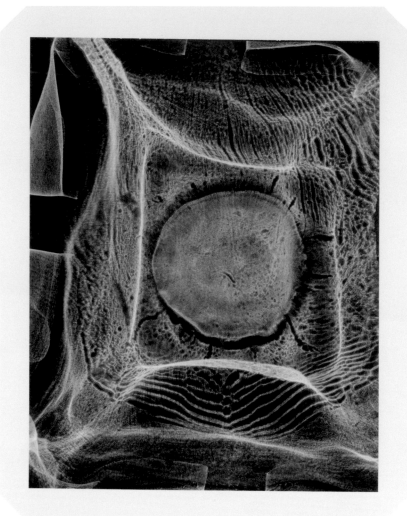

182

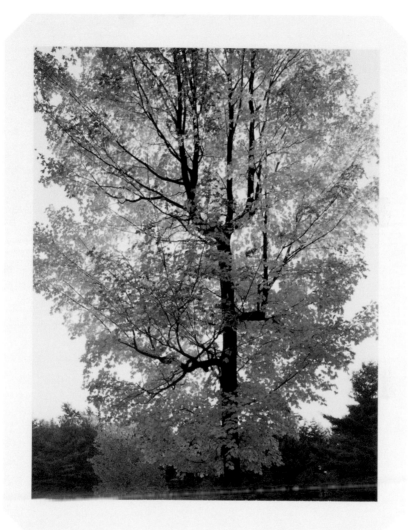

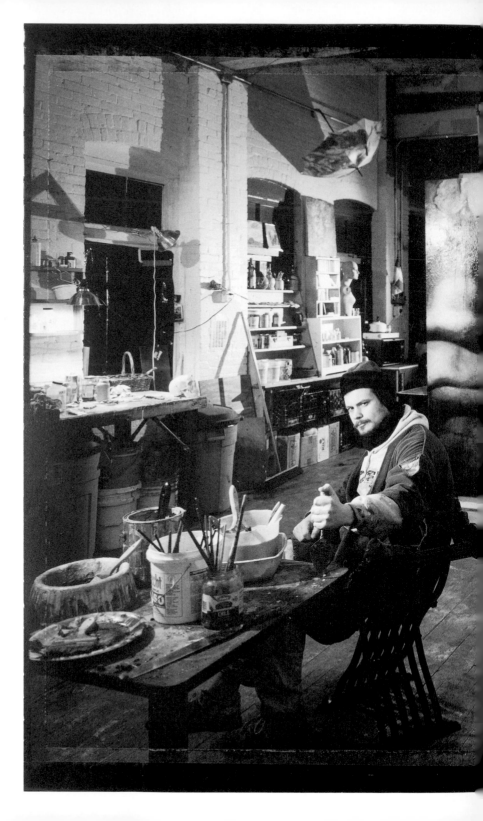

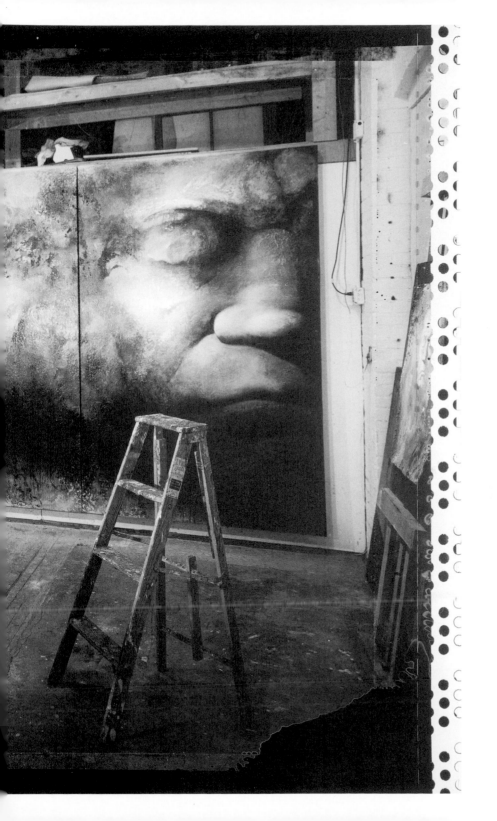

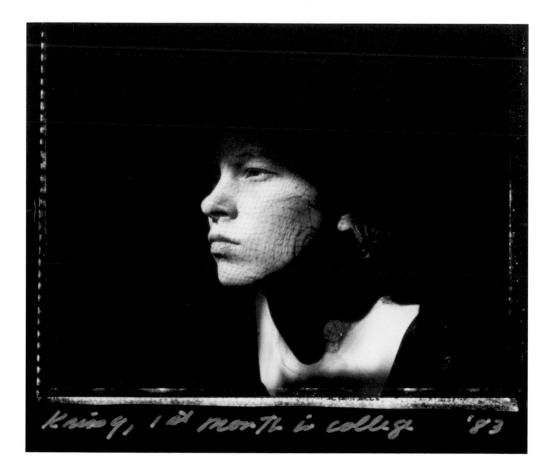

Krissy, 1st month in college '83

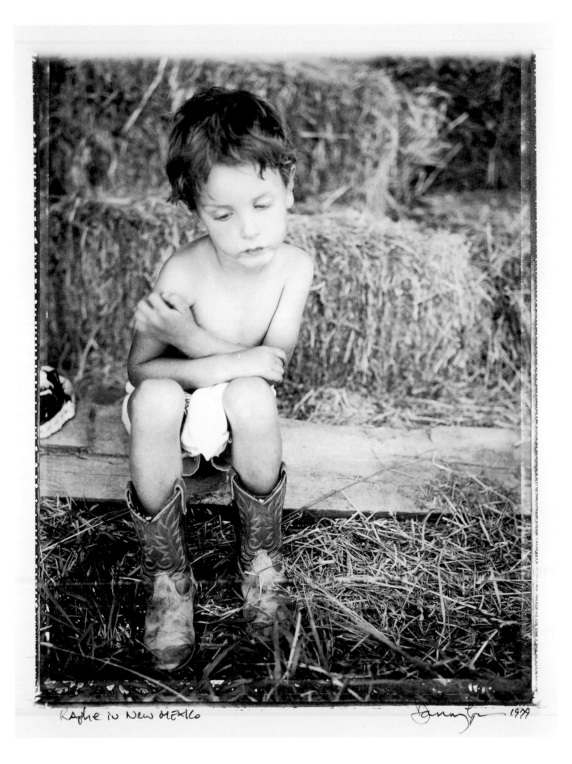

Raphe in New Mexico

Danny Lyon 1979

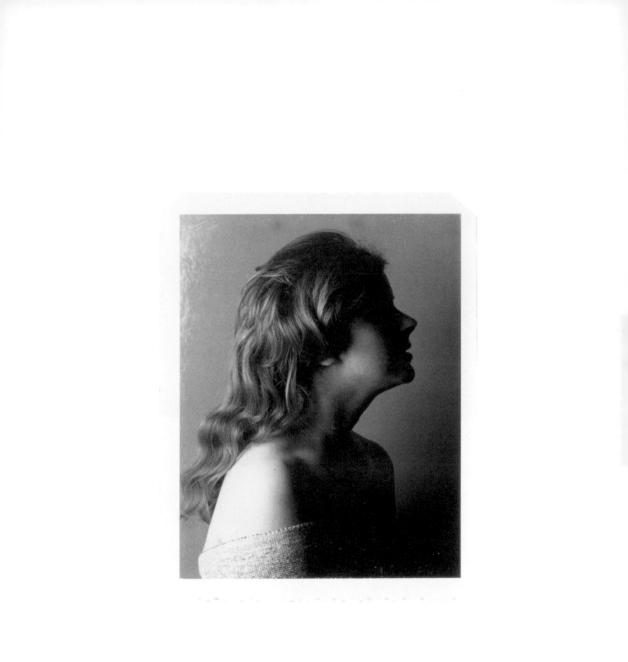

188

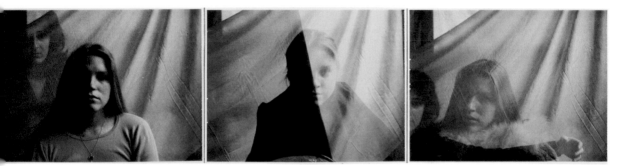

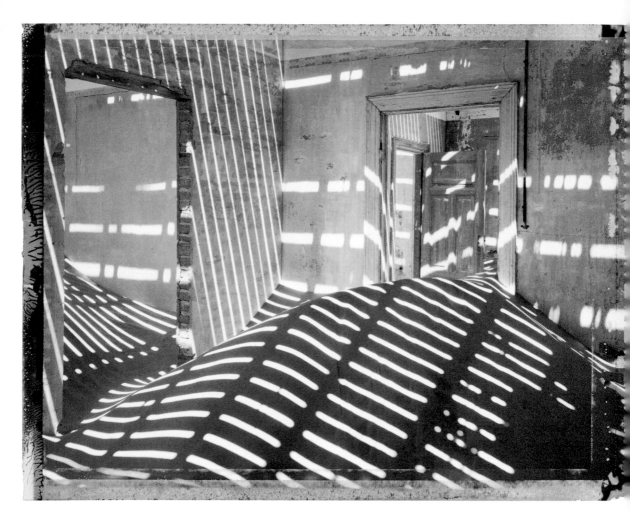

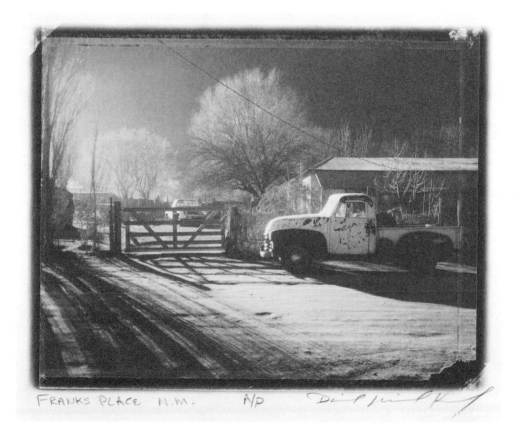

FRANKS PLACE N.M. A/P Di l finll Kfn

191

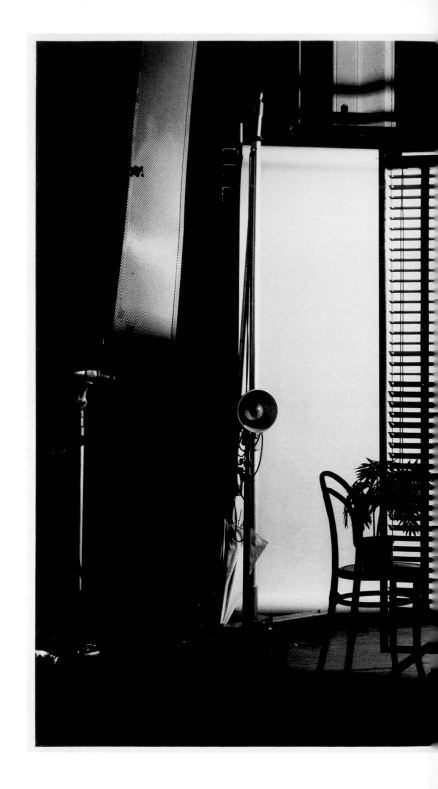

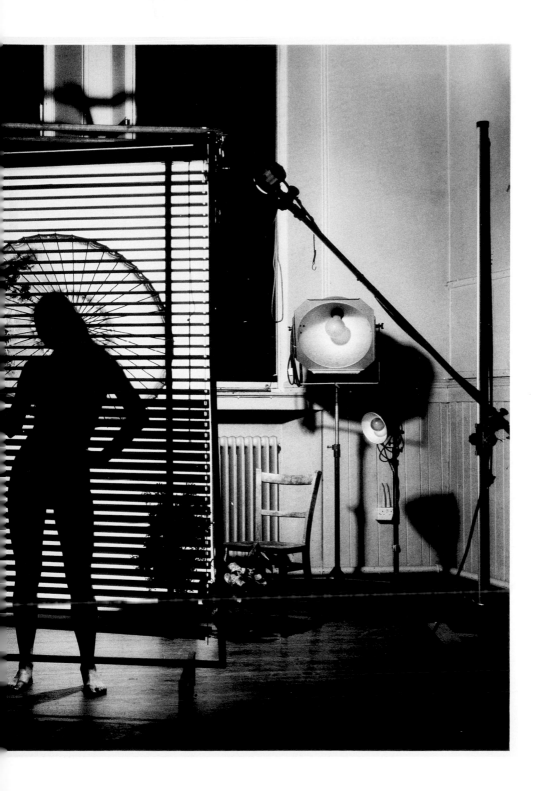

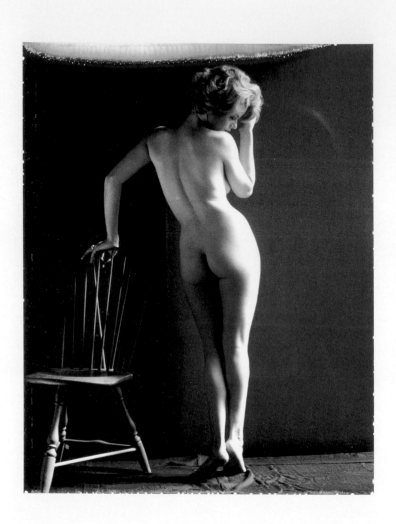

PETER GOWLAND

SANTA MONICA, CALIF.

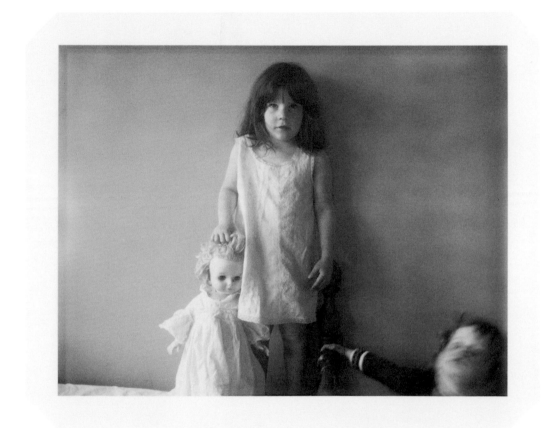

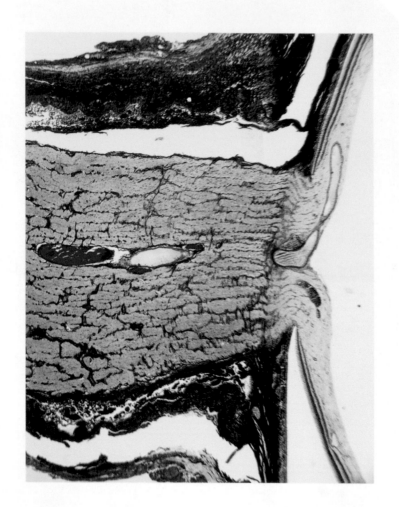

196

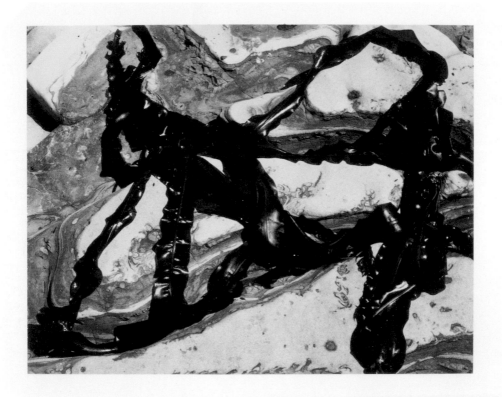

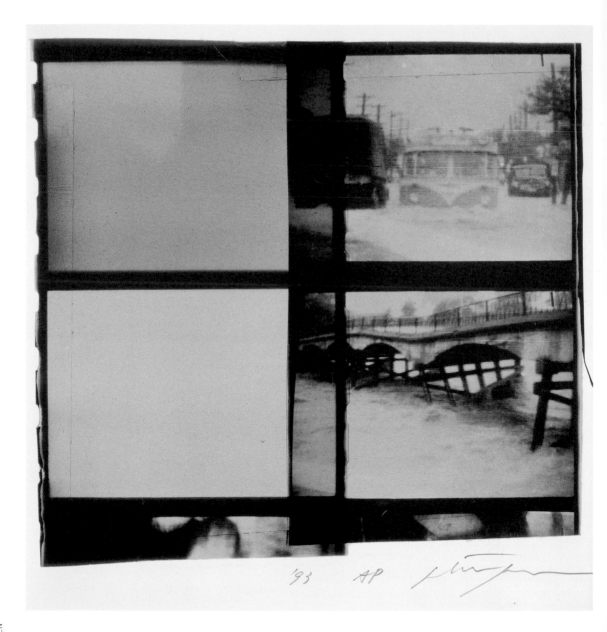

'93 AP [signature]

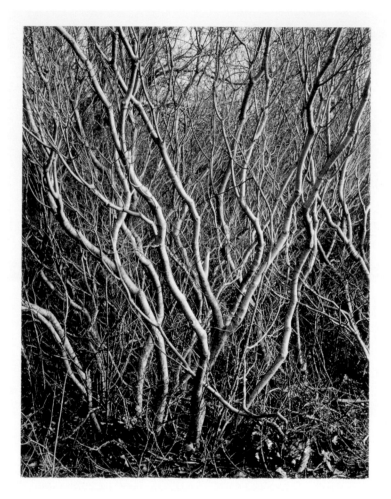

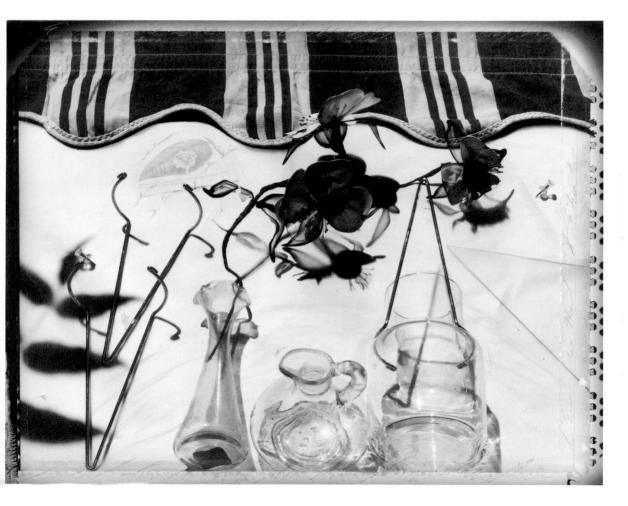

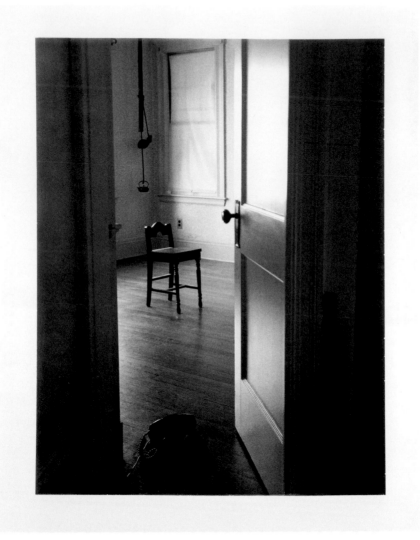

202

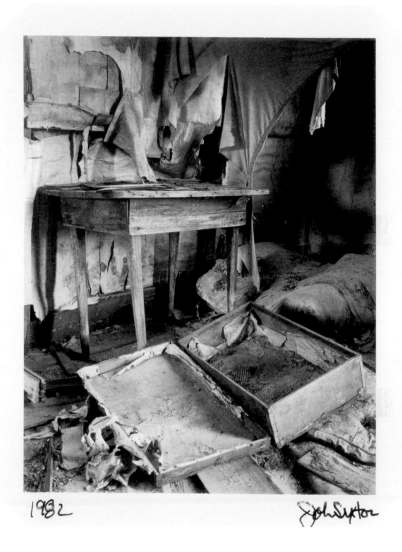

1982 John Sexton

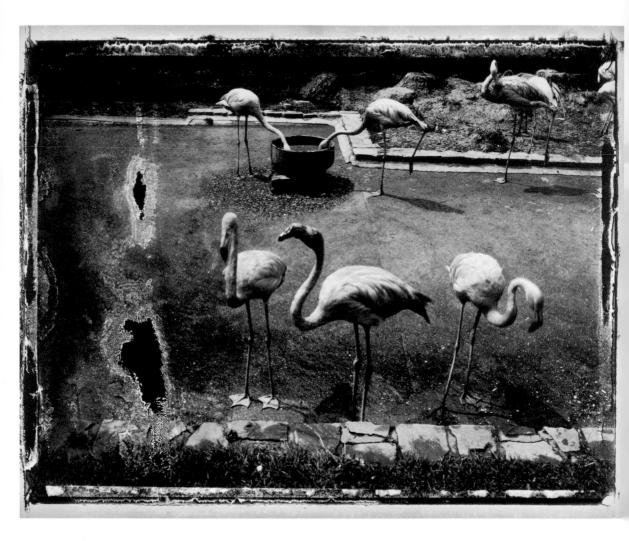

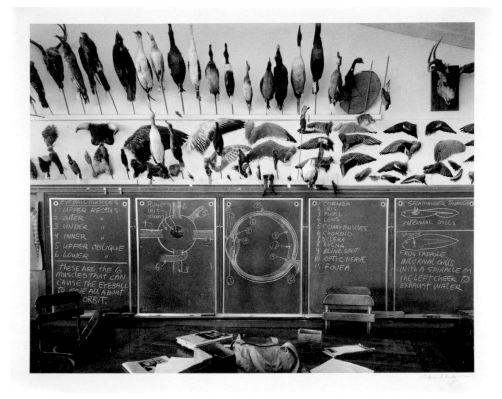

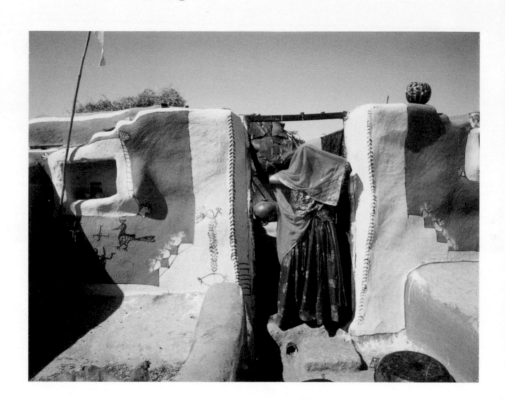

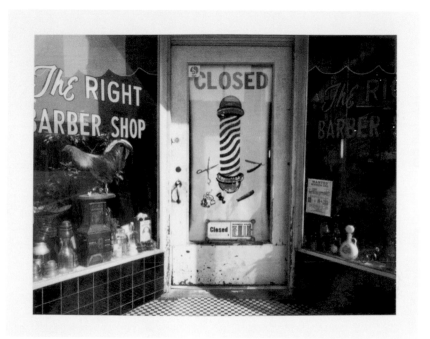

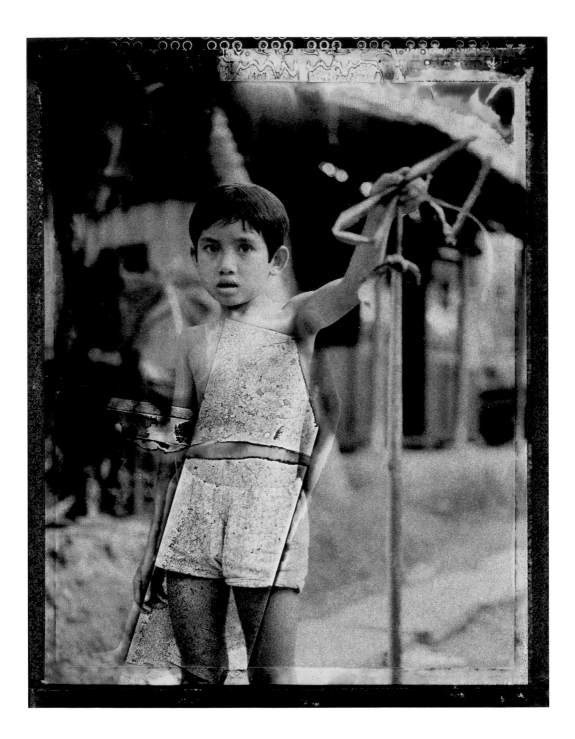

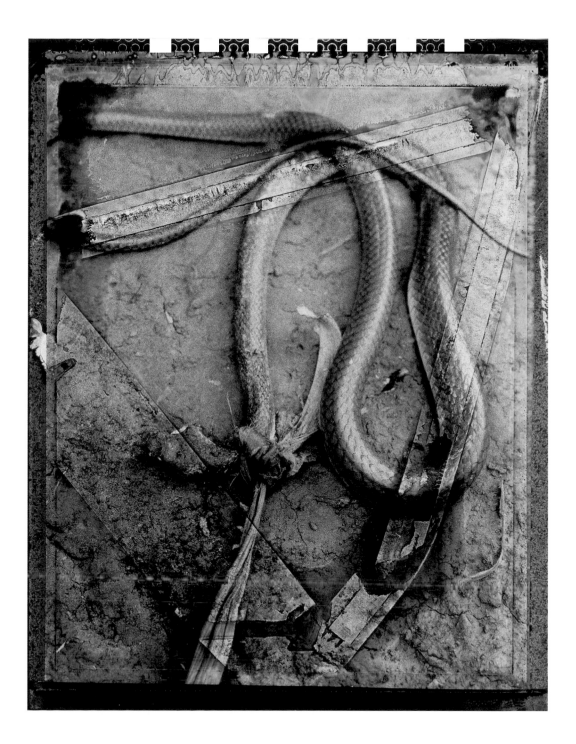

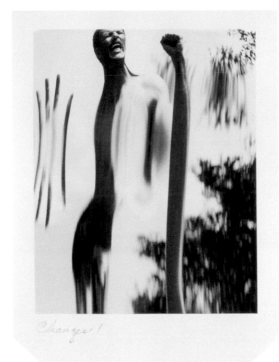

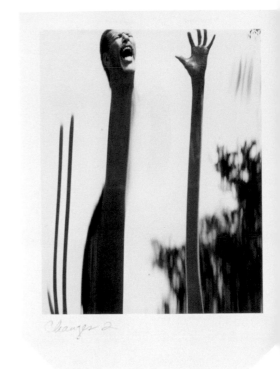

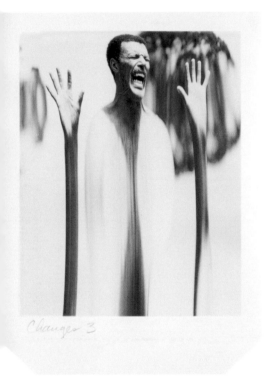

Changes 3

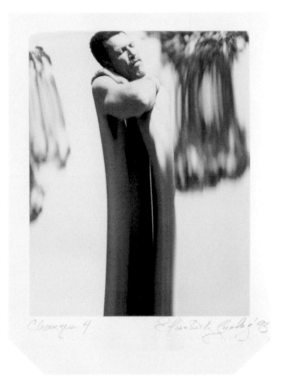

Changes 4 Elisabeth Sunday '93

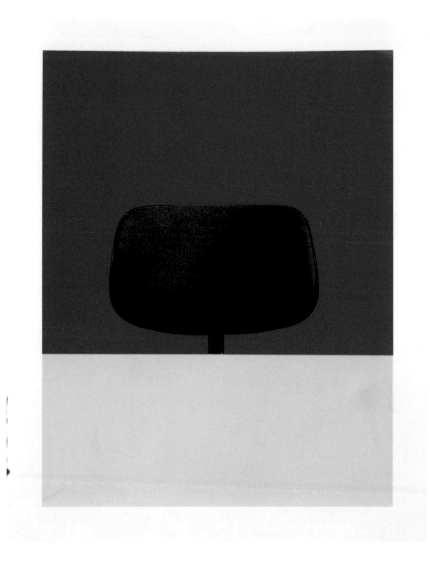

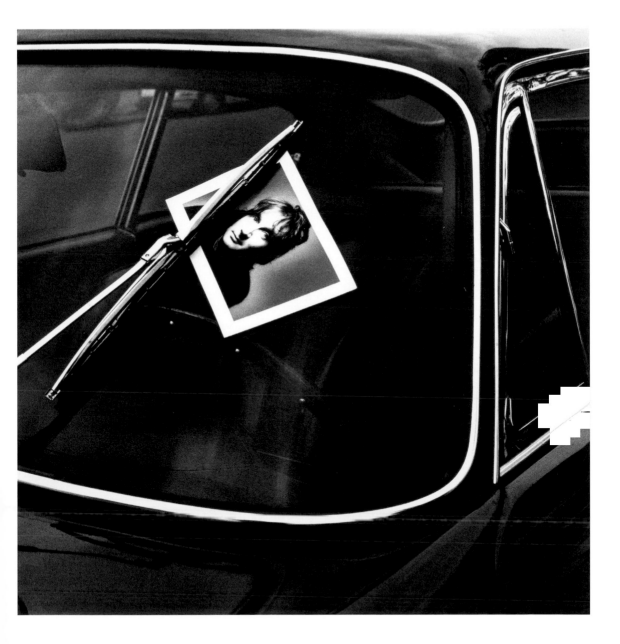

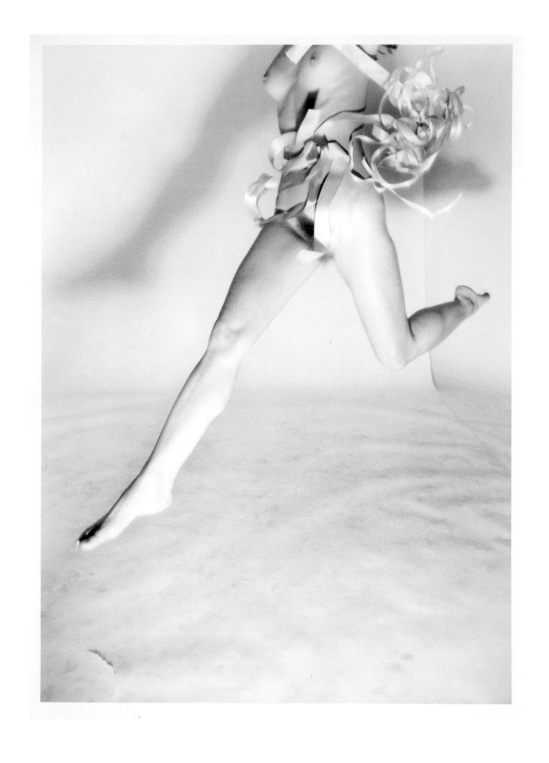

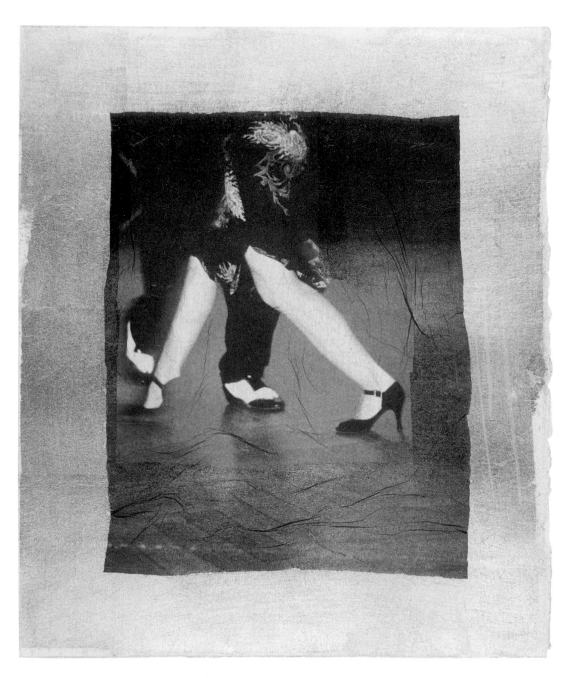

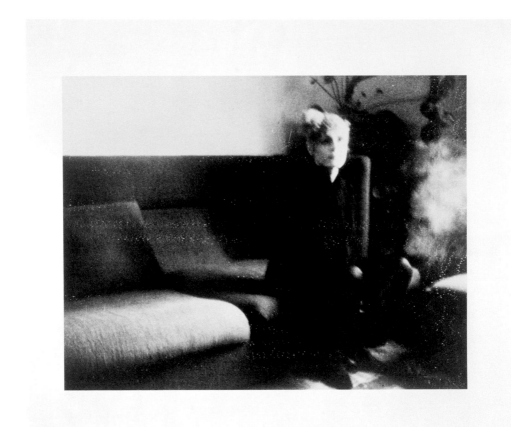

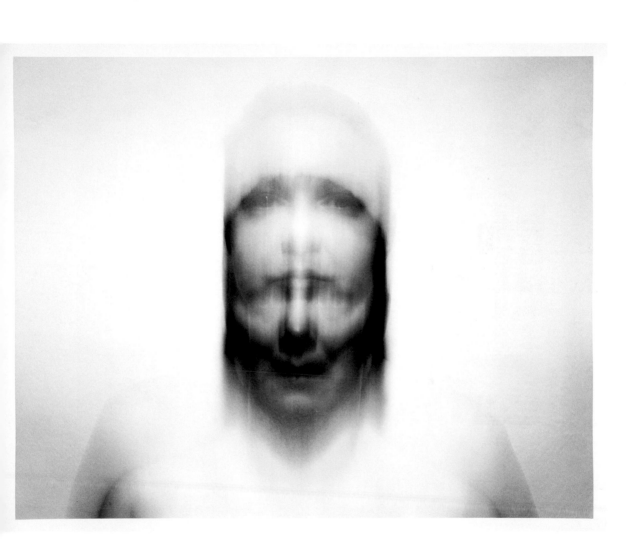

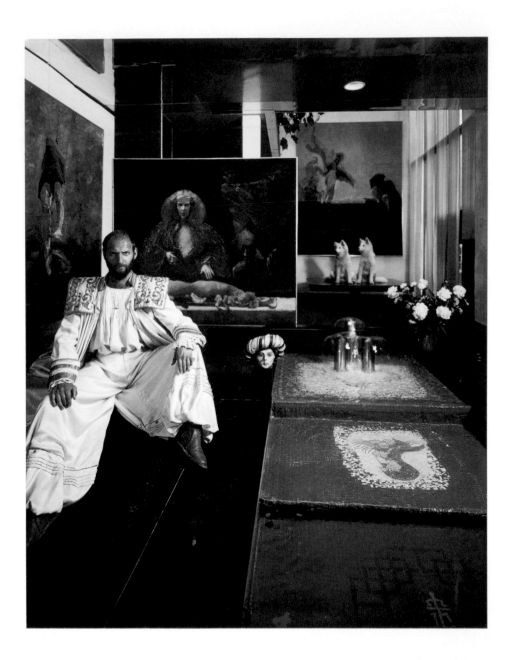

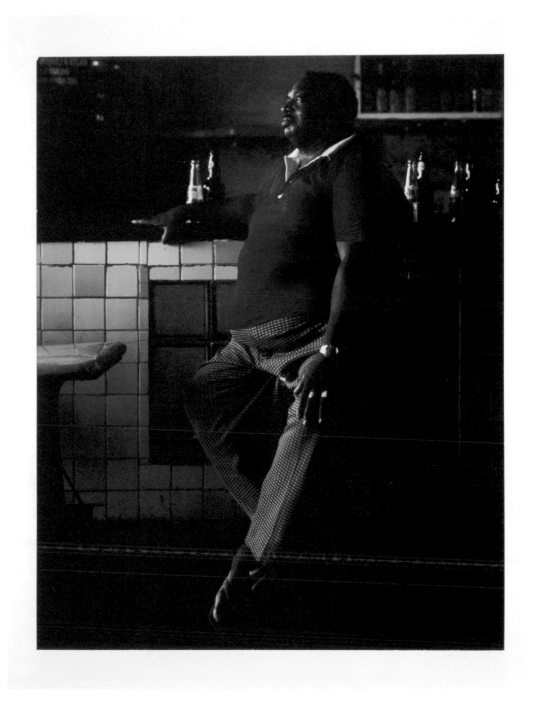

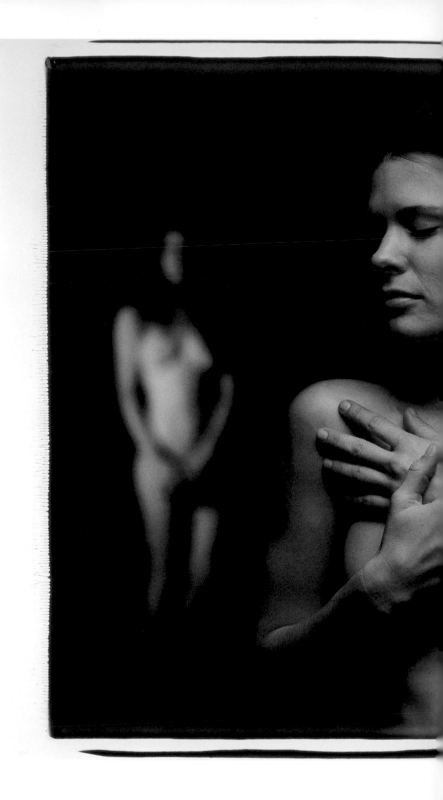

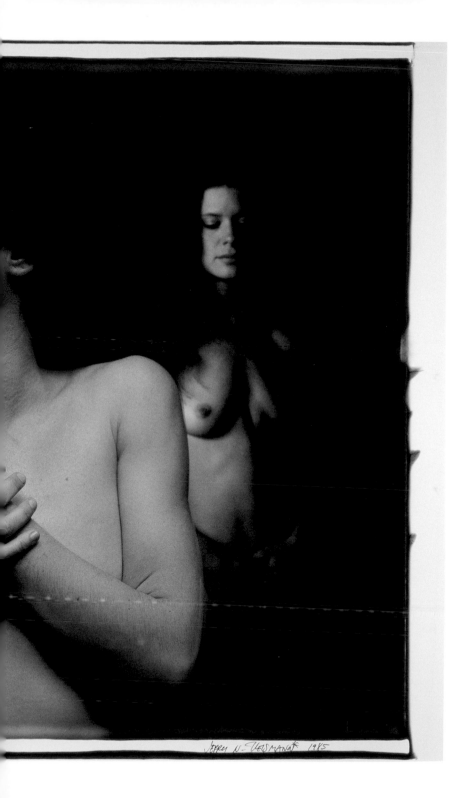

Jerry N. Uelsmann 1985

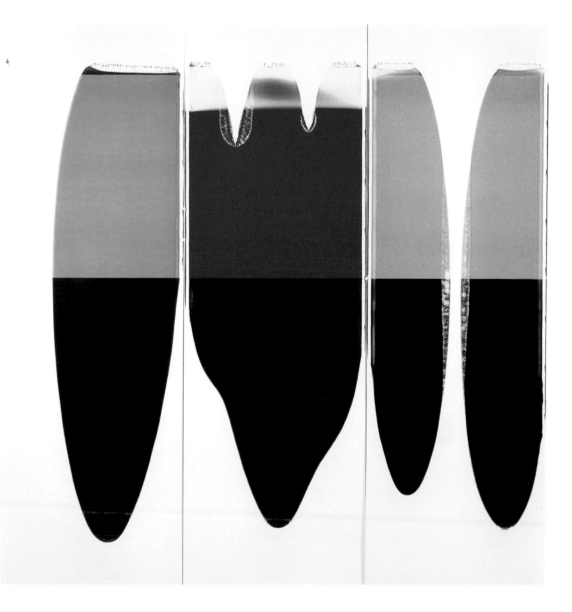

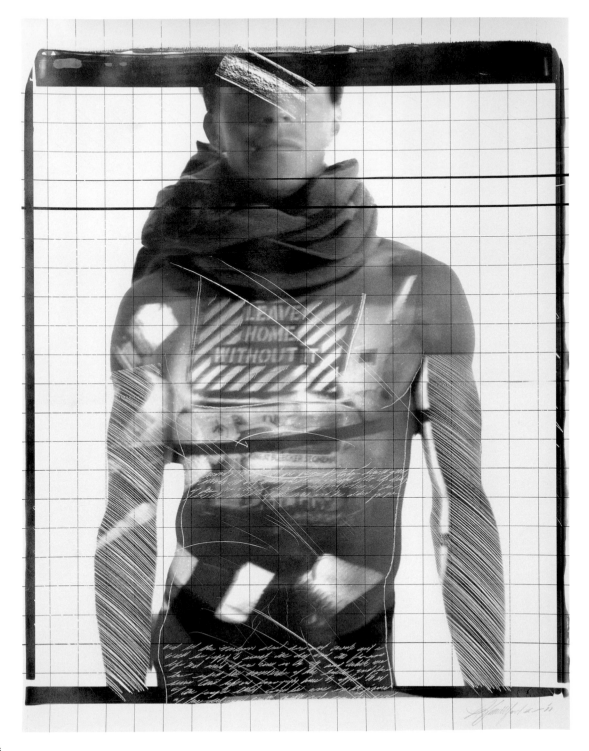

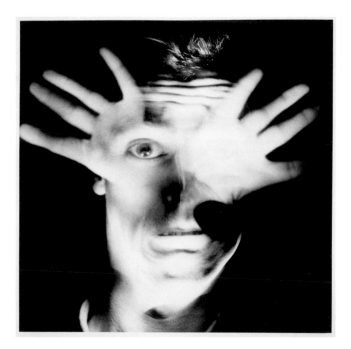

GABRIELE BASILICO

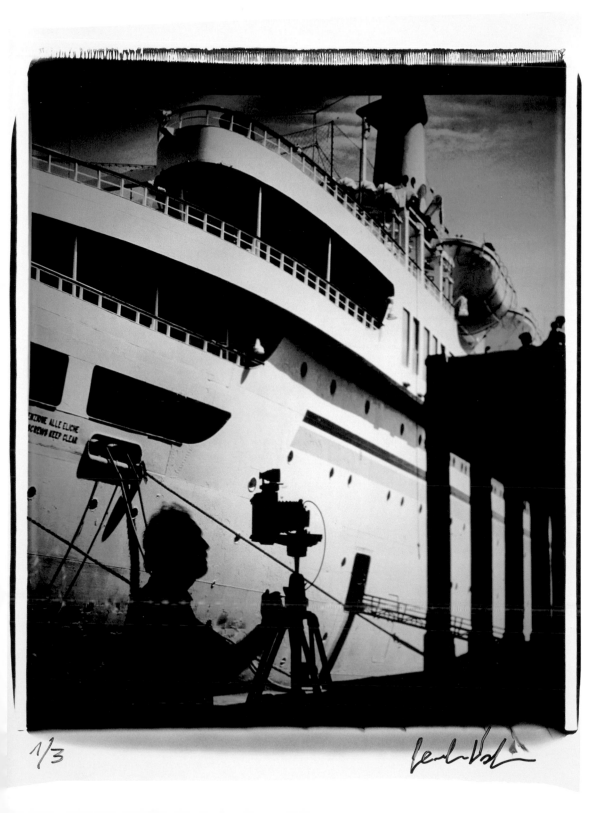

1/3

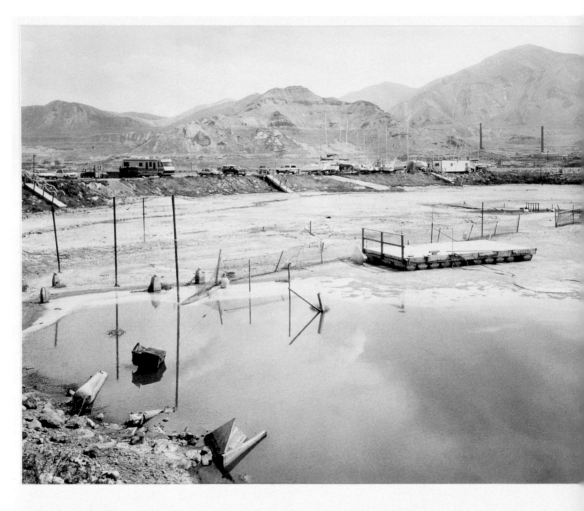

OQUIRR

BINGHAM COPPER MINE, SA

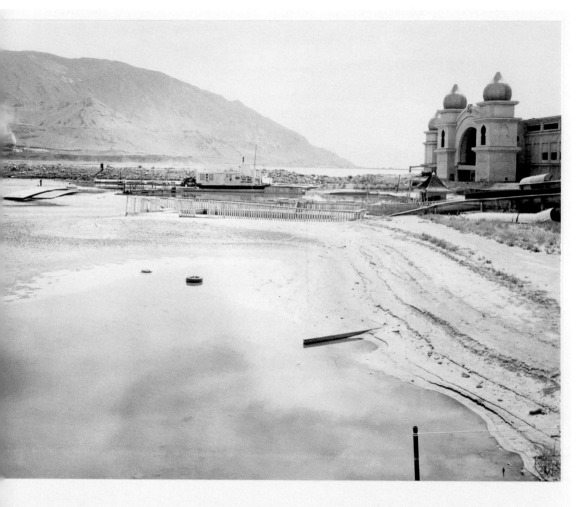

NTAINS
ALTAIR PAVILLION, UTAH

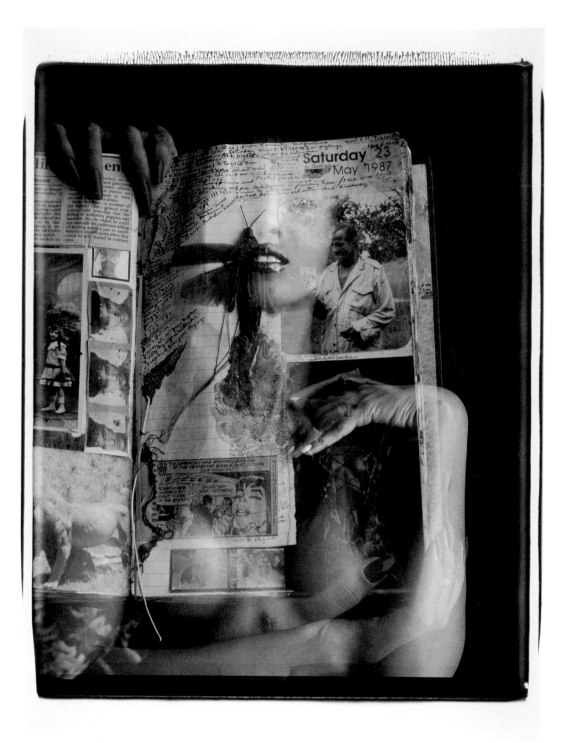

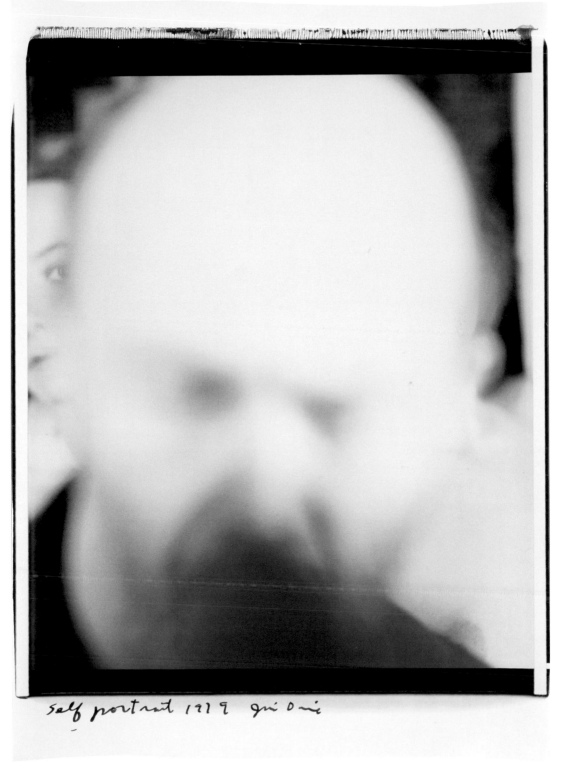

self portrait 1979 Jim Dine

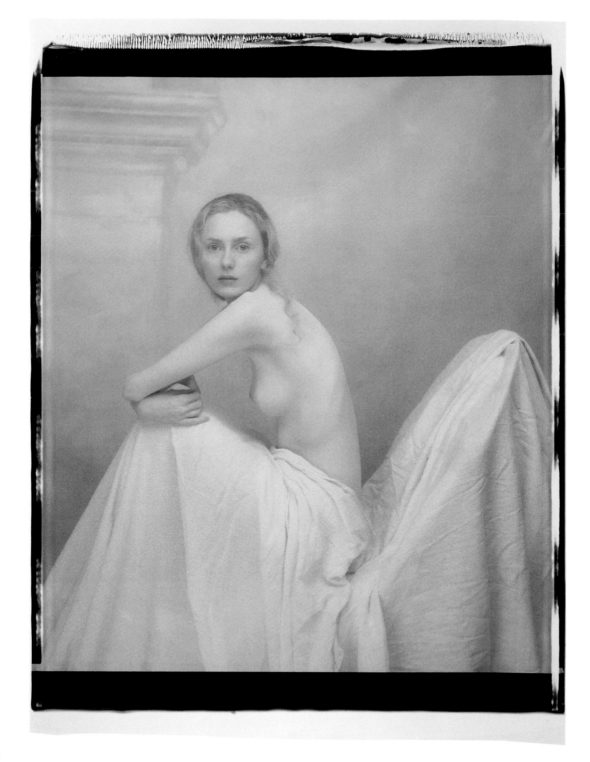

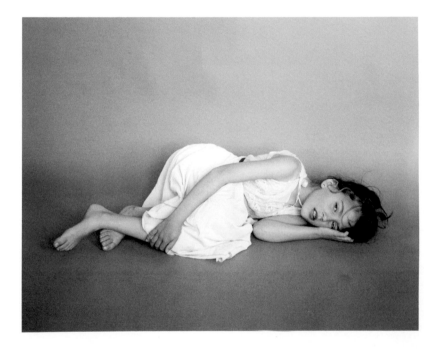

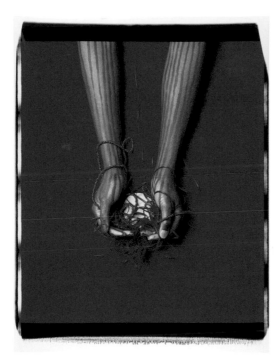
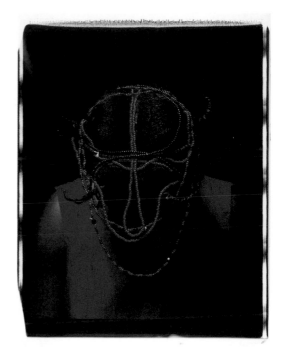
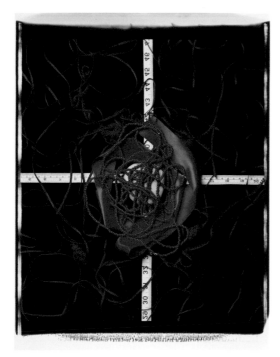
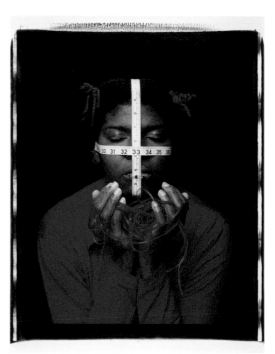

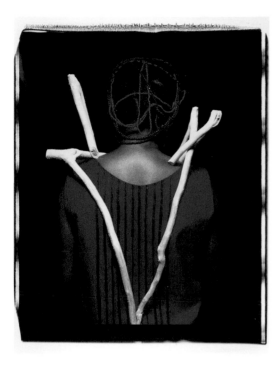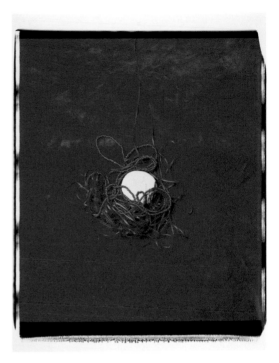
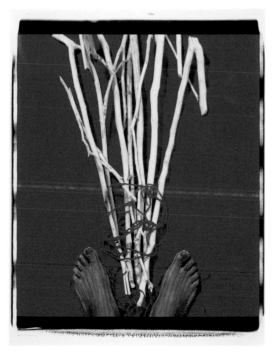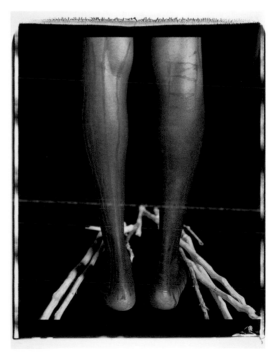

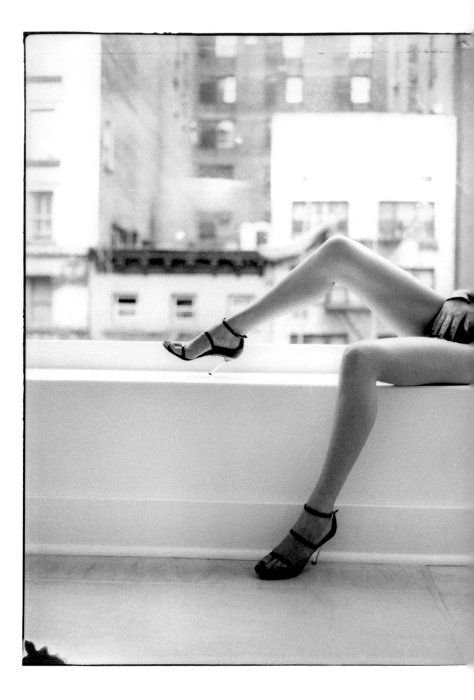

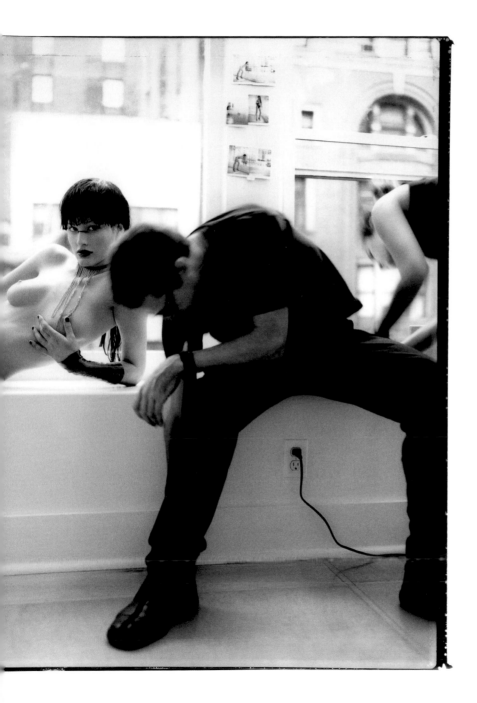

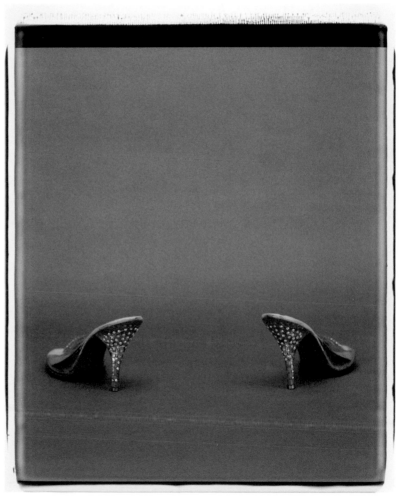

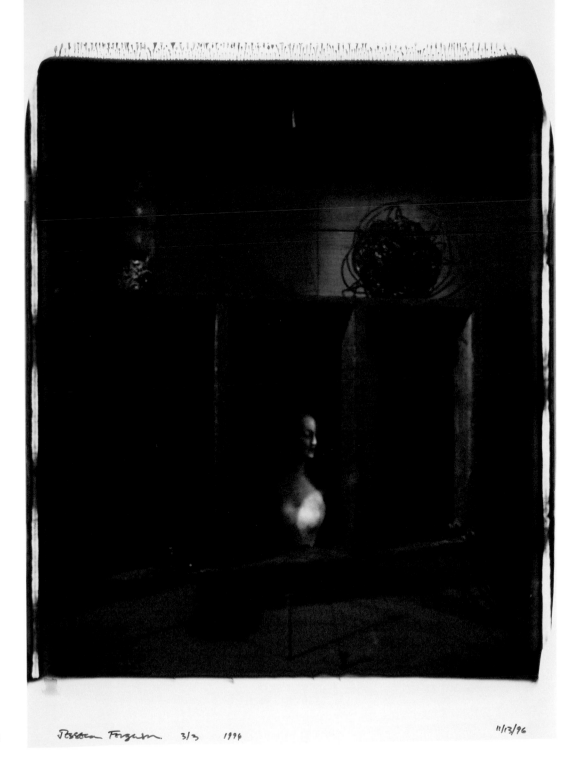

Jesseca Ferguson 3/3 1996 11/13/96

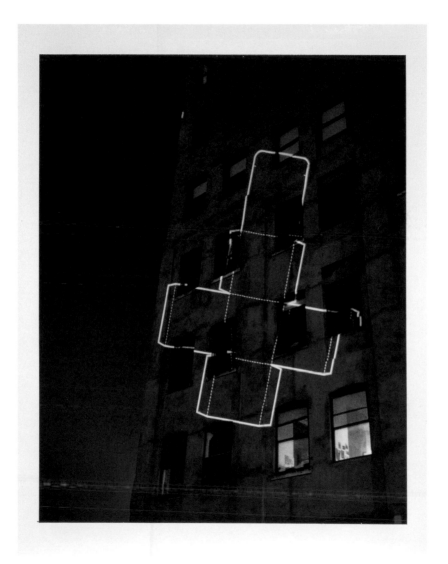

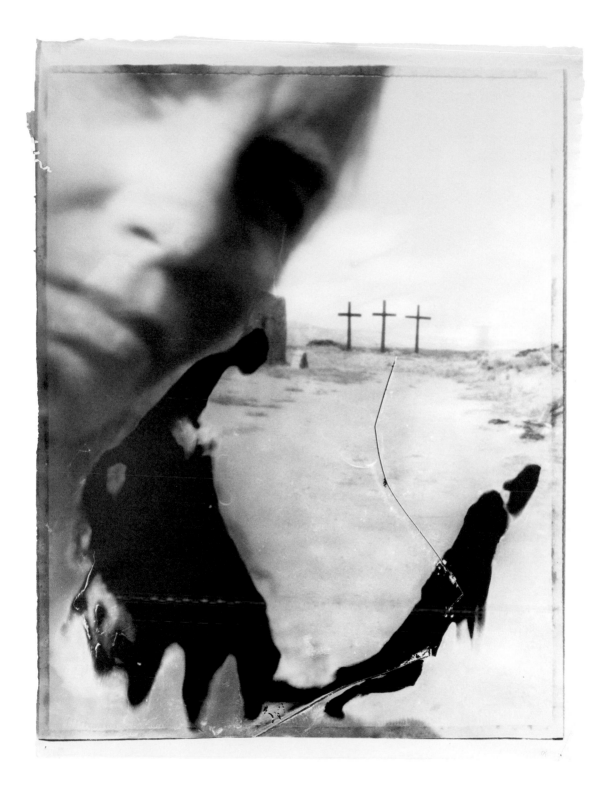

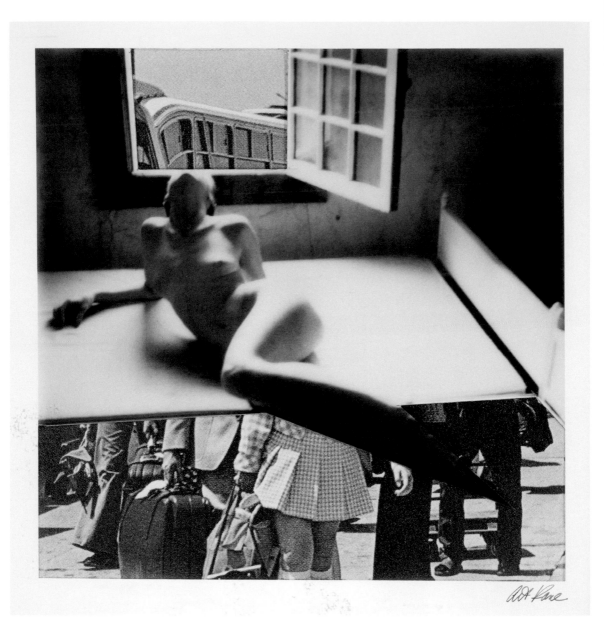

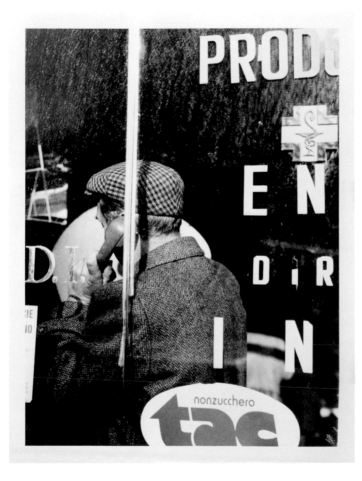

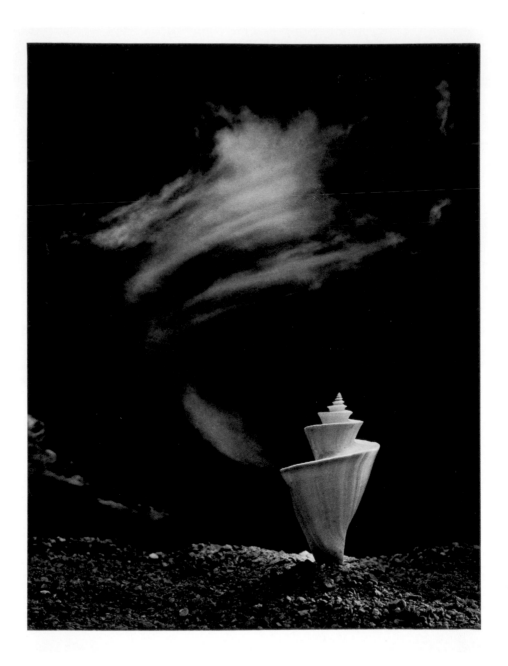

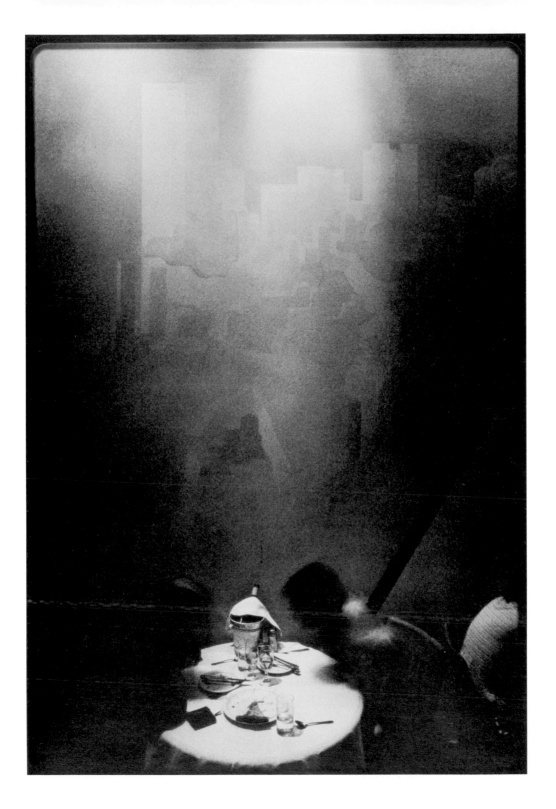

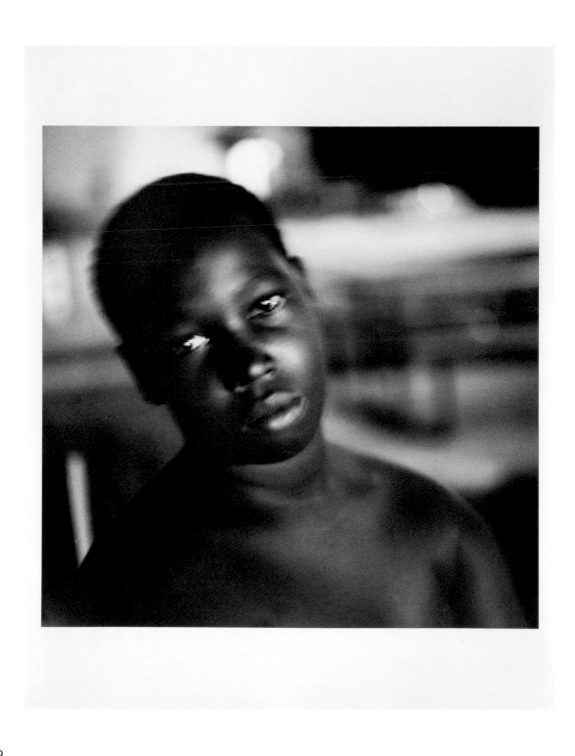

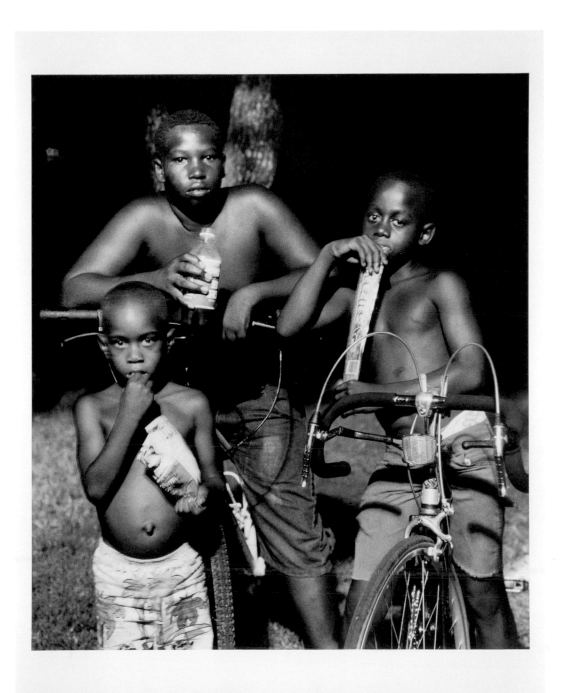

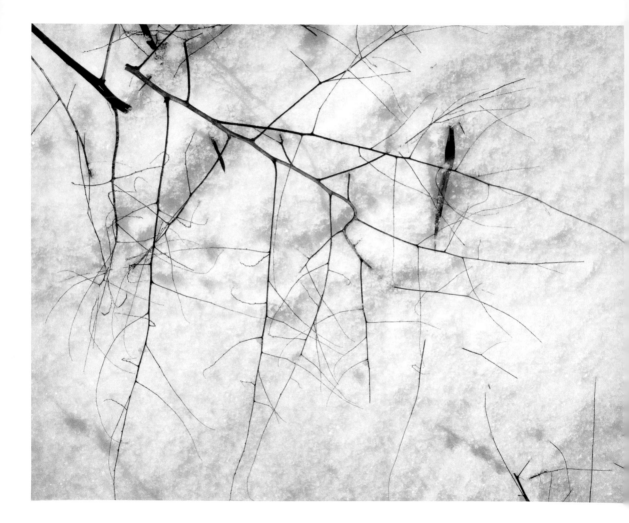

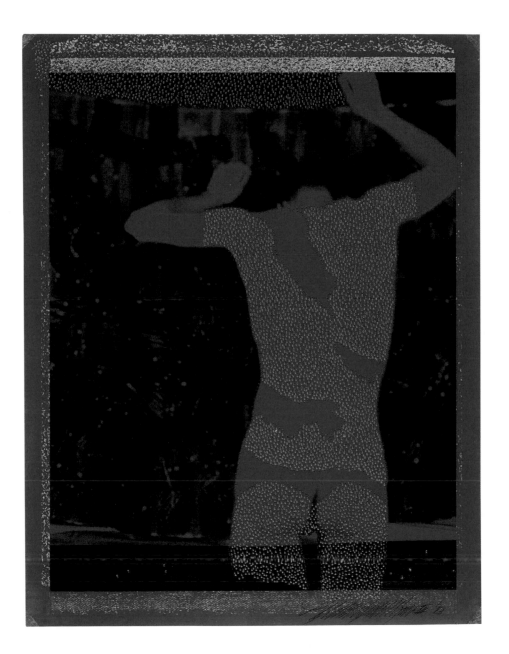

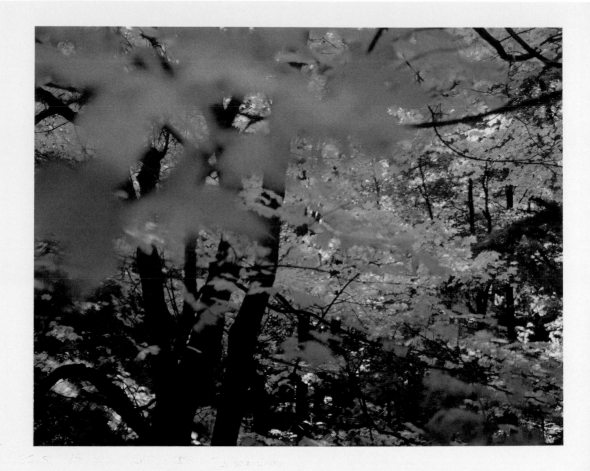

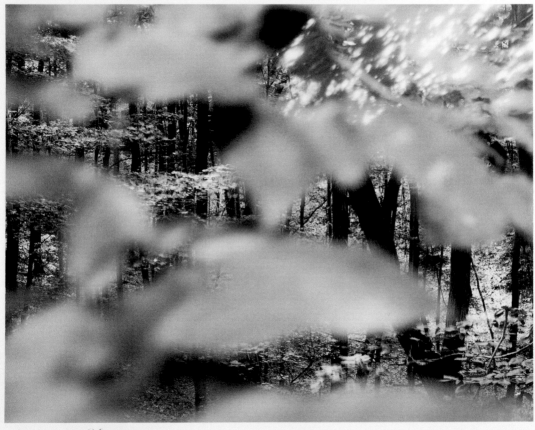

1/2 sec f'64

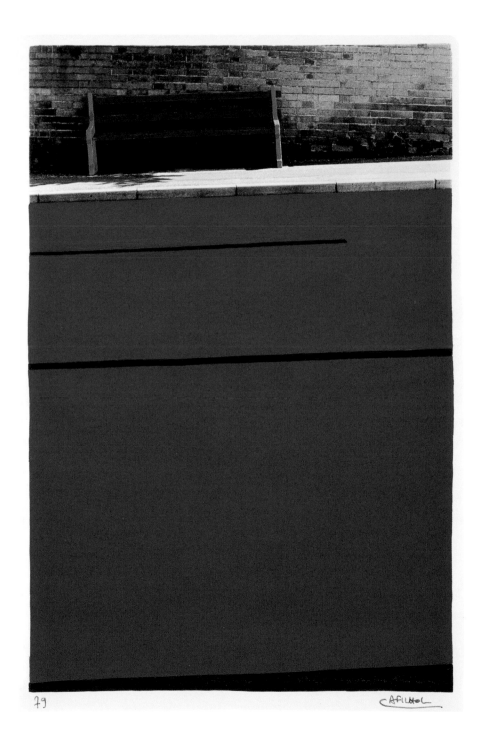

79

CAFILHOL

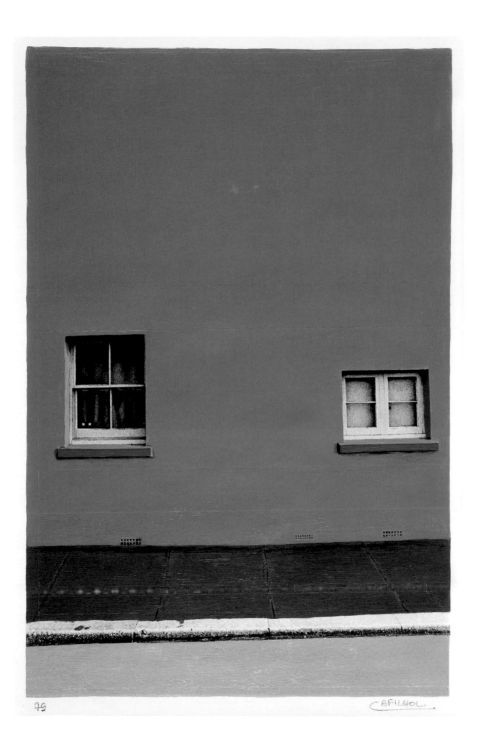

79

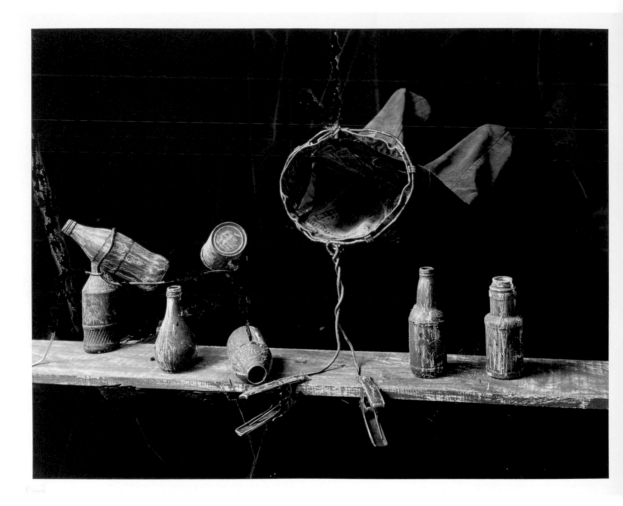

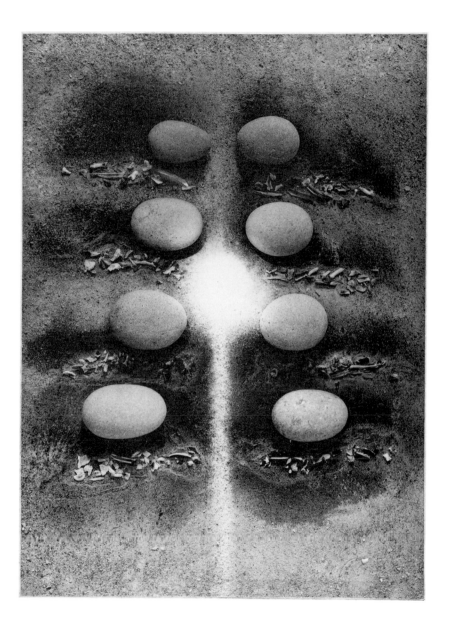

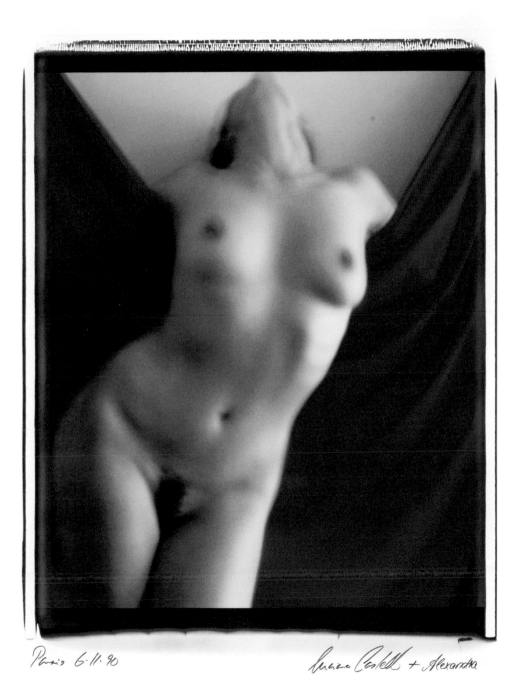

Paris 6.11.90 Luciano Castelli + Alexandra

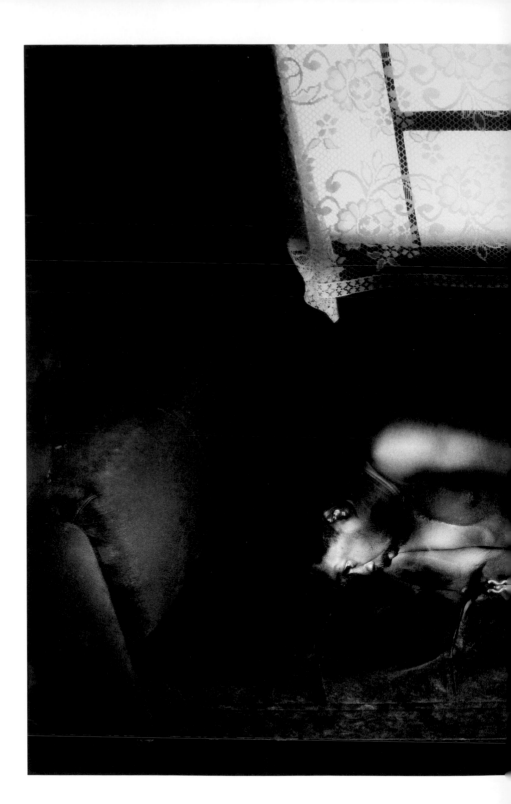

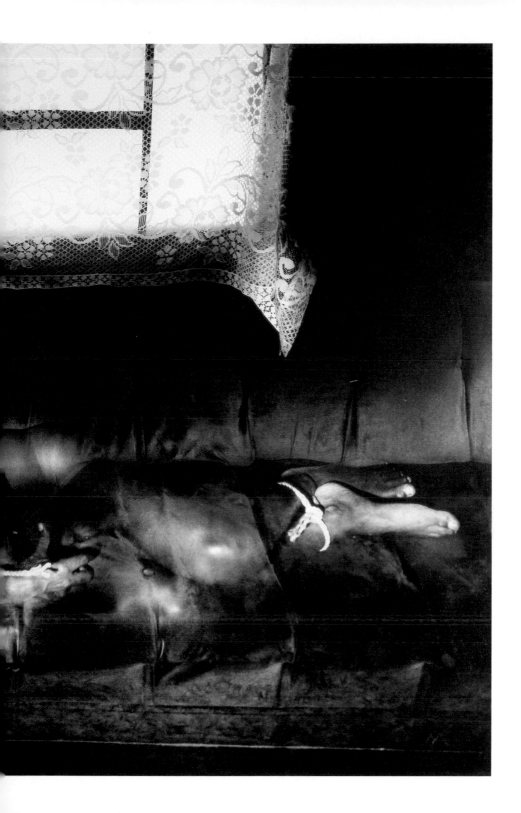

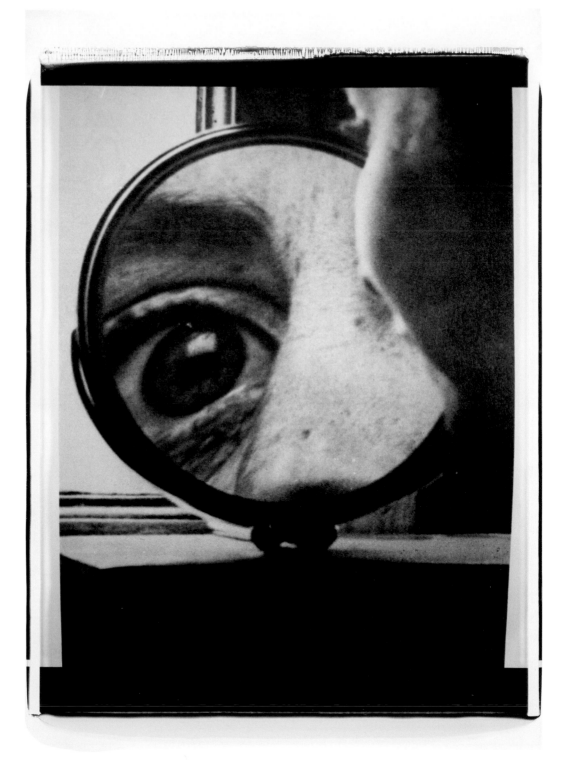

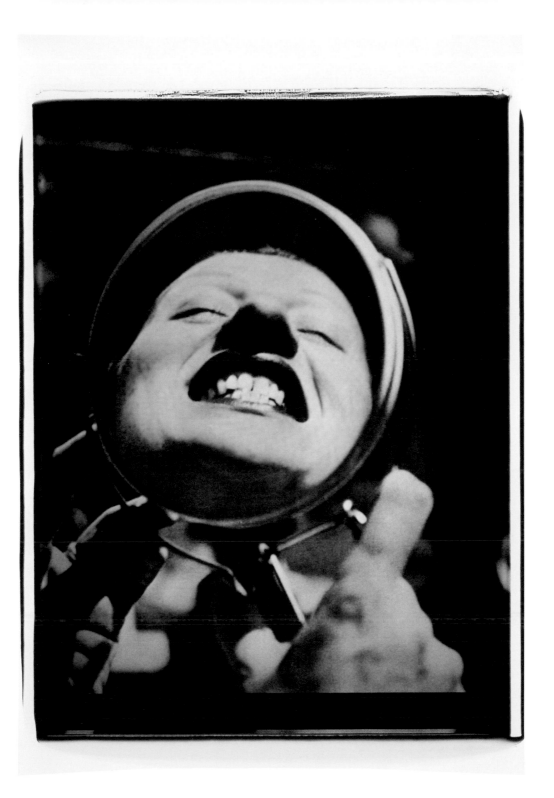

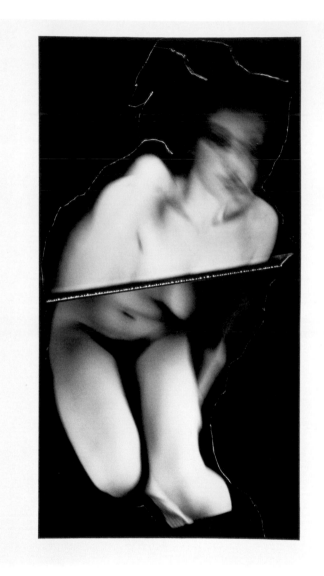

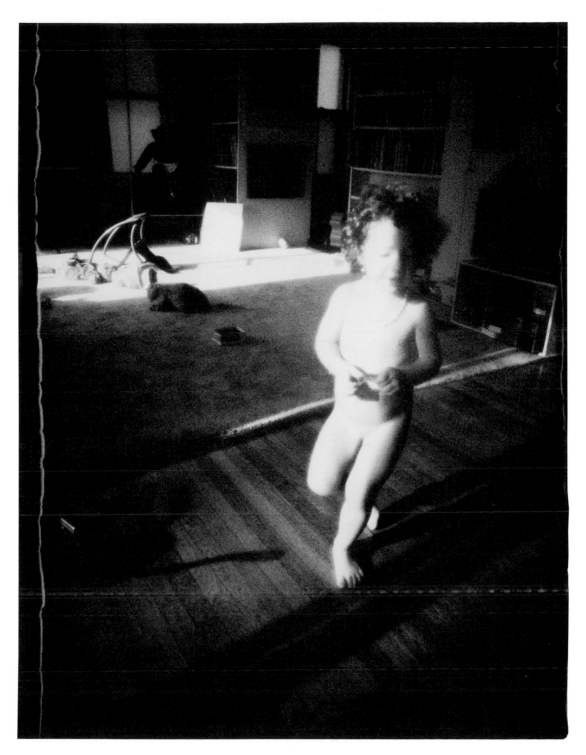

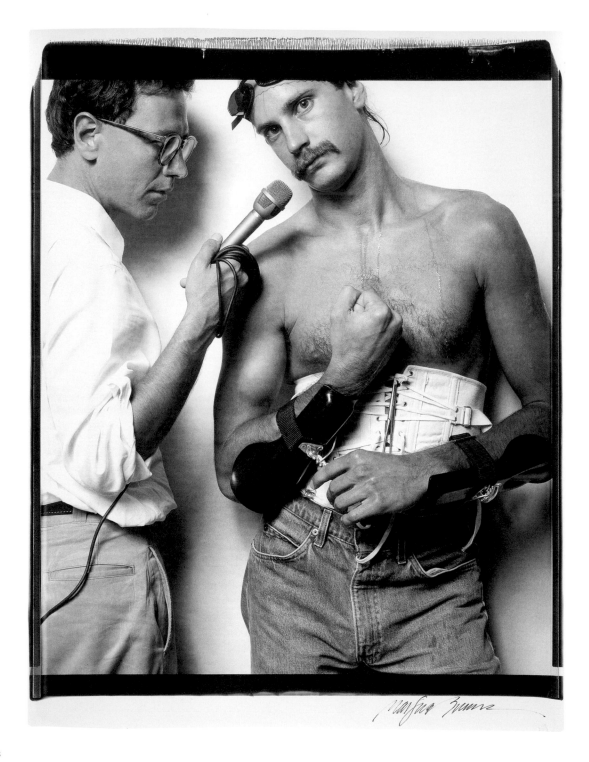

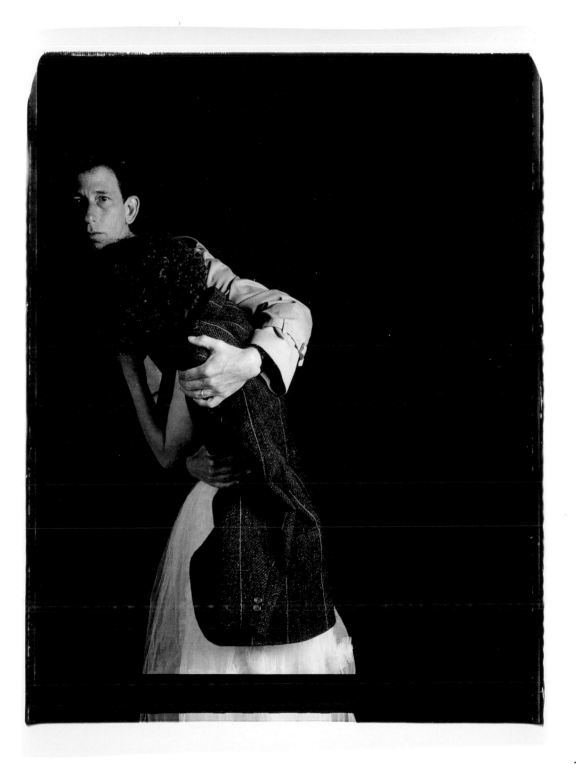

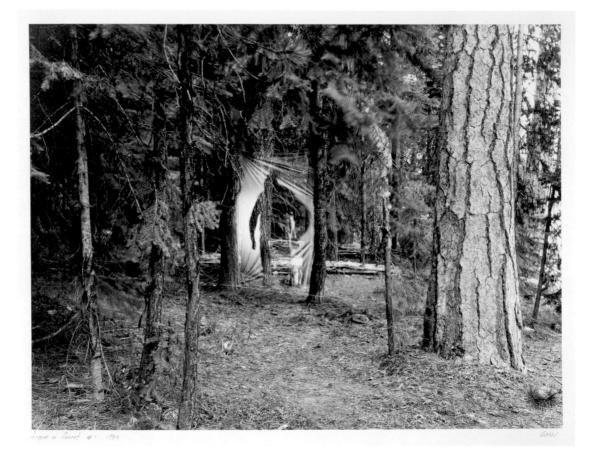

Figure in Forest #1 1980 Goin

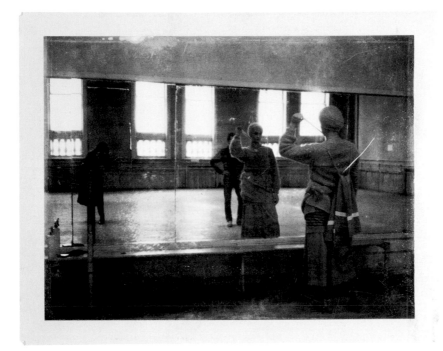

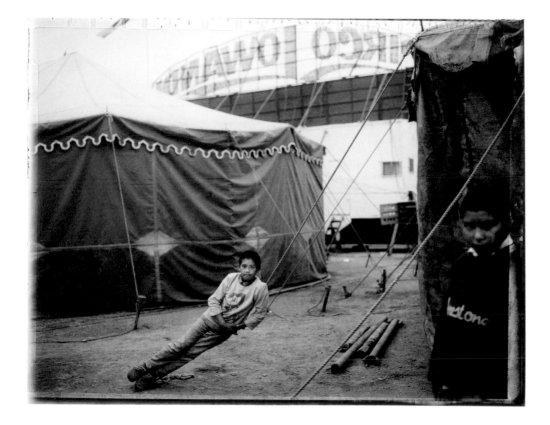

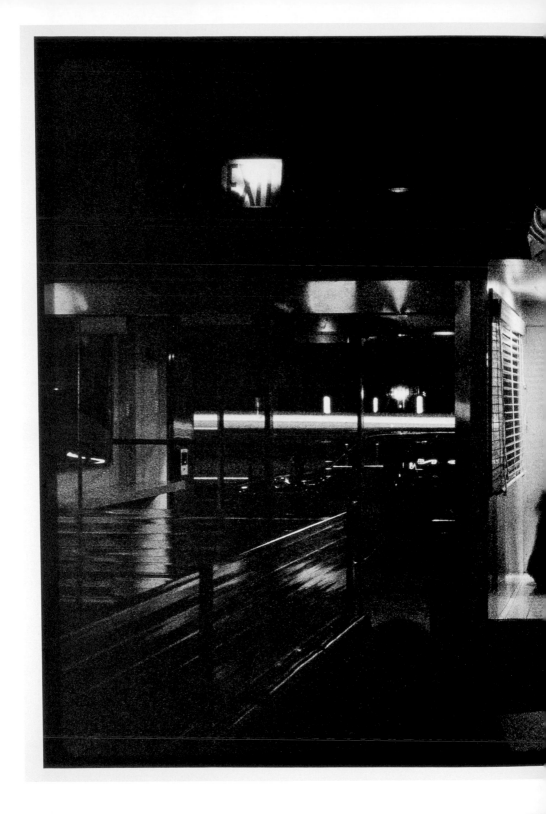

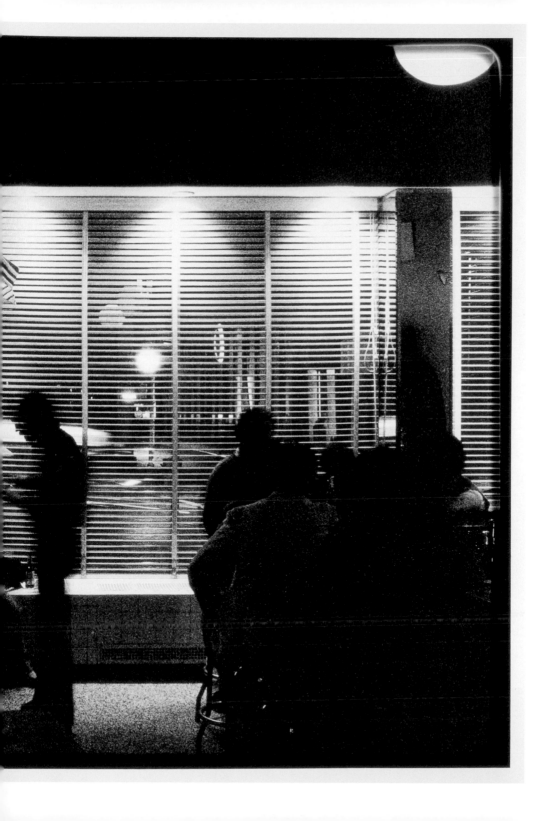

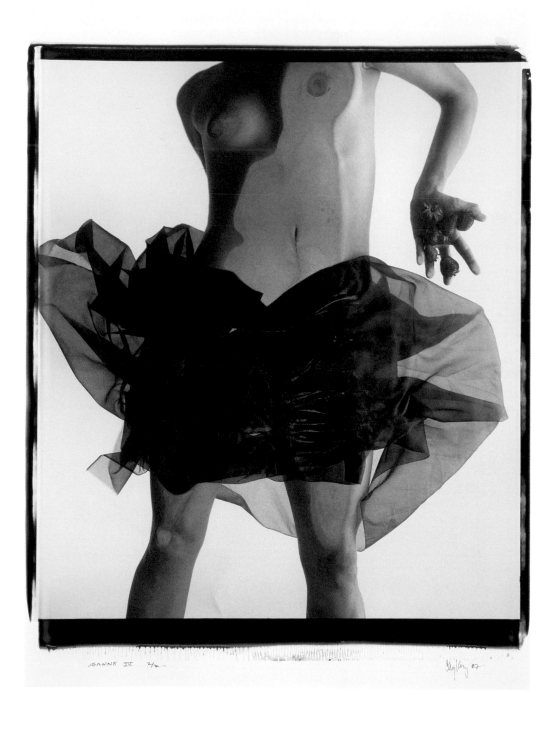

JEANNE IV 2/2

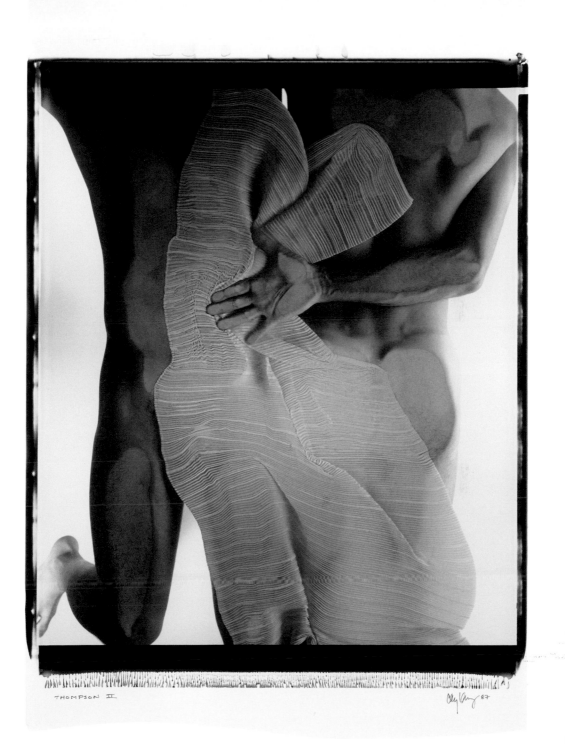

THOMPSON II

Cay Lang '87

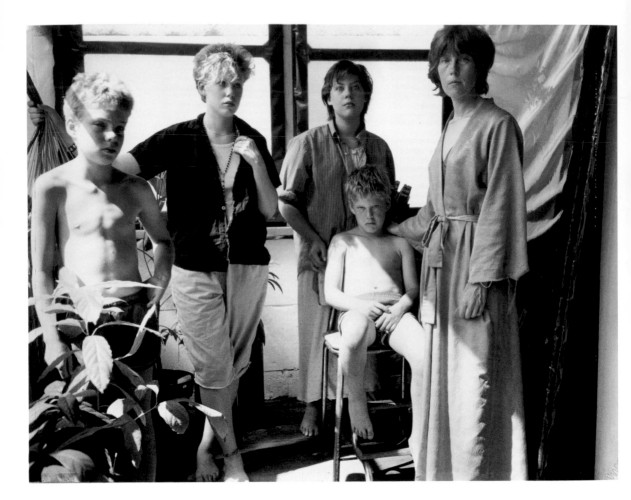

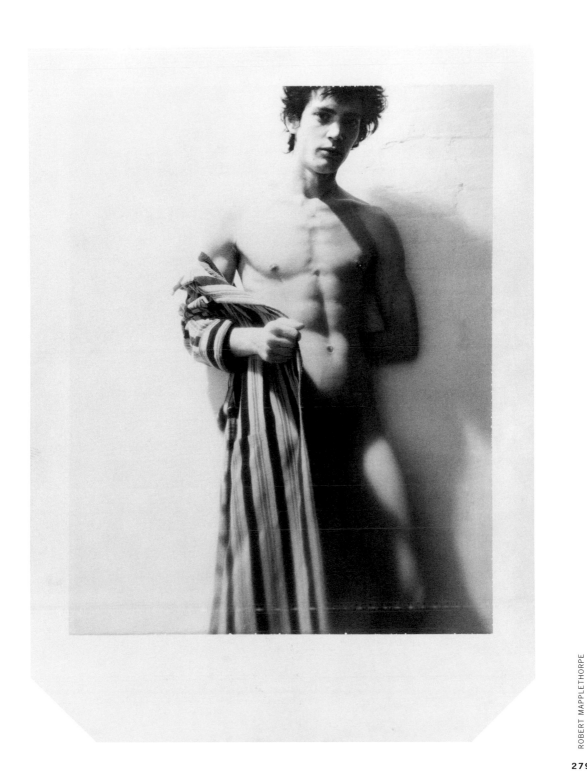

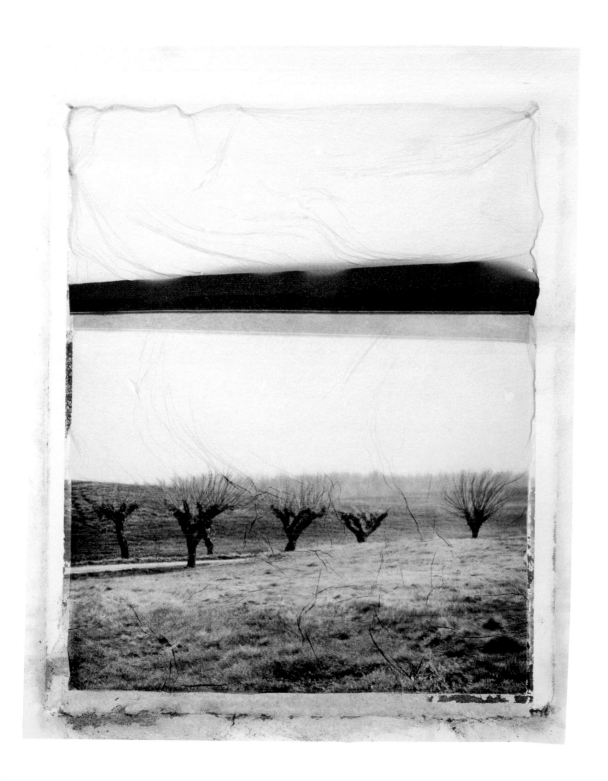

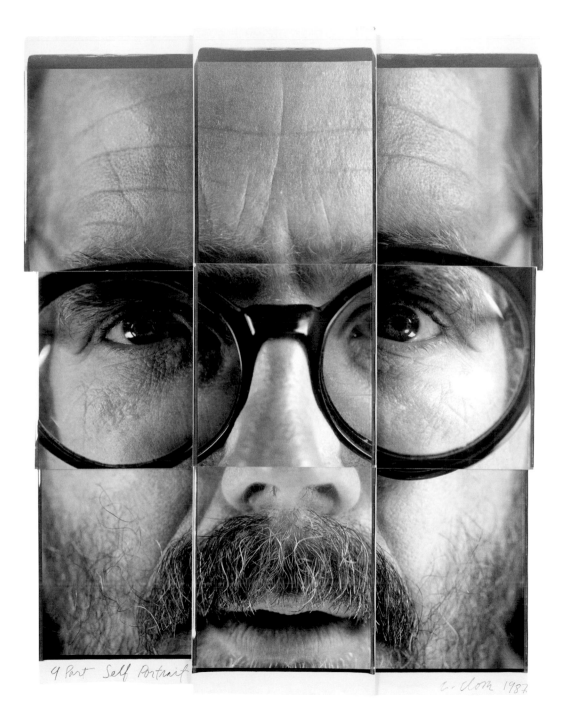

9 Part Self Portrait c. clom 1987

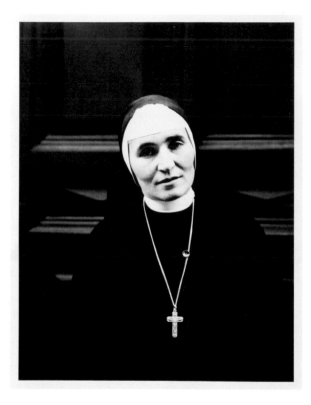

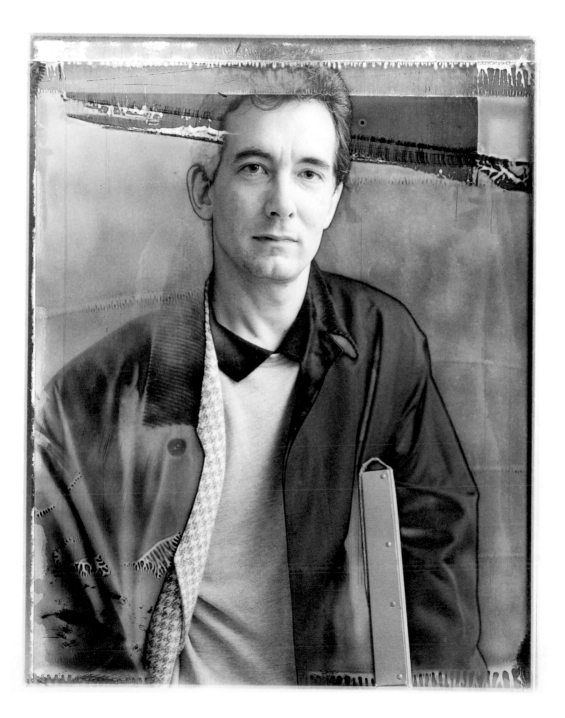

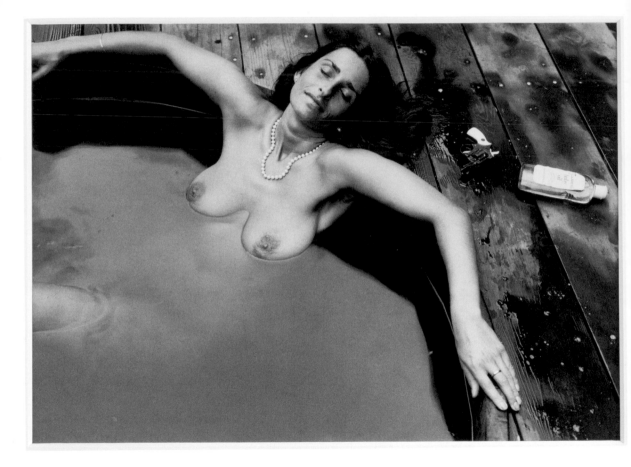

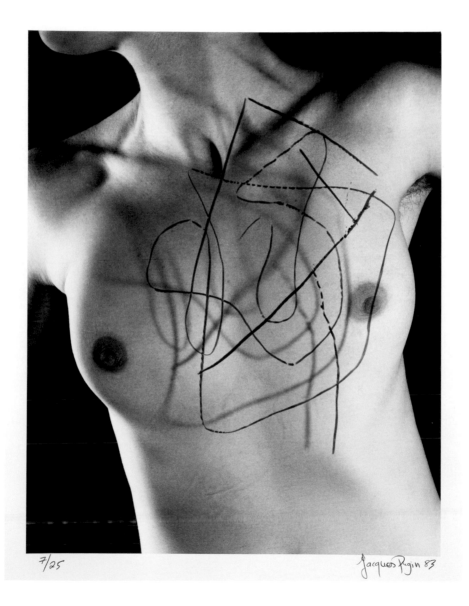

7/25

Jacques Pugin 83

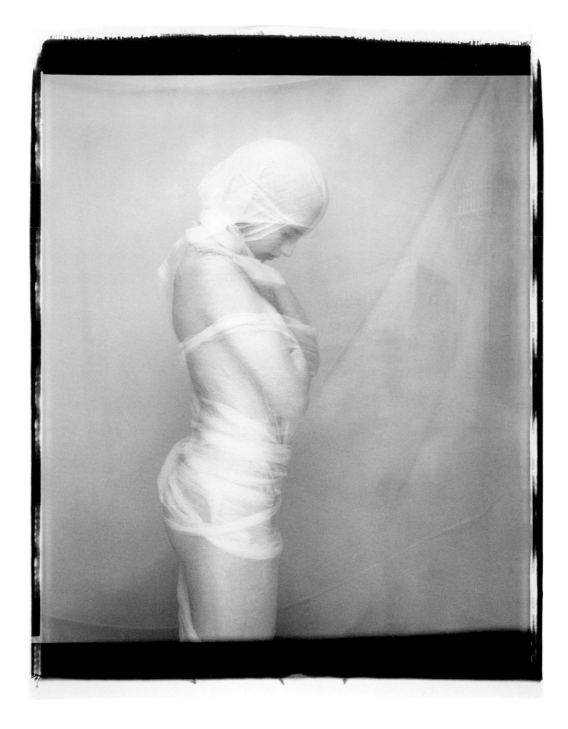

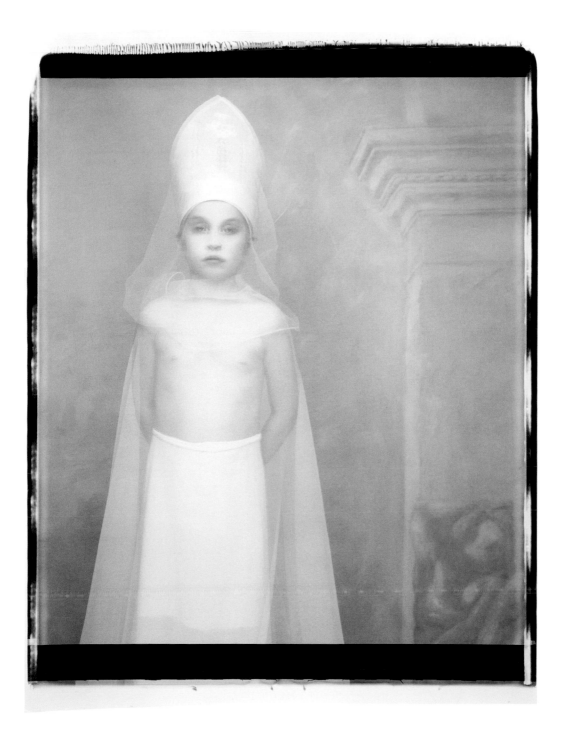

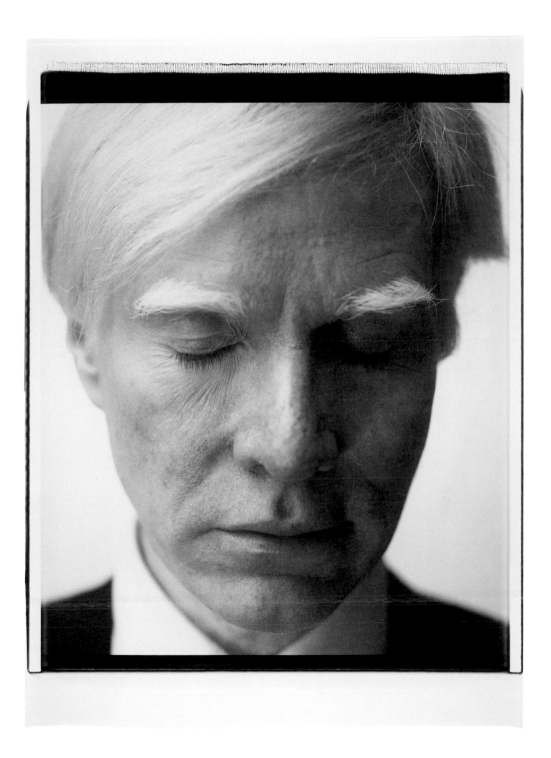

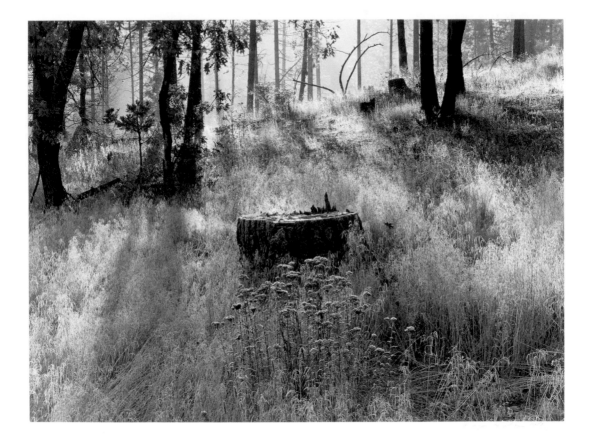

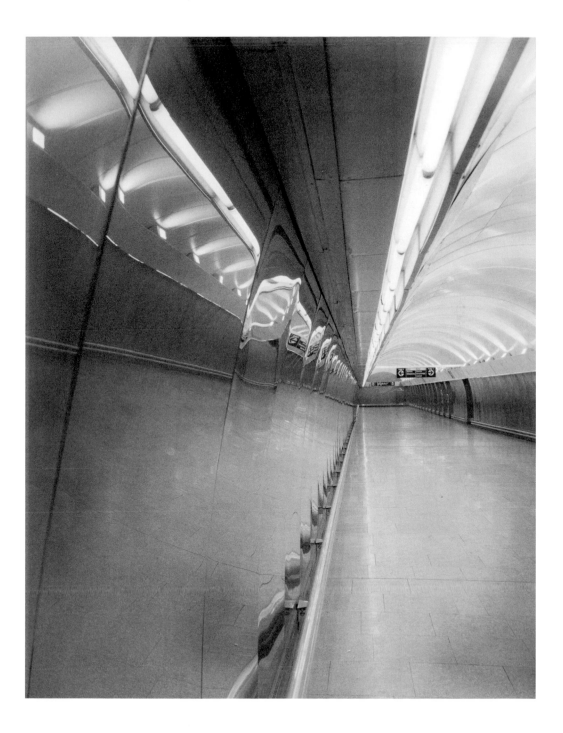

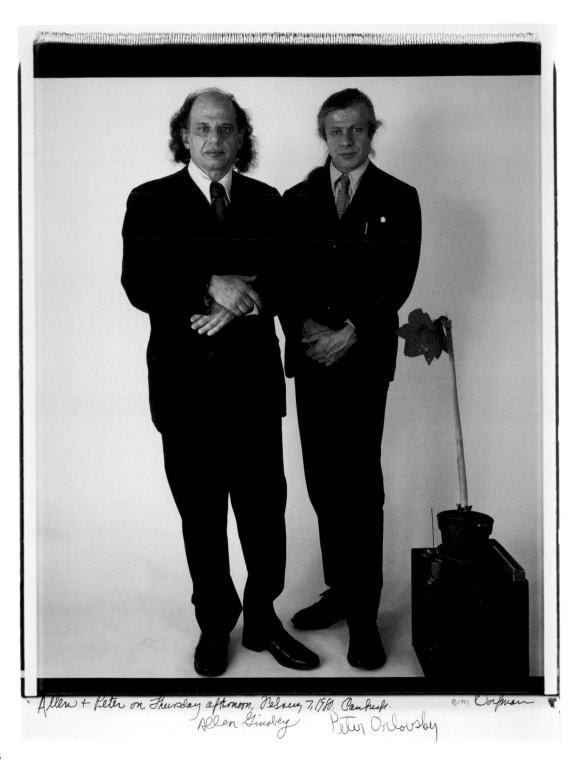

Allen + Peter on Thursday afternoon, February 7, 1980. Cambridge.

Allen Ginsberg Peter Orlovsky

©1989 Dorfman

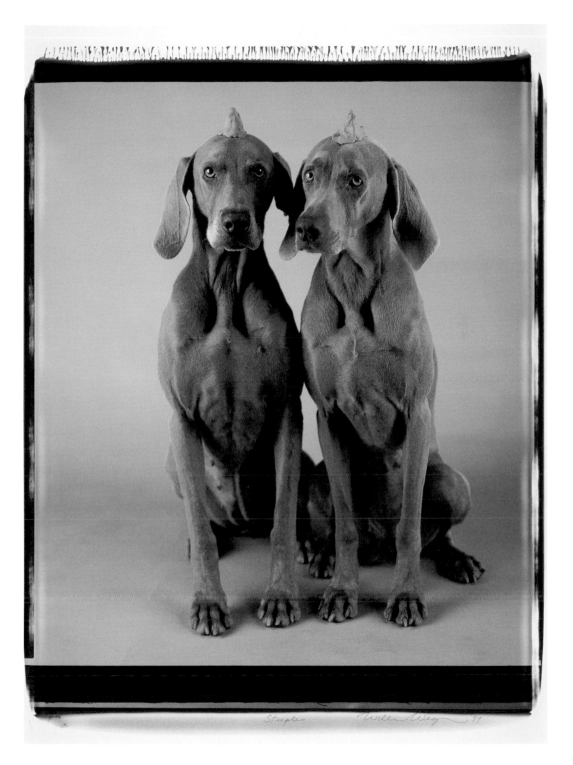

Steeples William Wegman 99

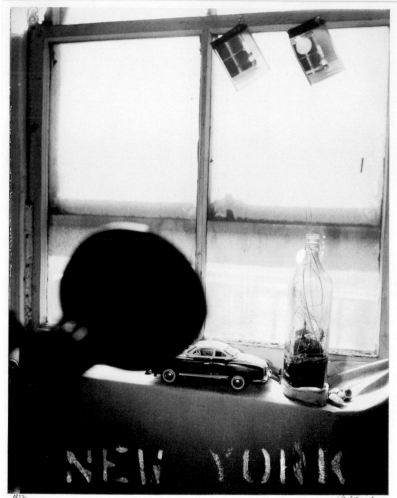

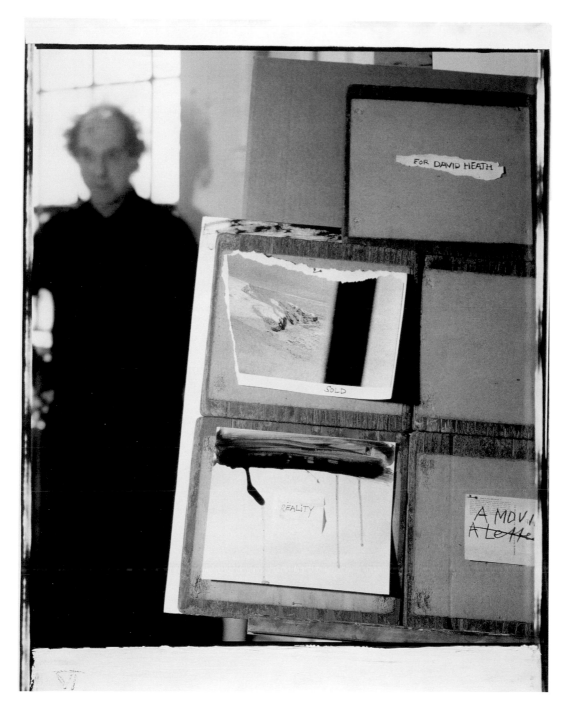

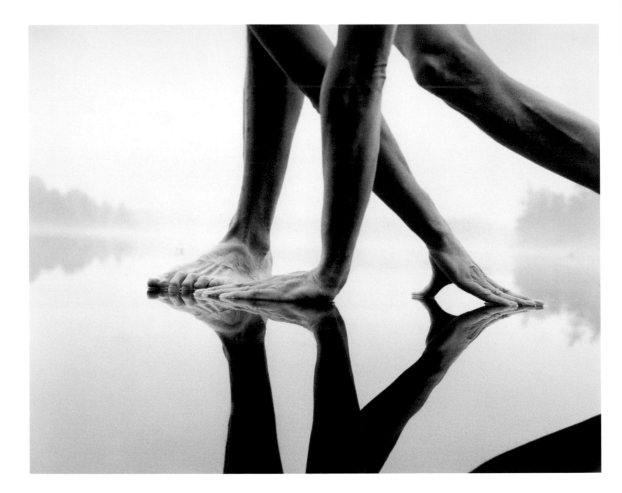

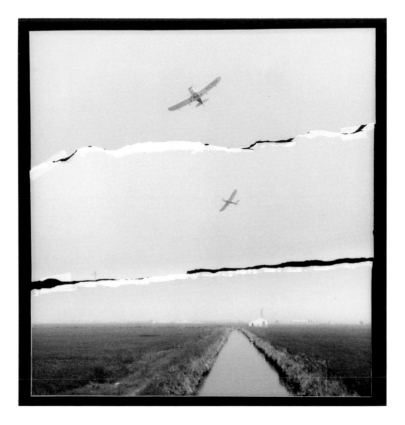

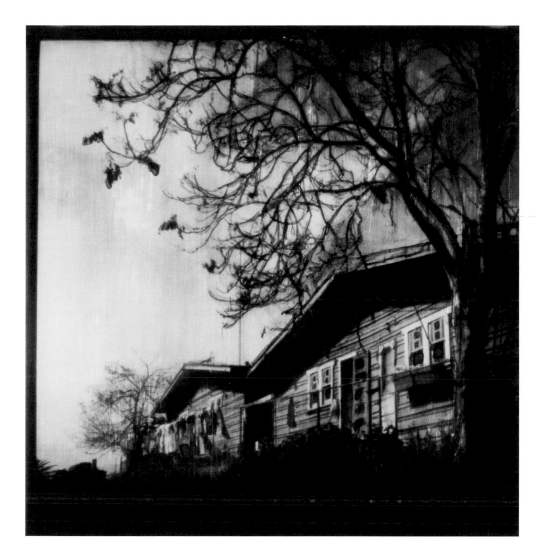

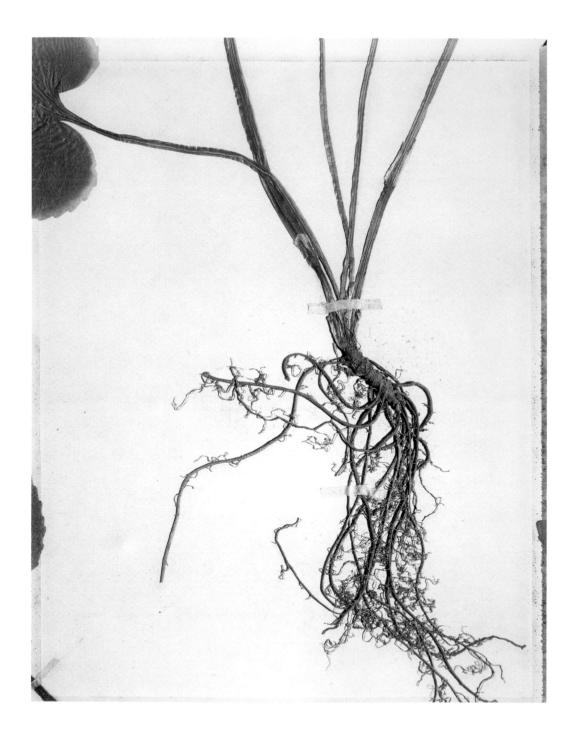

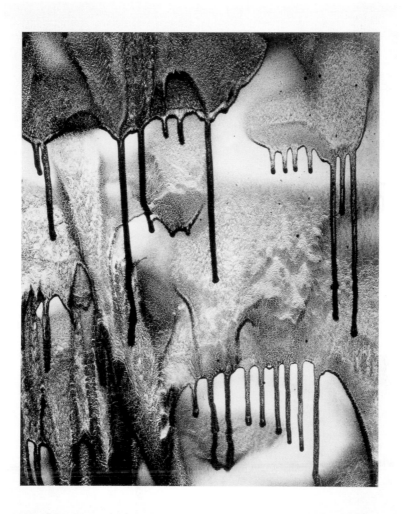

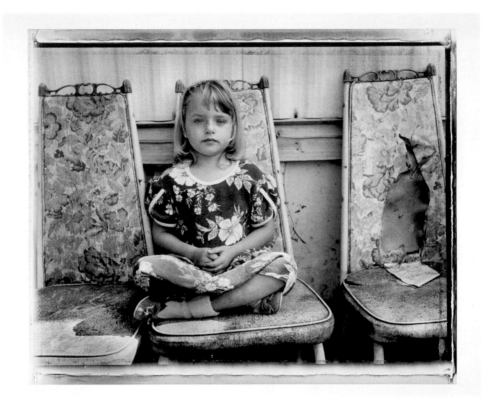

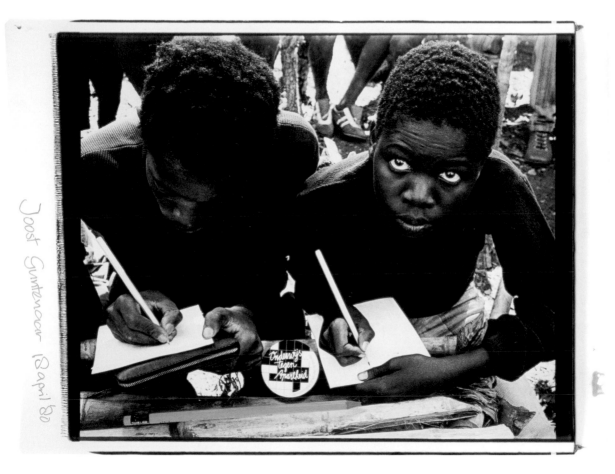

Joost Guntenaar 18april 80

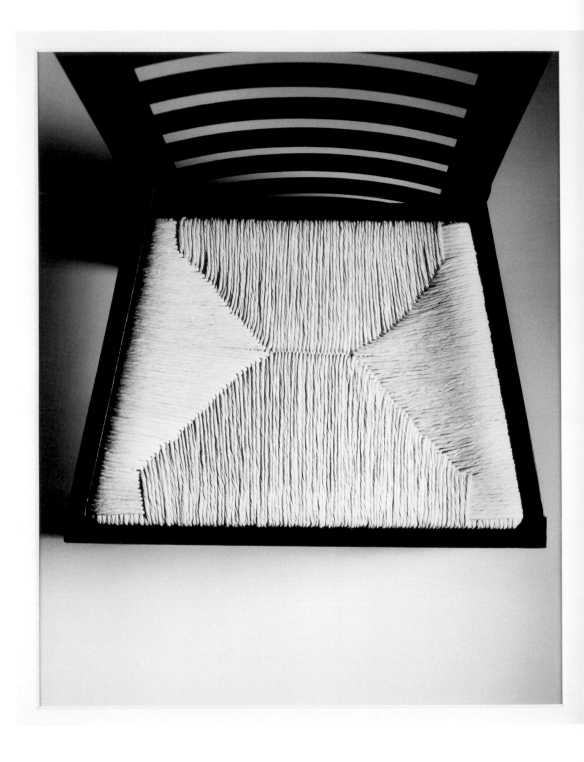

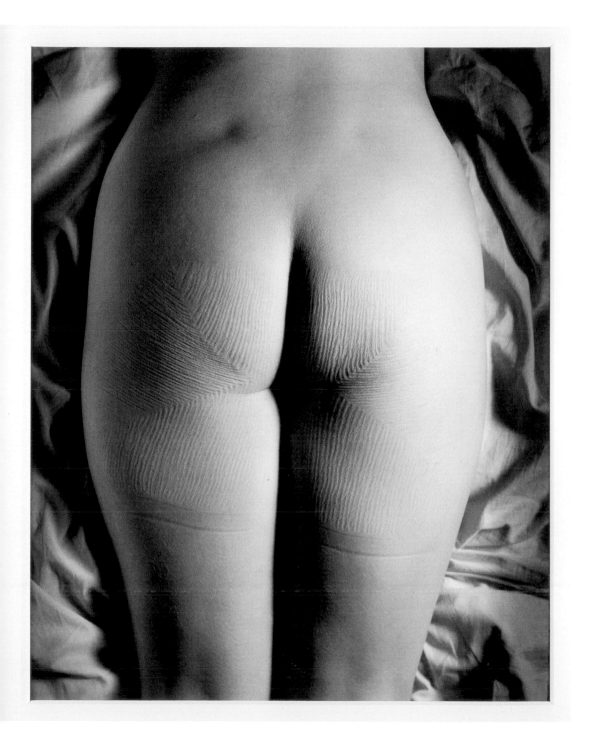

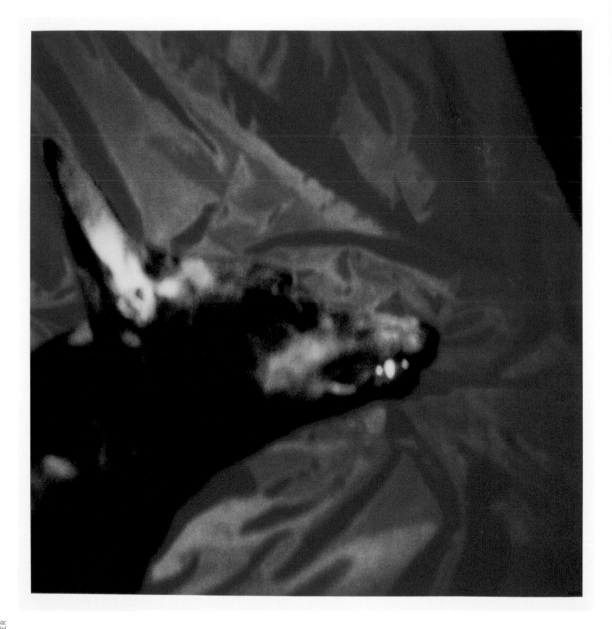

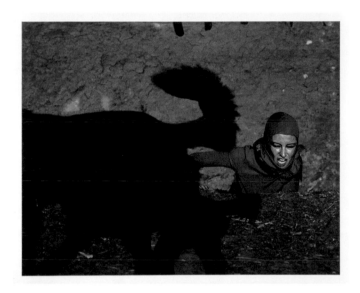

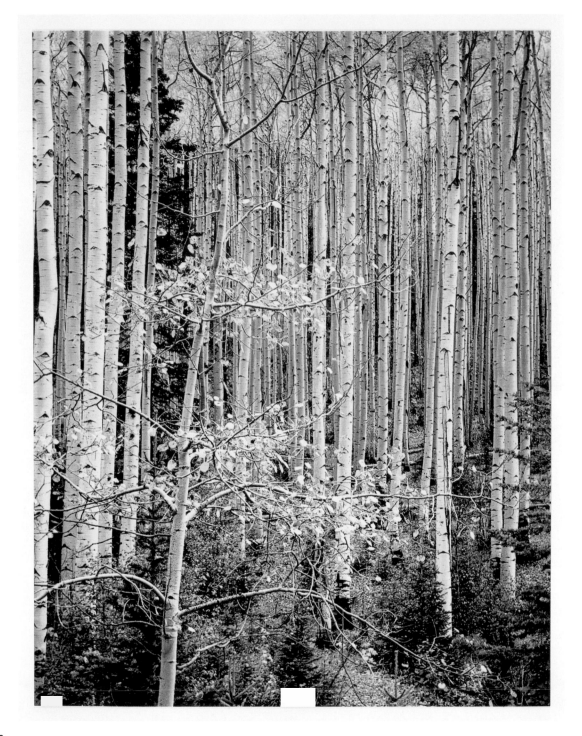

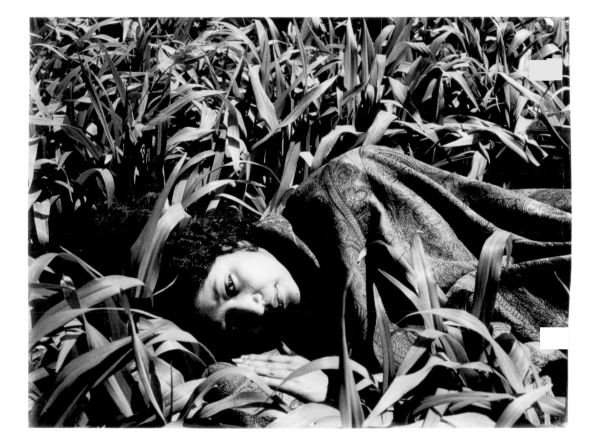

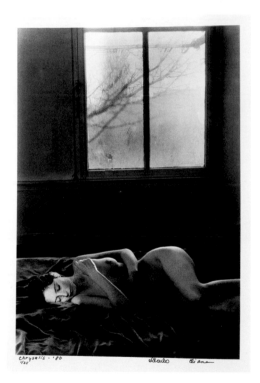

Chrysalis - '80
1/25

2c

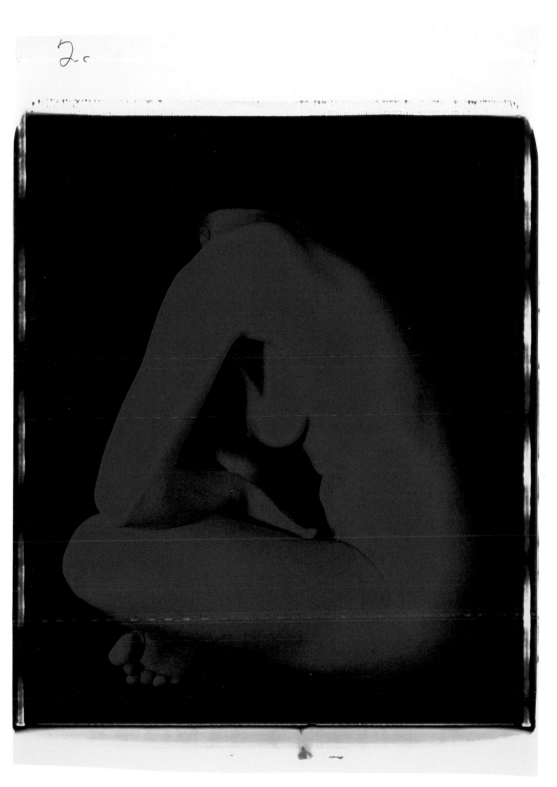

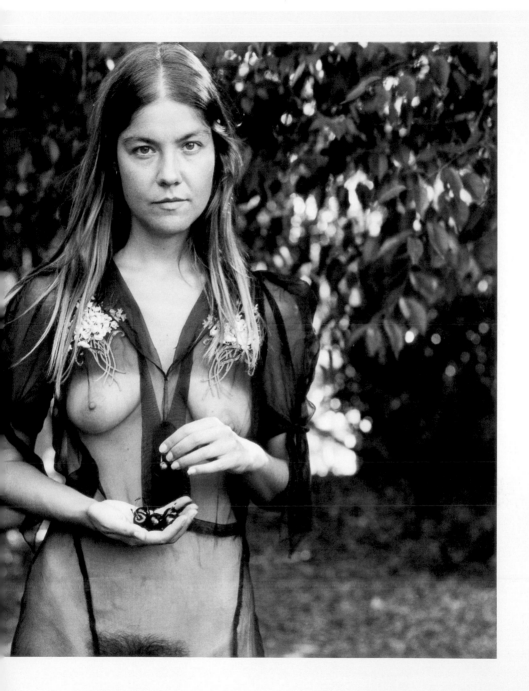

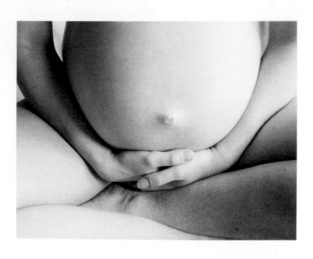

1979 Elliot Schildkrout made from Polaroid 55 P/N

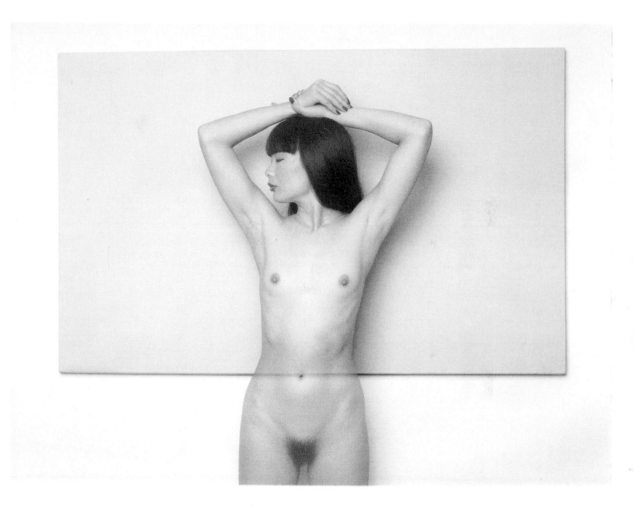

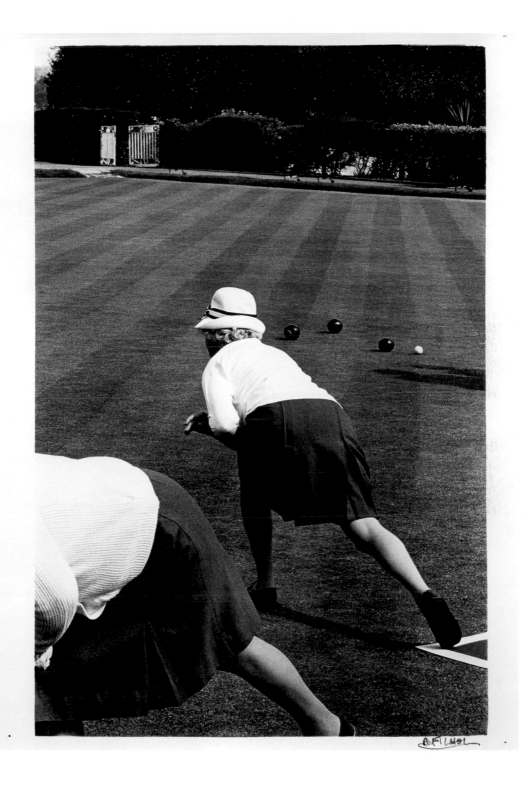

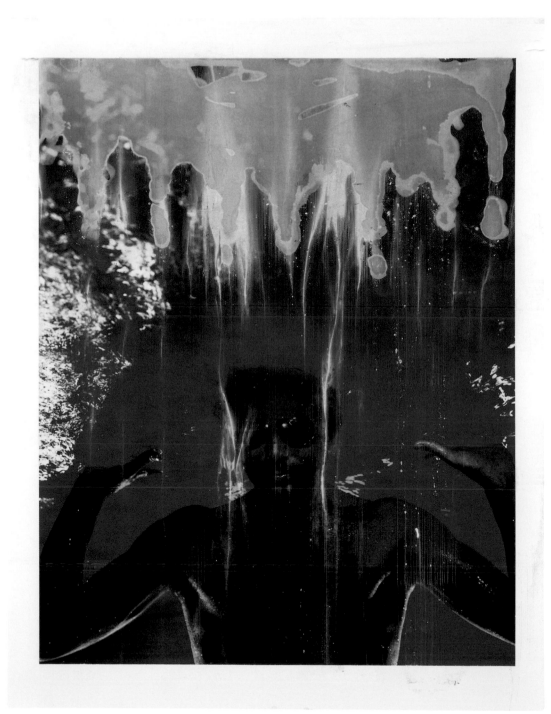

POLAROID CAMERAS

Polaroid cameras, using the patented process of Edwin H. Land, were the first commercially successful instant picture cameras that were easy to use and were not in need of bottles of chemicals, etc. The idea of in-camera development is not new; there are records of ideas for instant cameras from the first year of photography. In 1857, Bolles and Smith of Cooperstown, New York, patented the first instant camera that actually went into production. Jules Bourdin of France invented a simple system that was successfully marketed as early as 1864. Many other attempts met with mediocre success, but Polaroid caught on and became a household word. Because of the success of the company, their cameras generally are quite common, and obviously none are very old. There is more supply than demand for most models in the United States, but some of the early models sell better in Europe. We are listing them in order by number, rather than chronologically. We have not listed all of the models introduced after 1965, so this list is by no means a complete history of Polaroid cameras.

Polaroidkameras, bei denen das von Edwin H. Land patentierte Verfahren zur Anwendung kam, waren die ersten kommerziell erfolgreichen Sofortbildkameras, die benutzerfreundlich waren und keine Flaschen mit Chemikalien etc. erforderten. Die Idee der einstufigen Trockenentwicklung in der Kamera war nicht neu; es existieren Ideenskizzen für Sofortbildkameras aus dem Ursprungsjahr der Fotografie. 1857 ließen Bolles and Smith aus Cooperstown in New York die erste Sofortbildkamera patentieren, die auch tatsächlich hergestellt wurde. In Frankreich erfand Jules Bourdin ein einfaches System, das bereits 1864 erfolgreich vermarktet wurde. Viele andere Versuche auf diesem Gebiet waren nur von mäßigem Erfolg gekrönt, Polaroid jedoch setzte sich durch und wurde zum weltweit bekannten Markennamen. Da das Unternehmen so erfolgreich war, wurden seine Kameras im Allgemeinen in großer Stückzahl hergestellt, und sie sind natürlich durchweg nicht sehr alt. Bei den meisten Modellen ist in den USA das Angebot größer als die Nachfrage, doch einige der älteren Modelle lassen sich in Europa besser verkaufen. Wir führen sie hier nach Modellnummern geordnet auf und nicht chronologisch. Nicht alle nach 1965 auf den Markt gebrachten Kameras sind aufgeführt, weswegen diese Liste in keinster Weise eine vollständige Geschichte der Polaroidkamera darstellt.

La firme Polaroid fut la première à lancer sur le marché des appareils photographiques instantanés simples à utiliser. Fabriqués selon un procédé breveté par Edwin H. Land, ceux-ci permettaient de ne pas s'encombrer de flacons de produits divers. L'idée de développer le cliché à l'intérieur de l'appareil n'a pourtant rien de nouveau; elle semble être aussi vieille que la photographie elle-même. En 1857, l'entreprise de Bolles and Smith de Cooperstown, dans l'État de New York, breveta le tout premier appareil instantané jamais mis en fabrication. En France, Jules Bourdin inventa un système simple qui rencontra un certain succès commercial dès 1864. D'autre tentatives se soldèrent, pour la plupart, par un échec, jusqu'à l'arrivée de Polaroïd, qui rencontra vite un très grand succès. Celui-ci explique que les appareils de la compagnie soient aujourd'hui assez faciles à trouver. Pour des raisons évidentes, ils sont aussi relativement récents. Pour la plupart des modèles fabriqués aux États-Unis, l'offre dépasse la demande, même si les plus anciens se vendent souvent mieux en Europe. Les appareils ci-dessous sont classés par numéro et non chronologiquement. Cette liste n'est pas exhaustive car elle n'inclut pas les appareils lancés après 1965.

1. POLAROID 80 (HIGHLANDER) – 1954–57

The first of the smaller-sized Polaroid cameras. Grey metal body and hot shoe.
100 mm/f8.8 lens. Shutter ¹⁄₂₅–¹⁄₁₀₀ sec.

Die erste kleinere Polaroidkamera. Graues Metallgehäuse und Blitzschuh.
100 mm/f8,8-Objektiv. Belichtungszeiten ¹⁄₂₅–¹⁄₁₀₀ Sek.

Premier appareil Polaroid de format réduit. Boîtier et prise flash métalliques de couleur grise.
Objectif 100 mm/f8.8. Obturateur ¹⁄₂₅–¹⁄₁₀₀ sec.

2. POLAROID 80A (HIGHLANDER) – 1957–59

Like the 80, but with the shutter marked in the EV system.

Wie die 80, aber mit Belichtungsstufen-System (EV-System) auf dem Blendenring.

Semblable au modèle 80 à l'exception de l'obturateur, qui indique l'Indice de Lumination.

3. POLAROID 80B (HIGHLANDER) – 1959–61

Further improvement of the 80A with new cutter bar and film release switch.

Weiterentwicklung der 80A mit neuer Schneidevorrichtung und Filmauswurfknopf.

Version améliorée du modèle 80A, dotée d'un nouveau système de cutter intégré et de bouton éjecteur.

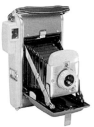

4. POLAROID 95 – 1948–53

The first of the Polaroid cameras that took the market by storm. Heavy cast-aluminum body, folding-bed style with brown leatherette covering. F11/135 mm lens. Folding optical finder with sighting post on the shutter housing. Diehard collectors like to distinguish between the early models with the flexible spring sighting post and the later ones with a rigid post.

Die allererste Polaroidkamera, die auf den Markt kam und ihn sofort im Sturm eroberte. Schweres Gehäuse aus Gussaluminium im Stil eines Klappbetts mit braunem Kunstleder-überzug. F11/135 mm-Objektiv. Ausklappbarer Sucher mit Fokussierstab am Verschluss-gehäuse. Akribische Sammler unterscheiden zwischen den frühen Modellen mit flexiblem Fokussierstab mit Feder und den späteren mit feststehendem Fokussierstab.

Tout premier appareil appareil Polaroïd, qui remporta un succès phénoménal. Boîtier massif en fonte d'aluminium gainé similicuir à rail pliant. Objectif f11/135 mm. Viseur optique avec tige de visée située sur le logement de l'obturateur. Les collectionneurs avertis distinguent les modèles plus anciens, équipés d'une tige flexible à ressort, des modèles plus tardifs, munis d'une tige rigide.

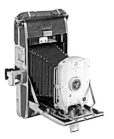

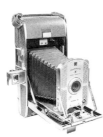

5. POLAROID 95A – 1954–57

Replaced the Model 95. Essentially the same but sighting post was replaced with a wire frame finder, X-sync added, and shutter speeds increased to $\frac{1}{12}$–$\frac{1}{100}$. 130 mm/f8 lens.

Ersetzte das Modell 95. Im Grunde baugleich, aber der Fokussierstab wurde durch einen Drahtsucher ersetzt, Blitzsynchronzeit neu, Belichtungszeiten verbessert auf $\frac{1}{12}$–$\frac{1}{100}$. 130 mm/f8-Objektiv.

Version modifiée du modèle 95. Il est grosso modo identique, si ce n'est que la tige de visée a été remplacée par un cadre iconomètre, que la synchro X a été rajoutée et que la vitesse d'obturation est passée de $\frac{1}{12}$ à $\frac{1}{100}$. Objectif 130 mm/f8.

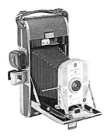

6. POLAROID 95B (SPEEDLINER) – 1957–61

Like the 95A, but the shutter is marked in the EV (Exposure Value) system, rather than the traditional speeds.

Wie die 95A, aber der Blendenring ist nicht in herkömmliche Blendenstufen eingeteilt, sondern in das EV-System (Belichtungsstufensystem).

Semblable au 95A, à l'exception de l'obturateur, qui indique l'IL (Indice de Lumination) et non les vitesses traditionnelles.

7. POLAROID 100 (ROLLFILM) – 1954–57 (NOT SHOWN)

(Do not confuse with the 1963 "Automatic 100" for pack film.) Industrial version of the 95A. Better roller bearings and heavy-duty shutter. Black covering.

(Nicht mit der „Automatic 100" für Packfilm von 1963 zu verwechseln.) Industrieversion der 95A. Bessere Schlittenlagerung und robuster Verschluss. Schwarzes Gehäuse.

(À ne pas confondre avec l' «Automatic 100» de 1963 fonctionnant avec des cartouches.) Version industrielle du 95 A. Châssis à pellicule plus performant, obturateur renforcé. Gainage noir.

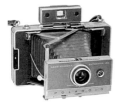

8. POLAROID 100 ("AUTOMATIC 100") – 1963–1966

An innovative, fully automatic transistorized electronic shutter made the world stand up and take notice once again that the Polaroid Corporation was a leader in photographic technology. In addition to the marvelous new shutter, Polaroid introduced a new type of film in a flat, drop-in pack that simplified loading. Furthermore, the photographs developed outside the camera so that exposures could be made in more rapid succession. Three-element f8.8/114 mm lens. Continuously variable speeds from 10 seconds to $\frac{1}{1200}$. RF/viewfinder unit hinged for compactness.

Ein innovativer, vollautomatischer, transistorisierter Elektronikverschluss brachte der Welt einmal wieder zu Bewusstsein, dass die Polaroid Corporation in fotografischer Technologie führend war. Zusätzlich zu dem fantastischen neuen Verschluss stellte Polaroid auch eine neue Art von Film in einer flachen, einschiebbaren Kassette vor („Packfilm"), die leichter geladen werden konnte. Außerdem entwickelten sich die Bilder außerhalb der Kamera, so dass in schnellerer Abfolge Fotos geschossen werden konnten. F8,8/14 mm-Objektiv mit drei Elementen. Stufenlos verstellbare Belichtungszeiten von 10 Sekunden bis $\frac{1}{1200}$. Das Sucher-/Entfernungsmesserelement hat ein Scharnier, mit dem es einklappbar und kompakt wird.

Avec son tout nouveau système d'obturateur électronique transistorisé et entièrement auto-matisé, ce modèle réaffirma aux yeux du monde entier la suprématic de la Polaroïd Corpo-ration en matière de technologie photographique. En plus de son obturateur génial, l'appareil fonctionnait avec un nouveau type de pellicule qui se présentait sous forme de cartouches plates, ce qui facilitait le chargement. Les photos étaient en outre développées à l'extérieur de l'appareil, de sorte qu'on pouvait réaliser des clichés en succession rapide. Objectif à trois éléments f8,8/114 mm. Vitesse à variation continue de 10 secondes à $\frac{1}{1200}$ de seconde. Compact grâce à son télémètre/viseur à charnière.

9. POLAROID 101 – 1964–67 (NOT SHOWN)

Similar to the Automatic 100, but only 2 film-speed settings (3,000 and 75) and 2 apertures (f/8.8 and f/42). A flash was required for indoor photos.

Vergleichbar mit Automatic 100, aber nur zwei Filmempfindlichkeitseinstellungen (ASA 3 000 und 75) und zwei Blenden (f/8,8 und f/42). Für Innenaufnahmen war ein Blitz notwendig.

Semblable à l'Automatic 100 mais avec seulement deux sensibilités de pellicule (3 000 et 75) et deux ouvertures (f/8.8 et f/42). L'appareil nécessitait un flash pour les photos d'intérieur.

10. POLAROID 102 – 1964–67 (NOT SHOWN)

This was a special markets version of the Polaroid 101.

Eine Sonderanfertigung der Polaroid 101 für Nischenmärkte.

Version du Polaroïd 101 pour les marchés spéciaux.

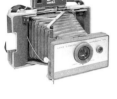

11. POLAROID 103 – 1965–67

Similar to the Polaroid 101, but plastic body and no tripod socket.

Mit der Polaroid 101 vergleichbar, Gehäuse jedoch aus Plastik und kein Stativgewinde.

Semblable au Polaroïd 101, mais avec un boîtier en plastique et sans fixation trépied.

12. POLAROID 104 – 1965–67

Similar to the Polaroid 103, but 2-element plastic lens. Also simplified "image sizer" rangefinder combined with a non-folding viewfinder. Plastic body and shutter housing, limited use of acces-sories.

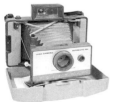

Mit der Polaroid 103 vergleichbar, aber Kunststoffobjektiv mit zwei Elementen. Neu ist außerdem ein vereinfachter „Bildsucher", ein mit einem feststehenden Sucher verbundener Entfernungsmes-ser. Kamera- und Verschlussgehäuse aus Kunststoff, begrenzte Verwendungsmöglichkeiten von Zubehör.

Semblable au Polaroïd 103, mais avec un objectif en plastique à deux éléments. L'appareil était aussi muni d'un télémètre « calibreur » simplifié combiné à un viseur sans soufflet. Boîtier et loge-ment de l'obturateur en plastique. Ne pouvait s'utiliser qu'avec un nombre limité d'accessoires.

13. POLAROID 125 – 1965–67 (NOT SHOWN)

Special markets version of the Polaroid 104.

Eine Sonderanfertigung der Polaroid 104 für Nischenmärkte.

Version du Polaroïd 104 pour marchés spéciaux.

14. POLAROID 135 – 1965–67 (NOT SHOWN)

Special markets version of the Polaroid 103.

Eine Sonderanfertigung der Polaroid 103 fur Nischenmärkte.

Version du Polaroïd 103 pour marchés spéciaux.

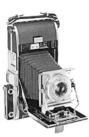

15. POLAROID 110 (PATHFINDER) – 1952–57

Wollensak Raptar f4.5/127 mm lens and coupled rangefinder. Shutter 1–¼₀₀ sec.

F4,5/127 mm-Wollensak-Raptar-Objektiv mit verbundenem Entfernungsmesser. Belichtungszeiten 1–¼₀₀ Sek.

Objectif Wollensak Raptar de f4.5/127 mm et télémètre couplé. Obturateur à 1–¼₀₀ de seconde.

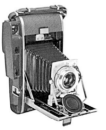

16. POLAROID 110A (PATHFINDER) – C1957–60

Improved version of the 110. Rodenstock Ysarex or Enna-Werk Ennit f4.7/127 mm lens in Prontor SVS 1–⅓₀₀ shutter. Special lens cap with f/90 aperture added in 1959 for the new 3,000 speed film. Charcoal covering.

Verbesserte Ausgabe der Polaroid 110. F4,7/127 mm-Objektiv: Rodenstock Ysarex oder Enna-Werk Ennit mit Prontor-SVS-Verschluss. 1–⅓₀₀ Sek. Belichtungszeiten. Besondere Objektivkappe mit der Blendenöffnung f/90 wurde ab 1959 für den neuen 3000 ASA–Film mitgeliefert. Graphit-graues Gehäuse.

Version améliorée du modèle 110. Objectif f4,7/127 mm de marque Rodenstock Ysarex ou Enna-Werk Ennit, obturateur Prontor SVS à 1–⅓₀₀. Bouchon d'objectif rajouté en 1959 permettant d'obtenir une ouverture de f/90 pour les nouvelles pellicules à 3000 ASA. Gainage anthracite.

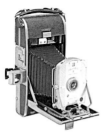

17. POLAROID 110B (PATHFINDER) – 1960–64

Like the 110A, but with single-window range/viewfinder. These professional models can be converted to pack film.

Wie die 110A, aber mit einem einzigen Fenster, das Sucher und Entfernungsmesser vereint. Diese Profimodelle können auf Packfilm umgestellt werden.

Semblable au modèle 110A, mais doté d'un télémètre/viseur à fenêtre unique. Ce type de modèle professionnel peut être converti de manière à fonctionner avec des cartouches.

18. POLAROID 120 – 1961–65 (NOT SHOWN)

Made in Japan by Yashica. Similar to the 110A, but with Yashica f4.7/127 mm lens in Seikosha SLV shutter. 1–500 B. Self-timer. Coupled rangefinder. Not as common in the USA as the other models, because it was made for foreign markets.

In Japan von Yashica hergestellt. Vergleichbar mit der 110A, aber mit f4,7/127 mm-Yashica-Objektiv und Seikosha-SLV-Verschluss. 1–500 B. Selbstauslöser. Kein separater Entfernungsmesser. In den USA nicht so verbreitet wie andere Modelle, da sie für den internationalen Markt produziert wurde.

Fabriqué au Japon par Yashica. Semblable au 110 A mais équipé d'un objectif Yashica de f4.7/127 mm et d'un obturateur Seikosha SLV. 1–500 B. Retardateur. Télémètre couplé. Fabriqué pour le marché étranger, il est moins répandu aux États-Unis que les autres modèles.

19. POLAROID 150 – 1957–60

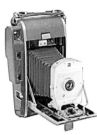

Similar to the 95B with EV system, but also including CRF with focus knob below bed, parallax correction, and hot shoe. Charcoal grey covering.

Vergleichbar mit dem Modell 95B mit EV-System, zusätzlich jedoch CRF mit Fokussierknopf unten, Parallaxenkorrektur und Blitzschuh. Graphitgraues Gehäuse.

Semblable au 95 B à système EV, mais également équipé d'un télémètre couplé avec bouton de mise au point situé sous le rail, correction de parallaxe et prise de flash. Gainage gris anthracite.

20. POLAROID 160 – 1962–65

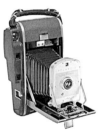

Japanese-made version of the 150 for international markets.

In Japan für den internationalen Markt hergestellte Version der 150.

Version du modèle 150 fabriquée au Japon pour les marchés internationaux.

21. POLAROID 180 – 1965–69 (NOT SHOWN)

Professional model pack camera made in Japan. Tominon f4.5/114mm lens in Seiko shutter 1–1/500 with self-timer. Zeiss-Ikon range/viewfinder. This camera has retained its value as a usable professional camera.

Professionelle, in Japan hergestellte Packkamera. Tominon f4,5/114 mm-Objektiv und Seiko-Verschluss. 1–1/500 mit Selbstauslöser. Zeiss-Ikon Sucher/Entfernungsmesser. Diese Kamera hat ihren Wert als immer noch einsetzbare Profikamera behalten.

Modèle professionnel à cartouches fabriqué au Japon. Objectif Tominon de f4,5/114 mm, obturateur Seiko de 1–1/500 à minuterie. Télémètre/viseur Zeiss-Ikon. Ce modèle est encore utilisé comme appareil professionnel.

22. POLAROID 185 – 1965–69 (NOT SHOWN)

Sold only in Japan. Mamiya Sekor f5.6 lens. CdS meter. Combined electronic and mechanical "trapped-needle" auto exposure with manual override. Reportedly only about 30 made. Rare.

Verkauf nur in Japan. F5,6-Mamiya-Sekor-Objektiv. CdS-Belichtungsmesser. Kombinierte mechanische und elektronische Automatikbelichtung mit manueller Belichtungskorrektur. Angeblich wurden nur 30 Stück hergestellt. Rarität.

Vente au Japon uniquement. Objectif Mamiya Sekor f5,6. Photomètre CdS. L'exposition est à la fois mécanique et électronique : elle se fait automatiquement au moyen d'une aiguille mais peut aussi être réglée à la main. Il semblerait qu'une trentaine d'exemplaires seulement en ait été fabriqués. Rare.

23. POLAROID 190 – EUROPEAN VERSION OF MODEL 195 (NOT SHOWN)

Zeiss finder, f3.8 lens. Electronic development timer.

Zeiss-Sucher, f3,8-Objektiv. Elektronischer Entwicklungszeit-Timer.

Viseur Zeiss, objectif f3,8. Le développement se fait grâce à une minuterie électronique.

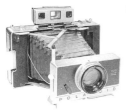

24. POLAROID 195

Like the Model 180, but Tominon f3.8/114 mm lens instead of f4.5. Albada finder like the Model 100. Mechanical wind-up development timer.

Wie Modell 180, aber mit f3,8/114 mm-Tominon-Objektiv statt f4,5. Albada-Sucher wie bei Modell 100. Mechanischer Entwicklungszeit-Timer zum Aufziehen.

Semblable au modèle 180, mais avec un objectif Tominon de f3,8/114 mm au lieu de f4,5. Le viseur Albada est le même que celui du modèle 100. Le développement se fait grâce à une minuterie mécanique à ressort.

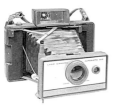

25. POLAROID AUTOMATIC 210 – 1967–69

Similar to the Automatic 104. Lightest model weighing only 37 ½ ounces.

Ähnliches Modell wie Automatic 104. Die mit 1 063 Gramm leichteste Kamera.

Semblable à l'Automatic 104. Avec son poids de 1063 grammes, ce modèle était le plus léger.

26. POLAROID AUTOMATIC 220 – 1967–69

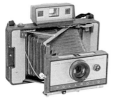

Similar to the Automatic 230, but 2-element plastic lens and non-folding rangefinder/viewfinder. Had limited accessory capabilities.

Ähnlich der Automatic 230, aber mit Kunststoffobjektiv mit zwei Elementen und ohne einklappbaren Sucher/Entfernungsmesser. Zubehör war nur begrenzt einsetzbar.

Semblable à l'Automatic 230, à l'exception de son objectif plastique à deux éléments et de son télémètre/viseur sans soufflet. Ne pouvait s'utiliser qu'avec un nombre limité d'accessoires.

27. POLAROID AUTOMATIC 230 – 1967–69 (NOT SHOWN)

Similar to the Automatic 240, but plastic body, no tripod socket. Plastic 3-element f8.8 lens. Folding rangefinder/viewfinder.

Ähnlich der Automatic 240, aber mit Plastikgehäuse und ohne Stativgewinde. F8,8-Kunststoffobjektiv mit drei Elementen. Einklappbarer Sucher/Entfernungsmesser.

Semblable à l'Automatic 240, mis à part son boîtier en plastique et son absence de fixation trépied. Objectif plastique à trois éléments f8.8. Télémètre/viseur à soufflet.

28. POLAROID AUTOMATIC 240 – 1967–69 (NOT SHOWN)

Similar to the Automatic 230, but metal body with tripod socket. Plastic 3-element f8.8 lens. Folding rangefinder/viewfinder. CdS electronic shutter to $\frac{1}{1200}$.

Ähnlich der Automatic 230, aber Metallgehäuse mit Stativgewinde. F8,8-Kunststoffobjektiv mit drei Elementen. Einklappbarer Sucher/Entfernungsmesser. Elektronischer CdS-Verschluss bis $\frac{1}{1200}$.

Semblable à l'Automatic 230, à l'exception de son boîtier métallique et de sa fixation trépied. Objectif plastique f.8.8 à trois éléments. Télémètre/viseur à soufflet. Obturateur électronique CdS à $\frac{1}{1200}$.

29. POLAROID AUTOMATIC 250 – 1967–69

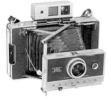

Similar to the Automatic 100, but had Zeiss-Ikon single window combined viewfinder/rangefinder. Able to use all of the available accessories.

Ähnlich der Automatic 100, aber mit kombiniertem Sucher und Entfernungsmesser aus Zeiss-Ikon-Glas. Alles erhältliche Zubehör ist verwendbar.

Semblable à l'Automatic 100, mais avec un viseur/télémètre combiné à fenêtre unique Zeiss-Ikon. Compatible avec tous les accessoires de la gamme.

30. POLAROID AUTOMATIC 320 – 1969–71

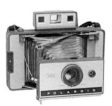

Body and lens same as Automatic 330, but 2-element plastic lens. No built-in development timer. This was the lowest-priced folding pack camera and had limited accessory capability.

Gehäuse und Objektiv wie bei der Automatic 330, aber Kunststoffobjektiv mit zwei Elementen. Kein eingebauter Entwicklungszeit-Timer. Dies war die preisgünstigste zusammenklappbare Pack-Kamera, Zubehör war nur begrenzt einsetzbar.

Même boîtier et objectif que l'Automatic 330, à ceci près que ce dernier est en plastique et composé de deux éléments. Pas de minuterie intégrée pour le développement. Ce modèle était le plus économique des appareils à soufflet à cartouches, et ne pouvait s'utiliser qu'avec un nombre limité d'accessoires.

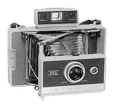

31. POLAROID AUTOMATIC 330 – 1969–71

Lens and body of the Automatic 340 but only 2 film speed settings and 2 apertures (f/8.8 and f/42). Built-in mechanical development timer. Single exposure range for black-and-white or color. Non-folding viewfinder/rangefinder. Had limited accessory capability as well.

Gehäuse und Objektiv wie bei der Automatic 340, aber nur zwei Filmempfindlichkeitseinstellungen und zwei Blendenöffnungen (f/8,8 und f/42). Eingebauter mechanischer Entwicklungszeit-Timer. Einzelbelichtungsspielraum für Schwarzweiß und Farbe. Kein einklappbarer Sucher/ Entfernungsmesser, Zubehör war ebenfalls nur begrenzt einsetzbar.

Même objectif et boîtier que l'Automatic 340, mais n'avait que deux sensibilités de pellicule et deux ouvertures (f/8.8 et f/42). Minuterie mécanique intégrée pour le développement. Plage d'exposition unique en noir et blanc ou en couleur. Viseur/télémètre sans soufflet. Comme l'appareil précédent, ce modèle ne pouvait s'utiliser qu'avec un nombre limité d'accessoires.

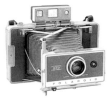

32. POLAROID AUTOMATIC 340 – 1969–71

Like the Automatic 230, but had built-in mechanical development timer. Able to use all available accessories.

Wie die Automatic 230, aber mit eingebautem mechanischem Entwicklungszeit-Timer. Alles erhältliche Zubehör ist verwendbar.

Semblable à l'Automatic 230, mais avec une minuterie mécanique intégrée pour le développement. Compatible avec tous les accessoires disponibles.

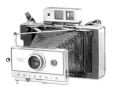

33. POLAROID AUTOMATIC 350 – 1969–71

Similar to the Automatic 250, but had automatic electronic development timer. Also able to use all accessories.

Ähnlich der Automatic 250, aber mit automatischem elektronischem Entwicklungszeit-Timer. Alles erhältliche Zubehör ist ebenfalls verwendbar.

Semblable à l'Automatic 250, mais avec une minuterie automatique électronique pour le développement. Cet appareil était lui aussi compatible avec tous les accessoires.

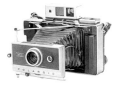

34. POLAROID AUTOMATIC 360 – 1969–71

The first camera with electronic flash unit with automatic flash exposure control coupled to the rangefinder. Rechargeable nickel-cadmium battery; charger supplied with the camera. Similar to the Automatic 250 except: improved shutter, smallest aperture is f/60, electronic development timer starts when yellow film tab is pulled out of camera.

Die erste Kamera mit speziellem, aufsetzbarem Elektronikblitz. Die Blitzlichtbelichtung wird automatisch über den Entfernungsmesser gesteuert. Wiederaufladbare Nickel-Cadmium-Batterie, Ladegerät wird mit der Kamera mitgeliefert. Vergleichbar mit der Automatic 250, jedoch: verbesserter Verschluss, kleinste Blende ist f/60; elektronischer Entwicklungszeit-Timer startet, wenn gelbe Filmlasche aus der Kamera gezogen wird.

Premier appareil photo muni d'un système de flash et d'un système de contrôle de l'exposition au flash intégré au télémètre. Batterie rechargeable au nickel cadmium ; chargeur fourni avec l'appareil. Semblable à l'Automatic, mais avec un obturateur amélioré et une ouverture minimale de f/60. La minuterie électronique pour le développement s'enclenche lorsqu'on tire sur la languette jaune.

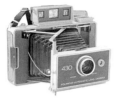

35. POLAROID AUTOMATIC 420 – 1971

Similar to the Automatic 320 except different flash system.

Wie die Automatic 320, nur mit anderem Blitzsystem.

Semblable à l'Automatic 320 mais avec un système de flash différent.

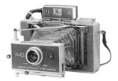

36. POLAROID AUTOMATIC 430 – 1971–77

Similar to Automatic 330 except different flash system.

Wie die Automatic 330, nur mit anderem Blitzsystem.

Semblable à l'Automatic 330 mais avec un système de flash différent.

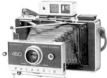

37. POLAROID AUTOMATIC 440 – 1971–76

Similar to the Automatic 340 but different flash system.

Wie die Automatic 340, nur mit anderem Blitzsystem.

Semblable à l'Automatic 340 mais avec système de flash différent.

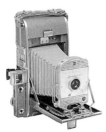

38. POLAROID AUTOMATIC 450 – 1971–74

Similar to the Automatic 350 but had different flash system.

Wie die Automatic 350, nur mit anderem Blitzsystem.

Semblable à l'Automatic 350 mais avec un système de flash différent.

39. POLAROID 415 (NOT SHOWN)

Variation of the Swinger Model 20.

Variante des Swinger-Modells 20.

Variante du modèle Swinger 20.

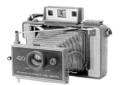

40. POLAROID 700 – 1955–57

Uncoupled rangefinder version of the 95A. Grey leatherette covering.

Version der 95A mit separatem Entfernungsmesser. Grauer Kunstlederüberzug.

Version du modèle 95A à télémètre non couplé. Gainage en similicuir gris.

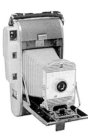

41. POLAROID 800 – 1957–62

All the features of the 150, but with carefully selected lens, electronically tested shutter, and permanently lubricated roller bearings.

Sämtliche Merkmale der 150, aber mit sorgfältig ausgewähltem Objektiv, elektronisch getestetem Verschluss und permanent gefetteter Schlittenlagerung.

Toutes les caractéristiques du modèle 150. Son objectif était en outre soigneusement sélectionné, son obturateur testé de manière électronique et ses châssis à pellicules bénéficiaient d'une lubrification constante.

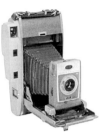

42. POLAROID 850 – 1961–63

Similar to the 900 below, but with dual-eyepiece rangefinder and viewfinder.

Vergleichbar mit untenstehender 900, aber mit zweiäugigem Sucher und Entfernungsmesser.

Semblable au modèle 900 ci-dessous, à l'exception de son télémètre/viseur à deux oculaires.

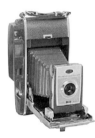

43. POLAROID 900 – 1960–63

The first Polaroid with fully automatic electric-eye controlled shutter. Continuously variable shutter speeds of $\frac{1}{12}$–$\frac{1}{600}$ and apertures of f/8.8-f/82.

Die erste Polaroid mit vollautomatischer Belichtungssteuerung („Electric Eye"). Stufenlos verstellbare Belichtungszeiten von $\frac{1}{12}$–$\frac{1}{600}$ und Blendenöffnungen von f/8,8–f/82.

Premier appareil Polaroïd à être équipé d'un obturateur entièrement commandé par une cellule photo-électrique. Vitesse de l'obturateur et ouverture en variation continue, respectivement de $\frac{1}{12}$ à $\frac{1}{600}$ et de f/8,8 à f/82.

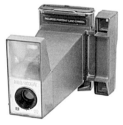

44. BIG SHOT – 1971–73

Unusually-designed pack-film camera for close-up portraits at a fixed distance of one meter. Since the lens is fixed focus, the rangefinder functions only to position the operator and subject at the correct distance. Built-in socket and diffuser for X-cubes.

Ungewöhnlich aussehende Packfilm-Kamera für Porträtaufnahmen im festen Abstand von einem Meter. Da das Objektiv einen Fix-Fokus hat, dienen die Entfernungsmesserfunktionen nur dazu, Fotograf und Motiv in korrekter Entfernung zu positionieren. Eingebauter Schuh und Diffusor für Blitzwürfel.

Appareil à cartouches au design insolite, prévu pour réaliser des portraits en gros plan à une distance d'un mètre. Étant donné que l'appareil est à foyer fixe, le télémètre ne sert qu'à indiquer la distance entre le photographe et son sujet. Prise et diffuseur intégrés pour Magicubes.

45. CAMEL (NOT SHOWN)

Special version of the Model 640, made in England for Camel Cigarettes. Used as a prize in a contest among vending machine suppliers in Germany. Uncommon.

Spezialversion von Modell 640, in England für Camel-Zigaretten hergestellt. Kam als Gewinn bei einem Preisausschreiben für Automatenbefüller in Deutschland zur Verwendung. Selten.

Version spéciale du modèle 640 fabriquée en Angleterre pour la marque de cigarettes Camel. L'appareil fut offert comme prix lors d'un concours qui s'adressait à des fabricants allemands de distributeurs automatiques. Peu répandu.

46. COUNTDOWN 90 – C.1971 (NOT SHOWN)

Folding filmpack camera with grey plastic body. Double-window finder, slide-on flash shoe, electronic timer on back.

Zusammenklappbare Filmpack-Kamera mit grauem Plastikgehäuse. Sucher mit Doppelfenster, aufschiebbarem Blitzschuh und elektronischem Timer auf der Rückseite.

Appareil pliant à cartouches à boîtier en plastique gris. Viseur à double fenêtre, prise flash à coulisse, minuterie électronique sur le dos.

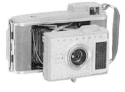

47. POLAROID J-33 – 1961–63

Newly-styled electric-eye camera to replace the "80" series. Still using the 30 series double-roll films for 6x8 cm pictures.

Kamera mit vollautomatischer Belichtungssteuerung im neuen Design, die die 80er-Serie ersetzt. Der doppelte Rollfilm der 30er-Serie für 6x8 cm-Bilder wird nach wie vor verwendet.

Cet appareil de style nouveau à cellule photo-électrique a remplacé la série «80». Il fonctionnait encore avec les pellicules à doubles rouleaux de la série 30 qui produisaient des photos de 6x8 cm.

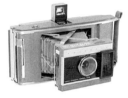

48. POLAROID J-66 – 1961–63

Newly-styled electric-eye camera, with simple f/19 lens. Tiny swing-out flash for AG-1 bulbs.

Kamera mit vollautomatischer Belichtungssteuerung im neuen Design mit einfachem f/19-Objektiv. Winziger, ausklappbarer Blitz für AG-1-Birnchen.

Appareil de style nouveau à cellule photo-électrique équipé d'un objectif simple de f/19. Minuscule flash rétractable à ampoules AG-1.

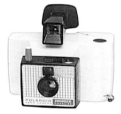

49. SWINGER MODEL 20 – 1965–70

White plastic camera for B&W photos on Type 20 roll film, the first roll film to develop outside the camera. If this is not the most common camera in the world, it certainly must be near the top of the list.

Weiße Kunststoffkamera für Schwarzweißbilder auf dem Typ-20-Rollfilm, dem ersten Rollfilm, der sich außerhalb der Kamera entwickelt. Dieses Modell belegt in der Liste der gebräuchlichsten Kameras der Welt einen der vorderen Plätze.

Appareil en plastique blanc réalisant des photos noir et blanc sur de la pellicule en rouleau de type 20 – première pellicule en rouleau à se développer en dehors de l'appareil. L'un des appareils les plus répandus au monde – sinon le plus courant.

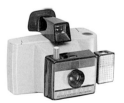

50. SWINGER SENTINEL M15 1966-70

Variation of the Swinger Model 20. Lacks built-in flash.

Variante des Swinger-Modells 20. Kein eingebauter Blitz.

Variante du modèle Swinger 20. Pas de flash intégré.

POLAROID CAMERAS

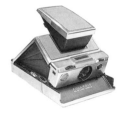

51. SX-70 (DELUXE MODEL) – 1972–77

The original SX-70 camera. Ingeniously designed folding SLR that ushered in a new era of instant photography. The miracle was watching the colored photo slowly appear in broad daylight after being automatically ejected from the camera. The technical and esthetic marvel was the compact machine that fit easily into a coat pocket. The basic folding design was not new. Perhaps one of Polaroid's engineers had seen the circa 1905 "Excentric" camera of R. Guénault, which is surprisingly similar. But Guénault would never have dreamed of an even more compact camera incorporating SLF focusing to 10½ inches, automatic exposure up to 14 seconds, and motorized print-ejection, all powered by a disposable flat battery hidden in the film pack. This is a landmark camera, but quite common because it was so popular.

Die originale SX-70-Kamera. Genial konstruierte, zusammenklappbare Spiegelreflexkamera, die eine neue Ära der Sofortbildfotografie einleitete. Zuzusehen, wie das Farbfoto langsam bei hellem Tageslicht sichtbar wurde, nachdem die Kamera es automatisch ausgeworfen hatte, war verblüffend. An ein technisches und ästhetisches Wunder grenzte die Kompaktheit des Fotoapparates, der problemlos in eine Jackentasche passte. Das Klappdesign war im Grunde nicht neu. Vielleicht hatte einer der Polaroid-Ingenieure die „Excentric"-Kamera von R. Guénault aus der Zeit um 1905 gesehen, die erstaunliche Ähnlichkeiten mit der SX-70 aufweist. Doch Guénault hätte sich nie träumen lassen, dass es einmal eine noch kompaktere Kamera geben würde mit Fokussierung durchs Objektiv bis auf 26 Zentimeter Nähe, mit automatischer Belichtung bis 14 Sekunden und motorgetriebenem Bildauswurf, all das betrieben von einer flachen Einmalbatterie, die sich im Filmpack versteckte. Diese Kamera war ein Meilenstein der Fotografie, und wegen ihrer Beliebtheit war sie weit verbreitet.

Tout premier appareil SX-70. Son boîtier reflex pliant mono-objectif révolutionna la photographie instantanée. La photographie en couleur était automatiquement éjectée de l'appareil et se développait peu à peu en plein jour, comme par miracle. La taille compacte de l'appareil, qui se glissait facilement dans une poche, était une véritable prouesse technique et esthétique. Le concept de base de ce modèle pliant n'a pourtant rien de nouveau : il n'est pas exclu qu'un ingénieur de chez Polaroid se soit inspiré du modèle « Excentric » créé par R. Guénault aux alentours de 1905, qui lui ressemble de manière frappante. Mais jamais Guénaut n'aurait pu imaginer un modèle aussi compact pouvant faire la mise au point à un peu plus de 25 cm, dont l'exposition automatique pouvait aller jusqu'à 14 secondes, et équipé d'un moteur pour éjecter le cliché, le tout actionné par une pile plate jetable dissimulée dans la cartouche de pellicule. Véritable jalon dans l'histoire de la photographie, cet appareil est assez répandu en raison du grand succès qu'il rencontra.

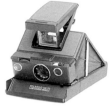

52. SX-70 MODEL 3 – 1975–78

Simplified model without SLR viewing.

Vereinfachtes Modell mit Sucher, keine Spiegelreflexkamera.

Modèle simplifié sans reflex mono-objectif.

Adams, Ansel
Yosemite Fall
1966
T-55 Film
© Photograph by Ansel Adams. Used with permission of the Trustees of the Ansel Adams Publishing Rights Trust. All rights reserved.
p. 125

Adamson, Valene
(In Studio)
year unknown
T-665 Film
© Valene Adamson
p. 192

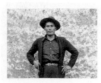

Alexanian, Nubar
Peru
1974
T-52 Film
© Nubar Alexanian
p. 174

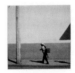

Allard, William Albert
Oaxaca, Mexico
1980
SX-70 Time Zero Film
© William Albert Allard
p. 35

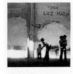

Allard, William Albert
Oaxaca, Mexico
1980
SX-70 Time Zero Film
© William Albert Allard
p. 69

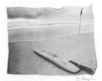

Anzai, Eiichi
Memories
May 1999
T-559 Film
© Eiichi Anzai
p. 120

Aschkenas, David
Nude in Tub
1980
SX-70 Time Zero Film
© David Aschkenas
p. 45

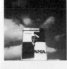

Assman, Ingrid
(Cigarettes, Panama)
year unknown
SX-70 Time Zero Film
© Ingrid Assman
p. 28

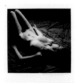

Auerbacher, Dominique
Ma cousine
Paris, 1981
SX-70 Time Zero Film
© Dominique Auerbacher, Paris 1981
p. 44

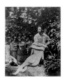

Baden, Karl
Drowned Woman (Bayard)
1989
T-55 Film
© Karl Baden
p. 108

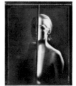

Banka, Pavel
Vertical Constructions
1985
T-55 Film
© Pavel Banka
p. 154

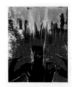

Barbieri, Gian Paolo
(Autoportrait)
year unknown
T-808 Film
© Gian Paolo Barbieri
p. 321

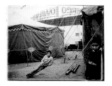

Barraco, Daniel
Circus "Lowandi", Mendoza, Argentina
1998
T-665 Film
© Daniel Barraco
p. 273

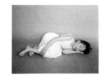

Barranti, Lou
Untitled (Kjrstn)
May 1989
T-55 Film
© Lou Barranti, 1989
p. 235

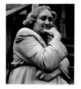

Baruch, Ruth-Marion
Woman on Haight Street, San Francisco
1957
film type unknown
© The Estate of Ruth-Marion Baruch
p. 98

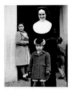

Baruch, Ruth-Marion
Nun and Chinese Child, San Francisco
1948
film type unknown
© The Estate of Ruth-Marion Baruch
p. 109

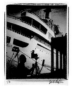

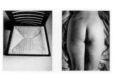

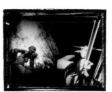

Basilico, Gabriele
Photographer with Ship (Assembled from "Genova 1985")
1985
20x24 Polacolor Film
© Gabriele Basilico
p. 229

Basilico, Gabriele
Contact
1983
T-55 Film
© Gabriele Basilico
p. 306

Bass, Pinky/MM
Tequio Climbing (From Limens and Sublimens Series)
1994
T-55 Film
© Pinky/MM Bass
p. 102

Bass, Pinky/MM
In Abiquiu (From Dreams of Death Series)
1987
T-55 Film
© Pinky/MM Bass
p. 244

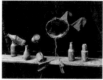

Bazen, Rien
(Blue Chair)
year unknown
T-58 Film
© Rien Bazen
p. 213

Beard, Peter
Iman
1987
20x24 Polacolor Film
© Peter Beard, 2004
p. 232

Benes, Jaroslav
Untitled
1985
T-55 Film
© Benes Jaroslav
p. 293

Bengston, Jim
Marius in the Pig Pen, from "Slow Motion" Series
1977
T-665 Film
© Jim Bengston, 1977
p. 142

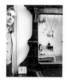

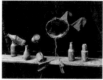

Benson, John
(Untitled)
year unknown
T-52 Film
© John Benson
p. 144

Berman, Zeke
Floating Pants
1997
T-55 Film
© Zeke Berman
p. 258

Bertoli, Giasco
Untitled
1993
T-59 Film
© Giasco Bertoli
p. 110

Bishop, Michael
Untitled (Photogram)
1973
T-58 Film
© Michael Bishop, 1973
p. 121

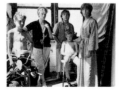

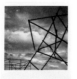

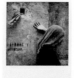

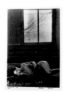

Black, Judith
Self with Children (Before Vacation with their Father)
July 14, 1984
T-55 Film
© Judith Black
p. 278

Blok, Diana & Broekmans, Marlo
Construction
1981
SX-70 Time Zero Film
© Marlo Broekmans and Diana Blok
p. 29, front cover

Blok, Diana & Broekmans, Marlo
The Message
1981
SX 70 Time Zero Film
© Marlo Broekmans and Diana Blok
p. 59

Blok, Diana & Broekmans, Marlo
Chrysalis
1980
T-665 Film
© Marlo Broekmans and Diana Blok
p. 312

Blumenfeld, Erika
*Light Leaks Variation No. 13
[Meditating on Evolution]*
1999
T-59 Film
© Erika Blumenfeld
p. 178

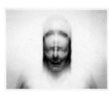

Bohnen, Blythe
Self-Portrait: Vertical Motion Up, Large
1983
T-55 Film
© Blythe Bohnen
p. 219

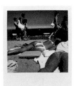

Bossan, Enrico
People on the Beach
year unknown
T-600 Film
© Enrico Bossan
p. 74

Bossard, Nicolas
(Collage of Nude)
year unknown
T-108 Film
© Nicolas Bossard
p. 114

Bourel, Bruno
(9x Abstract)
year unknown
SX-70 Time Zero Film
© Bruno Bourel
p. 43

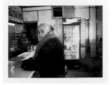

Braithwaite, Hilton
Newark, NJ
1993
PC PRO 100 Film
© Hilton Braithwaite
p. 177

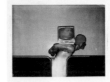

Braun-Eis, Rolf
(Man with T.V.)
year unknown
T-108 Film
© Rolf Braun-Eis
p. 95

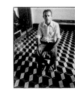

Bryan, Gail
Untitled
1981
SX-70 Time Zero Film
© Gail Bryan, 1981
p. 75

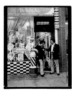

Burke, Bill
Smokers, Barber Shop, San Francisco
1979
T-665 Film
© Bill Burke
p. 118

Burke, Bill
Family, Kermit. W. Va.
1979
T-665 Film
© Bill Burke
p. 132

Burke, Bill
Seated Man, Tile Floor, Oinda Brasil
1982
T-665 Film
© Bill Burke
p. 141

Burns, Marsha
Marcus and Edwin
Seattle, 1993
T-55 Film
© Marsha Burns
p. 126

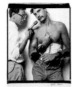

Burns, Marsha
Media Event
San Diego, 1983
20x24 Polapan Film
© Marsha Burns
p. 268

Burton, Valerie
Girl's Legs
France, 1979
SX-70 Time Zero Film
© Valerie C. Burton, Ottawa, Canada
p. 33, back cover

Callahan, Harry
Weed Against the Sky, Detroit
1948
film type unknown
© The Estate of Harry Callahan. Courtesy Pace/MacGill Gallery, New York
p. 224

Campos-Pons, Maria Magdalena
Abridor de Caminos
1997
20x24 Polacolor Film
© Maria Magdalena Campos-Pons
p. 236

Caponigro, Paul
Branches over Ice
year unknown
T-55 Film
© Paul Caponigro
p. 252

Carbone, Francesco
*Red Nude, Crossed Legs, Head
Down #2*
1987
20x24 Polacolor Film
© Francesco Carbone
p. 313

Carey, Ellen
No. 204
1997
20x24 Polacolor Film
© Ellen Carey. Courtesy of the Artist and
the Polaroid Collections
p. 225

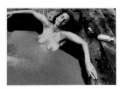

Casanave, Martha
Untitled
1979
T-665 Film
© Martha Casanave
p. 286

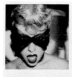

Castelli, Luciano
Irené
1978
SX-70 Time Zero Film
© Luciano Castelli/VG Bild-Kunst, Bonn
2007
p. 81

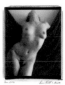

Castelli, Luciano
Alexandra
Paris, June 11, 1990
20x24 Polacolor Film
© Luciano Castelli/VG Bild-Kunst, Bonn
2007
p. 260

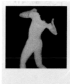

Charlesworth, Bruce
(Untitled)
1979
SX-70 Time Zero Film
© Bruce Charlesworth, 1979
p. 46

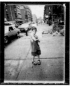

Charlesworth, Bruce
(Untitled)
1979
SX-70 Time Zero Film
© Bruce Charlesworth, 1979
p. 47

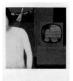

Charlesworth, Bruce
Domestic Scene #20
1979
SX-70 Time Zero Film
© Bruce Charlesworth, 1979
p. 78

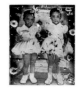

Chong, Albert
The Two Sisters
1986
T-55 Film
© Albert Chong
p. 127

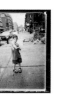

Church, Cathy
Underwater Divers with Masks
year unknown
SX-70 Time Zero Film
© Cathy Church
p. 41, front cover

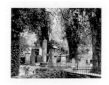

Cianni, Vincent
*Young Homeboy, Bedford Avenue,
Williamsburg, Brooklyn*
1995
T-665 Film
© Vincent Cianni
p. 140

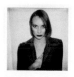

Cicic, Esad
Portrait of Woman
year unknown
SX-70 Time Zero Film
© Esad Cicic
p. 56, back cover

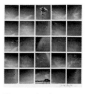

Clergue, Lucien
Le Cerf Volant, Bretagne, France
1984
SX-70 Time Zero Film
© Lucien Clergue
p. 48

Clergue, Lucien
Self-Portrait with Two Nude Models
Mexico, May 19, 1978
SX-70 Time Zero Film
© Lucien Clergue
p. 57

Clift, William
Hillsboro, North Carolina
1970
T-55 Film
© William Clift, 1970
p. 146

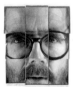

Close, Chuck
Self-Portrait
1987
20x24 Polapan Film
© Chuck Close
p. 282

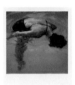

Cohen, Mark
Lillian in Swimming Pool
1976
SX-70 Time Zero Film
© Mark Cohen/VG Bild-Kunst, Bonn 2007
p. 55, back cover

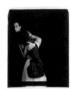

Cowin, Eileen
Untitled
1985
20x24 Polapan Film
© Eileen Cowin
p. 269

Crane, Barbara
From Coloma to Covert
1988
T-808 Film
© Barbara Crane
p. 254

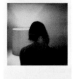

Crane, Barbara
From Coloma to Covert
1990
T-803 Film
© Barbara Crane
p. 255

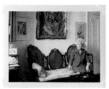

Curran, Donald
(Woman Seated on Couch)
year unknown
T-665 Film
© Donald Curran
p. 176

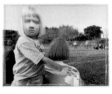

Dietz, Donald
Considering Her Feet
1976
SX-70 Time Zero Film
© Donald Dietz
p. 3, front cover

Dietz, Donald
Woman's Back
1976
SX-70 Time Zero Film
© Donald Dietz
p. 54, back cover

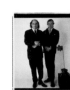

Dieuzaide, Jean
(Shell)
c. 1984
T-55 Film
© Jean Dieuzaide
p. 248

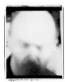

Dine, Jim
Self-Portrait
1979
20x24 Polacolor Film
© Jim Dine/VG Bild-Kunst, Bonn 2007
p. 233

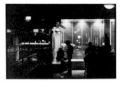

Doherty, Richard
Disturbed Girl (Allison, October 1992)
1992
T-55 Film
© Richard Doherty
p. 130

Dolfo, Ferdinando
A Philosophical Walk
1983
SX-70 Time Zero Film
© Ferdinando Dolfo
p. 58

Dorfman, Elsa
Allen and Peter on Thursday Afternoon
Cambridge, February 7, 1980
20x24 Polacolor Film
© Elsa Dorfman, February 7, 1980, all rights reserved. elsa.photo.net
p. 294

Erfurt, Stephan
New York Restaurants
1985
35mm PolaPanFilm
© Stephan Erfurt
p. 249

Erfurt, Stephan
New York Restaurants
1985
35mm PolaPan Film
© Stephan Erfurt
p. 274

Ernst, Beatrice
Time is an Endless Passing Traveller
1983
SX-70 Time Zero Film
© Beatrice Ernst
p. 68

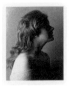

Erwitt, Elliott
(Woman/Side Profile)
year unknown
T-48 Film
© Elliott Erwitt
p. 188

Ewald, Wendy
"The Men are Dancing" by Florence
Maile
1993
T-665 Film
© Wendy Ewald
p. 119

Ewald, Wendy
*"I Deamed my Brother and his Friend
Sitting at his Feet"* by Franklin Monna
Katla
1993
T-665 Film
© Wendy Ewald
p. 131

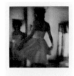

Federico, Maria Grazia
*Series: Eva Contro Eva; Spot
Publicitario "Tefal"*
1991
SX-70 Time Zero Film
© Maria Grazia Federico
p. 37, back cover

Ferguson, Jesseca
Theatre of Memory III
1996
20x24 Polacolor Film
© Jesseca Ferguson
p. 242

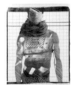

Ficek-Swenson, Bernice
Vessels and Vestiges III
1999
T-55 Film
© Bernice Ficek-Swenson
p. 259

Filhol, Alain
Bench on Red Street
1979
T-665 Film
© Alain Filhol
p. 256

Filhol, Alain
Green House
1979
T-665 Film
© Alain Filhol
p. 257

Filhol, Alain
Sport
1979
T-665 Film
© Alain Filhol
p. 319

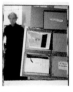

Fontana, Franco
Piscina
1984
T-600 Film
© Franco Fontana
p. 93

Franchi de Alfaro III, Luciano
Letter in Process
1988
20x24 Polacolor Film
© Luciano Franchi de Alfaro III
p. 226

Franchi de Alfaro III, Luciano
Flesh Stroke #15
1983
T-809 Film
© Luciano Franchi de Alfaro III
p. 253

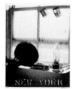

Frank, Robert
New York
1977
T-665 Film
© Robert Frank. Courtesy of Pace/MacGill
Gallery, New York
p. 296

Frank, Robert
Boston
March 20, 1985
20x24 Polacolor Film
© Robert Frank. Courtesy of Pace/MacGill
Gallery, New York
p. 297

French, Andrew
title unknown
2000
T-809 Film
© Andrew French
p. 76

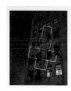

French, Andrew
title unknown
2000
T-809 Film
© Andrew French
p. 243

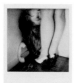

Frima, Toto
(Head, Legs, Telef.)
c. 1985
SX-70 Time Zero Film
© Toto Frima
p. 8, front cover

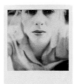

Frima, Toto
(Self-Portrait)
c. 1985
SX-70 Time Zero Film
© Toto Frima
p. 90

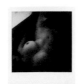

Frima, Toto
(Nude)
c. 1985
SX-70 Time Zero Film
© Toto Frima
p. 91

Fruitman, Sheva
Seeds
1996
T55 P/N
© Sheva Fruitman
p. 104

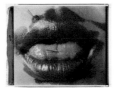

Fukase, Masahisa
A Game: Lips & Needles
1983
20x24 Polacolor Film
© Masahisa Fukase Estate
p. 4

Garzoni, Micaela
(Child Running)
1986
35mm PolaChrome Film
© Micaela Garzoni
p. 267

Ghirri, Luigi
From "Still-Life" Modena
1978
T-600 Film
© Archivio Eredi di Luigi Ghirri —
Reggio Emilia (I)
p. 62

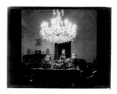

Gibson, Ralph
Self-Portrait
1977
SX-70 Time Zero Film
© Ralph Gibson
p. 63

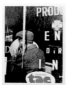

Gibson, Ralph
Roma #2
year unknown
T-665 Film
© Ralph Gibson
p. 247

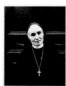

Gibson, Ralph
Roma #1
1980
T-665 Film
© Ralph Gibson
p. 284

Gioia, Joe
Andy, NYC
1988
T-55 Film
© Joe Gioia, 1988, 2004
p. 285

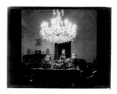

Gladys
*One Picture from the Series "Casa
Ortiz, Laredo, TX" (Two Girls under a
Luster)*
1993
T-665 Film
© Gladys
p. 122

Gohlke, Frank
Grain Elevator #7
Minneapolis, MN 1973
T-52 Film
© Frank Gohlke
p. 124

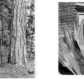

Goin, Peter
Shadow Figure in Forest
1989
T-55 Film
© Peter Goin
p. 270

Gomes, Lyle
Angel Island, California
1980
T-52 Film
© Lyle Gomes
p. 105

Goro, Fritz
*Glaucoma Damage to Optic Nerve
and Fovea of Eye*
1976
T-58 Film
© Fritz Goro
p. 196

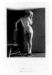

Gowland, Peter
Nude Woman by Chair
year unknown
T-53 Film
© Peter Gowland
p. 194

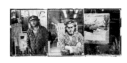

Graham, Brian
Saint Catherine Street East, Montreal, Quebec, Canada
1981
T-665 Film
© Brian Graham 1981
p. 148

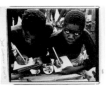

Guntenaar, Joost
In Apartheid
1980
20x24 Polacolor Film
© Joost Guntenaar
p. 305

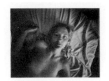

Haberman, Jim
Woman on Sheet
1976
T-55 Film
© Jim Haberman
p. 113

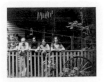

Haiko, Robert F.
On the Fence
1971
T-55 Film
© Robert F. Haiko
p. 147

Haiko, Robert F.
Grass and Snow
1968
T-55 Film
© Robert F. Haiko
p. 152

Haiko, Robert F.
Nude #1
1976
T-52 Film
© Robert F. Haiko
p. 160

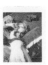

Halsman, Philippe
Tippi Hedren
1963
T-53 Film
© Photo by Philippe Halsman. Courtesy The Halsman Estate
p. 145

Halsman, Philippe
Salvador Dali
year unknown
T-42 Film
© Photo by Philippe Halsman. Courtesy The Halsman Estate
p. 158

Halsman, Philippe
Weegee
1961
T-53 Film
© Photo by Philippe Halsman. Courtesy The Halsman Estate
p. 159

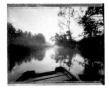

Hannappel, Werner J.
Sweden
1989
T-55 Film
© Werner Hannappel
p. 180

Haxton, David
Side Lights on Torn Yellow over Violet
1979
T-58 Film
© David Haxton
p. 150

Hays, David M.
Untitled (From the Series The Mannequin)
Paris, France, July, 1981
SX-70 Time Zero Film
© David M. Hays
p. 66

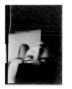

Herdy, Kenneth Laing
"M" from Anatomy Series
1993
35mm PolaPan Film
© Kenneth Laing Herdy
p. 112

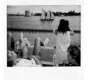

Hitchcock, Barbara
Circle Line, NYC
1986
SPECTRA (Image) Film
© Barbara Hitchcock
p. 38

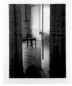

Hitchcock, Barbara
(Chair)
1979
T-52 Film
© Barbara Hitchcock
p. 202

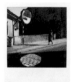

Hnizdo, Jan
(Woman on Street)
year unknown
SX-70 Time Zero Film
© Jan Hnizdo
p. 34

Hockney, David
Interior, Pembroke Studios, London
1986
1986
40x80 Polacolor Film
© David Hockney
p. 129

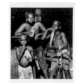

Hudnall, Earlie
Boy at Sundown
1993
T-665 Film
© Earlie Hudnall Jr.
p. 250

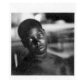

Hudnall, Earlie
Break Time
1993
T-665 Film
© Earlie Hudnall Jr.
p. 251

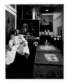

Huf, Paul
(Man w/ Dogs)
1977
T-808 Film
© Paul Huf/VG Bild-Kunst, Bonn 2007
p. 220

Huijbers, Ton
SX-70 Moonrise
1991
SX-70 Time Zero Film
© Ton Huijbers
p. 50

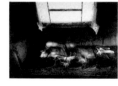

Humbert, Florence
(Little Tree at the Left – Standing Man
at the Right – Big Top with Red
Tarpaulin in Background)
1990
600 HS Film
© Florence Humbert
p. 139

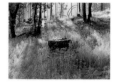

Hyde, Philip
Photographer's Backyard, Greenville,
California
year unknown
film type unknown
© Philip Hyde
p. 292

Irutchka
Revision
New York, 1983
SX-70 Time Zero Film
© Irutchka
p. 96

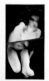

Janssens, Alain
Violence d'amour 7/8
year unknown
T-665 Film
© Alain Janssens
p. 266

Johnson, Chris
Triptych
1991
T-55 Film
© Chris Johnson
p. 262

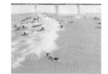

Jones, Harold
Big Surf
1980
T-55 Film
© Harold Jones
p. 153

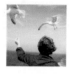

Jones, Peter
Seagulls and Boy
year unknown
SX-70 Time Zero Film
© Peter Jones
p. 27

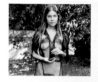

Kaida, Tamarra
Girl with Cherries
1983
T-55 Film
© Tamarra Kaida
p. 314

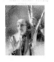

Kaminski, Edward
Portrait of Ansel Adams
1963
T-50 Film
© Edward Kaminski
p. 134

Kane, Art
Untitled
c. 1960
T-108 Film
© Art Kane Archives
p. 135

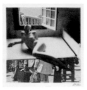

Kane, Art
Untitled, 1977
1977
SX-70 Time Zero Film
© Art Kane Archives
p. 246

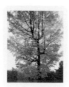

Kaufman, Daniel
(Fall Tree)
year unknown
T-58 Film
© Daniel Kaufman
p. 183

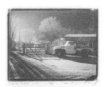

Kennedy, David Michael
Frank's Place
March 1988
T-55 Film
© David Michael Kennedy, www.david-
michaelkennedy.com
p. 191

Keresztes, Lajos
Masculin-Feminin
1987
SX-70 Time Zero Film
© Lajos Keresztes
p. 70

Klett, Mark
*Looking North through the Snow
Tunnel at Goat Lake, Sawtooth Range,
ID*
year unknown
T-55 Film
© Mark Klett
p. 137

Kolbrener, Bob
Lake & Line
1977
T-52 Film
© Bob Kolbrener
p. 161

Kommer, Karen
Fantastische Vertellingen
1980
SX-70 Time Zero Film
© Karen Kommer
p. 72

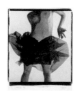

Kommer, Karen
Fantastische Vertellingen
1980
SX-70 Time Zero Film
© Karen Kommer
p. 73

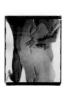

Kommer, Karen
Lady in Classic Interior
1980
SX-70 Time Zero Film
© Karen Kommer
p. 79, back cover

Krupsaw, Warren
Untitled
March 31, 1968
T-52 Film
© Warren Krupsaw
p. 200

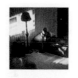

Kuru, Sachiko
(Girl with Dog)
c. 1979
T-808 Film
© Sachiko Kuru
p. 309

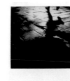

Lang, Cay
Jeanne IV
1987
20x24 Polacolor Film
© Cay Lang
p. 276

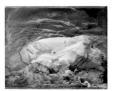

Lang, Cay
Thompson II
1987
20x24 Polacolor Film
© Cay Lang
p. 277

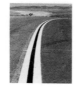

Lee, Jim
Two Green Houses
March 1998
SX-70 Time Zero Film
© Jim Lee
p. 301

Levinthal, David
*Untitled, from the Series "Modern
Romance"*
1985
SX-70 Time Zero Film
© David Levinthal
p. 36, back cover

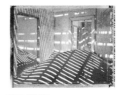

Ling, Elaine
Abandoned, Namib Desert #8
1997
T-55 Film
© Elaine Ling
p. 190

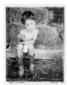

Lyon, Danny
Raphael in New Mexico, 1979
1979
T-665 Film
© Danny Lyon, Courtesy Edwynn Hour
Gallery
p. 187

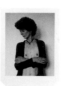

Mapplethorpe, Robert
Skinny Woman
year unknown
T-55 Film
© Robert Mapplethorpe
p. 106

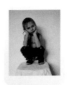

Mapplethorpe, Robert
Skinny Woman
year unknown
T-55 Film
© Robert Mapplethorpe
p. 107

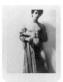

Mapplethorpe, Robert
Untitled (Robe Series, 1/2 Dressed)
1975
T-55 Film
© Robert Mapplethorpe
p. 279

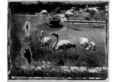

Mark, Mary Ellen
(Bridesmaids) First Communion Girls
1986
SPECTRA (Image) Film
© Mary Ellen Mark
p. 40

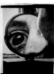

McQueen, Ann
*Jumping Naked Series: A. with
Ribbons*
1983
T-55 Film
© Ann McQueen
p. 216

Michals, Duane
*Three Doors with Shutters New
Orleans*
year unknown
SX-70 Time Zero Film
© Duane Michals
p. 85

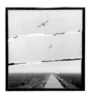

Minkkinen, Arno Rafael
Self-Portrait, Fosters Pond
1989
T-55 Film
© Arno Rafael Minkkinen
p. 298

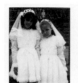

Moon, Sarah
Les oiseaux d'anvers
1990
T-665 Film
© Sarah Moon
p. 204

Mosconi, Davide
(Little Round Mirror)
1987
20x24 Polacolor Film
© Davide Mosconi
p. 264

Mosconi, Davide
(Little Round Mirror)
1987
20x24 Polacolor Film
© Davide Mosconi
p. 265

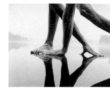

Müller-Pohle, Andreas
Albufera II
1985
T-665 Film
© Andreas Müller-Pohle, Berlin
p. 299

Namuth, Hans
title unknown
year unknown
SX-70 Time Zero Film
© Hans Namuth Ltd.
p. 84

Natal, Judy
*Series: EarthWords, Title: Y-Y-Y
(Triptych)*
1999
T-55 Film
© Judy Natal
p. 100

Nestler von Rosen, Monica
Untitled
1980
T-88 Film
© M. Nestler & M. von Rosen
p. 82

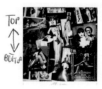

Newton, Helmut
title unknown
1976
SX-70 Time Zero Film
© The Estate of Helmut Newton
p. 65

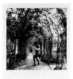

Newton, Helmut
(Kiss)
year unknown
SX-70 Time Zero Film
© The Estate of Helmut Newton
p. 83

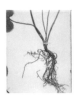

Oelbaum, Zeva
Roots, 1998
1998
T-55 Film
© Zeva Oelbaum
p. 302

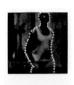

Ouazan, Paul
Rome
1985
SX-70 Time Zero Film
© Paul Ouazan
p. 67

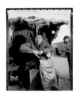

Perrin, Gilles
Tian Lei, "Pom Pom" Driver (Diesel Motor Tricycle), He Xi Village, Anhui Province
1989
T-55 Film
© Gilles Perrin
p. 167

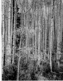

Petegorsky, Stephen
Untitled #30
1991
T-59 Film
© Stephen Petegorsky
p. 11

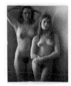

Pletka, Irene
Woman in Turkish Trousers, Jerusalem 1985, from the Series "Women in Israel"
1985
T-665 Film
© Irene Pletka
p. 162

Polaroid Archives
(Woman in Front of Window)
year unknown
T-40 Film
© Courtesy the Polaroid Collections
p. 99

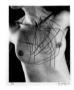

Porter, Eliot
Aspens, Autumn, N.M.
1949
film type unknown
© Amon Carter Museum, Fort Worth, Texas 1990
p. 310

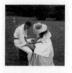

Powell, Dan
Chart of Brief Forms #16
1989
T-55 Film
© Dan Powell
p. 201

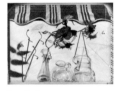

Power, Mark
Sisters 1
1970
T-58 Film
© Mark L. Power
p. 173

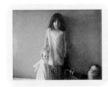

Power, Mark
Sisters 2
1971
T-58 Film
© Mark L. Power
p. 195

Pugin, Jacques
Ombres et lumière (Shadows & Light)
1983
T-55 Film
© Jacques Pugin
p. 287

Purcell, Carl
Couple on Lawn
year unknown
SX-70 Time Zero Film
© Carl Purcell
p. 60

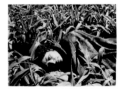

Purcell, Rosamond Wolff
(Bed of Leaves)
year unknown
T-55 Film
© Rosamond Wolff Purcell
p. 311

Radke, James
Saudi Arabia
January 18, 1991
SX-70 Time Zero Film
© James K. Radke
p. 30

Reisberg, Leonie
Self-Portrait
1978
T-108 Film
© Leonie Reisberg
p. 189

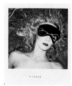

Rodan, Don
Hypnos
1977
SX-70 Time Zero Film
© Don Rodan
p. 64, front cover

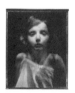

Ropp, William
Lou
1999
T-55 Film
© William Ropp
p. 163

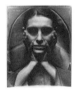

Ropp, William
Micha
1996
T-55 Film
© William Ropp
p. 175

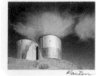

Ross, Alan
Tanks and Clouds, Death Valley
October 7, 1977
T-52 Film
© Alan Ross
p. 172

Rousakis, Helen
Untitled (Albino Frog)
1996
T-669 Film
© Helen Rousakis
p. 111

Rovner, Michal
Red Teeth
1987
SX-70 Time Zero Film
© Michal Rovner, 2004/VG Bild-Kunst, Bonn 2007
p. 308

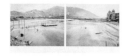

Ruwedel, Mark
Oquirrh Mountains/Saltair Pavilion
1991
T-55 Film
© Mark Ruwedel
p. 230

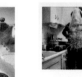

Saenz, Jorge
Ruta 2, Paraguay
1994
SX-70 Time Zero Film
© Jorge Saenz, 1994
p. 31

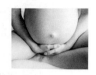

Saenz, Jorge
Venta de Peces, Asuncion, Paraguay
1994
SX-70 Time Zero Film
© Jorge Saenz, 1994
p. 53, front cover

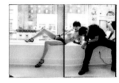

Salvo, Dana
Veiled Woman Jaisalmer India
1993
T-59 Film
© Dana Salvo
p. 206

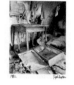

Samaras, Lucas
Photo Transformation
December 28, 1973
SX-70 Time Zero Film
© Lucas Samaras. Courtesy Pace Wildenstein
p. 87

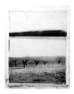

Sartoni, Danilo
Landscape
c. 1988
T-808 Film
© Danilo Sartoni
p. 280

Schildkrout, Elliot
Barbara and Aaron
1979
T-55 Film
© Elliot Schildkrout
p. 316

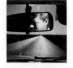

Scott, Nigel
title unknown
2000
T-665 Film
© Photograph by NIGEL SCOTT
p. 238

Sexton, John
Interior, Benton Crossing, California
1982
T-52 Film
© John Sexton, 1982. All rights reserved.
p. 203

Sexton, John
Defaced Window, Monterey, CA
1982
T-808 Film
© John Sexton, 1982. All rights reserved.
p. 303

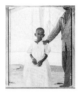

Sheikh, Fazal
Hadija and her Father Badel Addan Gadel, Somali Refugee Camp, Mandera, Kenya
1992
T-665 Film
© Fazal Sheikh
p. 166

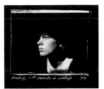

Shook, Melissa
Krissy, 1st Month in College
year unknown
T-55 Film
© Melissa Shook
p. 186

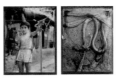

Short, William
Boy with Cobra on the Island of the Coconut Monk, Viet Nam
1990
T-55 Film
© William Short
p. 208

Shuden, Jungo
Zakubaran No. 12
1993
35mm PolaPan Film
© Jungo Shuden
p. 198

Sieff, Jeanloup
Self-Portrait
1978
T-665 Film
© The Estate of Jeanloup Sieff
p. 215

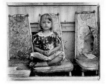

Sills, Vaughn
Tasha
1992
T-665 Film
© Vaughn Sills
p. 304

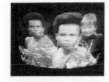

Silver, Michael D.
My Darkroom, My Life, My Circumstances
1988
T-665 Film
© The Estate of Michael Silver
p. 151

Silverthorne, Jeffrey
title unknown
year unknown
film type unknown
© Jeffrey Silverthorne
p. 156

Simpson, Lorna
Shoe Lover
1992
20x24 Polacolor Film
© Lorna Simpson
p. 240

Siskind, Aaron
Untitled
1984
SX-70 Time Zero Film
© Aaron Siskind Foundation
p. 6

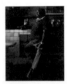

Sivack, Denis
Hands in Skirt
1980–81
SX-70 Time Zero Film
© Denis Sivack
p. 32, front cover

Slavin, Neal
title unknown
c. 1979
T-808 Film
© Neal Slavin
p. 221

Stefanelli, Umberto
Passi a ritmo di Milonga
2002
T-809 Film
© Umberto Stefanelli
p. 217

Stone, Jim
Cotton Trailer: Dateland, Arizona
1988
T-55 Film
© Jim Stone
p. 181

Struebing-Beazley, Kristen
Republic, Michigan: 1914
1997
T-669 Film
© Kristen Struebing-Beazley
p. 157

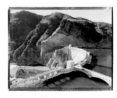

Stupich, Martin
Roosevelt Dam Before Entombment, Arizona
1987
T-55 Film
© Martin Stupich
p. 116

349

ARTIST INDEX S - W

Sunday, Elisabeth
Changes: Johnny Spain, former Black Panther Leader, California
1993
SX-70 Time Zero Film
© Elisabeth Sunday
p. 210

Taka, Rei
Still Life #57
1992
T-55 Film
© Rei Taka
p. 170

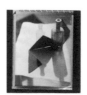

Taka, Rei
Still Life #62
1992
T-55 Film
© Rei Taka
p. 171

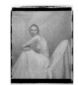

Tenneson, Joyce
Suzanne in Chair
1987
20x24 Polacolor Film
© Joyce Tenneson
p. 234

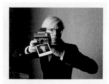

Tenneson, Joyce
Eaux
1987
20x24 Polacolor Film
© Joyce Tenneson
p. 288

Tenneson, Joyce
title unknown
1987
20x24 Polacolor Film
© Joyce Tenneson
p. 289

Thacker, Gail
Mark Morrisroe in Bed
1989
T-665 Film
© Gail Thacker
p. 165

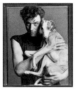

Thurber, Shellburne
Donald + Koko
1983
T-665 Film
© Shellburne Thurber
p. 168

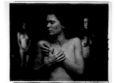

Toscani, Oliviero
(Andy w/ Camera)
year unknown
T-105 Film
© Oliviero Toscani
p. 94

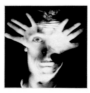

Turbeville, Deborah
Tannenbaum Hair Stylists Poster for Salon
New York City, 1976
T-55 Film
© Deborah Turbeville
p. 218

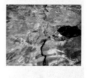

Turbeville, Deborah
Dayton's Oral Room
New York City, 1976
T-105 Film
© Deborah Turbeville
p. 271

Turner, Pete
Women on Black Beach
1976
SX-70 Time Zero Film
© Pete Turner
p. 52

Uelsmann, Jerry
Untitled
1986
20x24 Polacolor Film
© Jerry N. Uelsmann
p. 222

Van Beeck, Martien
Self-Portrait with Hands
1989
T-665 Film
© Martien Van Beeck
p. 227

van Steenwijk, Jan
Waves
1986
SPECTRA (Image) Film
© Jan van Steenwijk
p. 88

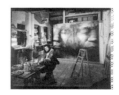

van Steenwijk, Jan
Tom Halloran – Painter
2000
T-55 Film
© Jan van Steenwijk
p. 184

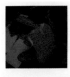

Van't Veen, David
(Child at Work)
year unknown
SX-70 Time Zero Film
© David Van't Veen
p. 89, front cover

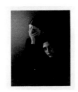

Vaughan, Caroline H.
Lauren and Jeanette
1973
T-52 Film
© Caroline H. Vaughan, 1973
p. 169

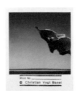

Vogt, Christian
From "Yellow Sequence"
1978
SX-70 Time Zero Film
© Christian Vogt
p. 39

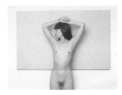

Vogt, Christian
From the Series "Pola-Portraits"
c. 1980
T-55 Film
© Christian Vogt
p. 317

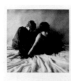

Wachler, E. Louise
Meditations #101
1983
SX-70 Time Zero Film
© E. Louise Wachler
p. 61

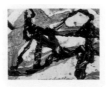

Wagner, Catherine
7th & 8th Grade Science Classroom/
From American Classroom
1984
T-55 Film
© Catherine Wagner
p. 205

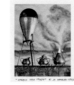

Warhol, Andy
(Andy Sneezing)
year unknown
SX-70 Time Zero Film
© 2007 Andy Warhol Foundation for the
Visual Arts/ARS, New York
p. 80, back cover

Warhol, Andy
Untitled
1979
20x24 Polacolor Film
© 2007 Andy Warhol Foundation for the
Visual Arts/ARS, New York
p. 291

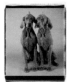

Wegman, William
Related (Models: Fay and Batty)
1994
20x24 Polacolor Film
© William Weman
p. 295

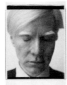

Weston, Brett
Untitled
1966
T-56 Film
© The Brett Weston Archive. Photograph
by Brett Weston
p. 197

Whaley, Jo
Atomic Tea Party v.2
1993
PC PRO 100 Film
© Jo Whaley, 1993
p. 138

Whealton, Stephen
Ashtray Photogram/Experimental
Image
December 1977
T-58 Film
© Stephen Whealton
p. 182

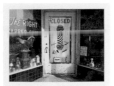

Willis, Deborah
Virginia Back Roads
1993
PC PRO 100 Film
© Deborah Willis
p. 207

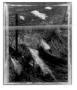

Woodman, Donald
From Detritus on the Highway
1980
T-55 Film
© Donald Woodman
p. 136

ACKNOWLEDGEMENTS:

Special thanks to Christophe Blaser, curator, Musée de l'Elysée, Lausanne, Switzerland
and to Thomas Gustainis, assistant, the Polaroid Collections, Waltham, Massachusetts.

EACH AND EVERY TASCHEN BOOK PLANTS A SEED!

TASCHEN is a carbon neutral publisher. Each year, we offset our annual carbon emissions
with carbon credits at the Instituto Terra, a reforestation program in Minas Gerais, Brazil,
founded by Lélia and Sebastião Salgado. To find out more about this ecological partner-
ship, please check: www.taschen.com/zerocarbon
Inspiration: unlimited. Carbon footprint: zero

To stay informed about TASCHEN and our upcoming titles, please subscribe to our free
magazine at www.taschen.com/magazine, download our magazine app for iPad, follow us
on Twitter, Instagram and Facebook, or e-mail your questions to contact@taschen.com.

Editor: Steve Crist, Los Angeles
Package and cover concept: Steve Crist, Los Angeles
Design: Carrie Worthen and Ben Pope, Thirdthing.com, Los Angeles
Production: Thomas Grell, Cologne; Stefan Klatte, Los Angeles
Reproduction photography: Jan van Steenwijk, Boston
Editorial coordination: Julia Krumhauer, Cologne
German translation: Anke Caroline Burger, Berlin
French translation: Marie Dumont-Agarwal, Brussels
Collaboration: Ethel Seno, Kate Soto, Los Angeles

Printed in Slovakia
ISBN 978-3-8365-0189-7